SOFA
CHICAGO
SCULPTURE OBJECTS
& FUNCTIONAL ART

**The Eleventh Annual International Exposition of
Sculpture Objects & Functional Art**

November 5-7
Navy Pier

A project of Expressions of Culture, Inc.

front cover:
*Silvia Levenson**
Cinderella, 2000
pâte de verre, copper nail
4 x 3 x 8
represented by
Caterina Tognon Arte Contemporanea
*Silvia Levenson is the 2004 recipient of the
Corning Museum of Glass Rakow Commission

All dimensions in the catalog
are in inches (h x w x d)
unless otherwise noted

Library of Congress – in Publication Data

SOFA CHICAGO 2004
The Eleventh Annual International
Exposition of Sculpture
Objects & Functional Art

ISBN 0-9713714-3-1
2004111188

Published in 2004 by Expressions of Culture, Inc., Chicago, Illinois

Graphic Design by Design-360° Incorporated, Chicago, Illinois
Printed by Pressroom Printer & Designer, Hong Kong

SOFA
CHICAGO

SCULPTURE OBJECTS
& FUNCTIONAL ART

Expressions of Culture, Inc.
4401 North Ravenswood, #301
Chicago, IL 60640
voice 773.506.8860
fax 773.506.8892
www.sofaexpo.com

Mark Lyman, president
Anne Meszko
Julie Oimoen
Kate Jordan
Jennifer Haybach
Greg Worthington
Barbara Smythe-Jones
Therese Donnelly
Patrick Seda
Bridget Trost

Conte

S O F A
CHICAGO
SCULPTURE OBJECTS
& FUNCTIONAL ART

Welcome to SOFA CHICAGO 2004!

After celebrating its Tenth Anniversary last year, SOFA CHICAGO kicks off its second decade with a truly international arts exposition. 90 of the world's foremost galleries and dealers present a wide range of cultural expressions, materials and perceptions of art—from the tribal to the most contemporary, in a rich mosaic of form, technique and reference. 32 international galleries from 10 countries make this SOFA one of the most far-reaching ever. Special thanks are again due the British Crafts Council for its support in part of the participation of nine galleries from the United Kingdom; and Danish Crafts and The Danish Trade Council for its support of six Danish galleries at SOFA CHICAGO.

Building on the mosaic analogy, the SOFA CHICAGO Lecture Series might aptly be spoken of as a tapestry woven by many. The reference to fiber is especially apt this year, as a record number of presentations focus on textile arts. Special thanks to Friends of Fiber Art International for organizing a series of lectures featuring American artists selected to exhibit in the 11th annual 2004 International Triennial of Tapestry at The Central Museum of Textiles in Lódz, Poland, the oldest and most prestigious international exhibition promoting contemporary tapestry in the world. Thanks also to the many SOFA galleries, artists and arts organizations contributing their time and expertise to make the 33 Lecture Series presentations relevant and compelling explorations of ideas and context.

Principal among five Special Exhibits at SOFA CHICAGO 2004 is *Israel2004, Contemporary and Conceptual Art*, organized by the Association of Israel's Decorative Arts (AIDA), a project initiated at SOFA CHICAGO 2003 by collectors Charles and Andy Bronfman and Doug and Dale Anderson. AIDA again presents the work of artists living and working in Israel, whose successful debuts at SOFA CHICAGO has led to U.S. gallery representation for many. Many thanks to curator, Dale Anderson and advisors Jane Adlin, Metropolitan Museum of Art, NY; Aviva Ben-Sira, Eretz Israel Museum, Israel; Rivka Saker, Sotheby's Israel; and Davira Taragin, Racine Art Museum.

Special thanks to Tom and Rhonda Grotta of browngrotta arts and LongHouse Reserve for organizing the Special Exhibit, *Ed Rossbach: Quiet Revolutionary*, a fitting tribute to a master and key pioneer in the fiber arts movement. Thanks also to Collectors of Wood Art and Mark Leach, Deputy Director, The Mint Museums, for organizing the comprehensive survey of contemporary turned wood and sculptural art, *Whole Grain: Sculpted Wood 2004*.

SOFA CHICAGO is delighted to welcome back the Hot Glass Roadshow of the Corning Museum of Glass. In a fusion of fire, molten glass and virtuoso craftsmanship, artists represented by SOFA galleries will create blown glass sculpture and vessel forms on-site. Thanks again to Steve Gibbs and Hot Glass Roadshow team.

Just as SOFA's international profile is building, its national profile is growing with the addition of a new venue! SOFA will join forces with the prestigious International Fine Art Expositions (IFAE) and dmg world media to produce Palm Beach[3], January 13-17, 2005 at the new state-of-the-art Palm Beach County Convention Center. IFAE's strong reputation and experience as producers of fine art fairs will combine with SOFA's expertise in sculpture and objects to create a vital synergy of artforms and talent, building Palm Beach[3] into a premier contemporary arts fair. In its partnership with IFAE, SOFA will be taking a major step towards its long-term goal of bridging the worlds of contemporary decorative and fine art. We are also very excited to offer the dealers of our successful and on-going expositions in New York and Chicago, the opportunity to exhibit in South Florida with its strong art market. And a warm destination in January for collectors!

Following the lead of key art fairs around the world to open their previews to a broader public, SOFA CHICAGO's Opening Night Preview has undergone a creative revisioning! This year there are two entrance times: First Choice Preview, 5 – 7 pm, by gallery invitation only; and Public Preview from 7 – 10 pm, open to the general public.

Our thinking is three-fold. First, we have been able to offer a variety of arts-related non-profit organizations the opportunity to host private benefits in conjunction with the SOFA CHICAGO Opening Night Preview. For example Northwestern Memorial Foundation, with whom we've worked for the past three years, will host a private fundraising function this year for the Arts Program at Northwestern Memorial Hospital centered around First Choice Preview. Second, we hope to attract key buyers to First Choice Preview by offering SOFA CHICAGO galleries and dealers the opportunity to invite their best clients to be the first to view and purchase artwork. Lastly, SOFA CHICAGO has always been robustly attended by the general arts-interested public. Offering an affordable Public Preview to this audience will nurture another generation of art lovers and collectors.

An arts exposition is only as strong as its network of participants, call it a mosaic, a tapestry, a fusion of energies. We hope you will enjoy this year's SOFA CHICAGO synergy as much as we do.

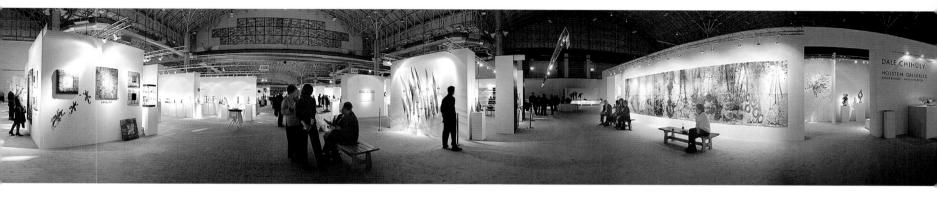

Expressions of Culture, Inc. would like to thank the following individuals and organizations:

Participating galleries, artists, speakers and organizations
American Airlines
Aaron Anderson
Dale Anderson
Doug Anderson
Art Alliance for Contemporary Glass
Art Jewelry Forum
Association of Israel's Decorative Arts
Bruce Bachman
Sam Bailey
David Barnes
Barbara Berlin
Sandra Berlin
Kathy Berner
Jim Bradaric
Lou Bradaric
Kirk Bravendar
British Crafts Council
Andrea Bronfman
Charles Bronfman
Rhonda Brown
John Brumgart
Meg Buchanan
Desiree Bucks
Sheryll Catto
Chicago Art Dealers Association
Chicago Woodturners

Julian Chu
Claridge Hotel
Kelly Colgan
Collectors of Wood Art
Camille Cook
Keith Couser
John Cowden
Michael Davis
Design-360°
Dietl International
Digital Hub
Floyd Dillman
Hugh Donlan
Anne Dowhie
Lenny Dowhie*
Jeff Drabant
Robin Dreyer
D. Scott Evans
Sean Fermoyle
Fine Art Risk Management
The Fitzpatrick Hotel
Focus One
Don Friedlich
Friends of Contemporary Ceramics
Friends of Fiber Art International
Steve Gibbs
Judith Gorman-Prawdzik

Kathryn Gremley
Tom Grotta
Chris Gustin
Lauren Hartman
Matt Haughey
Adam & Paula Haybach
Bruce Heister
Scott Hodes
Holiday Inn City Centre
Holly Hotchner
J & J Exhibitor Service
Scott Jacobson
James Renwick Alliance
Mike Jentel
Nicholas Joerling
Howard Jones
John Keene
Ryan Kouris
Jane Kozlow
Corey Kuhn
Lakeshore Audio Visual
Mark Richard Leach
Edward Lebow
Matthew Lipinski
Ellie Lyman
Nate Lyman
George Mazzarri
Michael Macigewski
Jeanne Malkin
Arthur Mason

Jane Mason
David Revere McFadden
Brad Merrick
Metropolitan Pier & Exposition Authority
Dara Metz
Gretchen Meyer
Kay Mitchell
Dana Moore
Bill Murphy
Cathy Murphy
Nancy Murphy
Susan Murphy
Kathleen G. Murray
Museum of Arts & Design
Museum of Contemporary Art
Ann Nathan
National Basketry Organization
Wells Offutt
John Olson
Penland School of Crafts
Bruce Pepich
Bin Pho
Pressroom Printer & Designer
Racine Art Museum
Bruce Robbins
Pat Rodimer

Christina Root-Worthington
Al Sanchez
John Schafer
Linda Schlenger
Sheraton Chicago Hotel & Towers
Dana Singer
Ken Sitkowski
Gary Smith
Society of North American Goldsmiths
Julian Stair
Surface Design Association
Lynn Thompson
VU Case Rentals
Natalie van Straaten
Israel Vines
The W Hotel Lakeshore
WXRT
Danny Warner
Watershed Center for the Ceramic Arts
Daniel Webster
James White
Kathleen Whitney
Anne Carolyn Wollman

OFFICE OF THE MAYOR

CITY OF CHICAGO

RICHARD M. DALEY
MAYOR

November 3, 2004

Greetings

As Mayor and on behalf of the City of Chicago, it is my pleasure to welcome everyone attending the Eleventh Annual International Exposition of Sculpture Objects and Functional Art: SOFA CHICAGO 2004 at Navy Pier.

SOFA CHICAGO 2004 features a wide variety of artistic styles and media from glass, ceramics and wood to metal and fiber. This eleventh annual art exposition features the works of nearly 800 artists from 90 international galleries and dealers.

Chicago has a long and vibrant artistic tradition and we are proud to host SOFA CHICAGO. I commend the artists represented here for their talent and hard work, as well as Expressions of Culture, Inc. for bridging the worlds of contemporary decorative and fine art. May you all have an enjoyable and memorable exposition.

Sincerely,

Mayor

CHICAGO ART DEALERS ASSOCIATION

730 North Franklin
Suite 308
Chicago, Illinois
60610

Phone
31.649.0065

Fax
312.649.0255

November 3, 2004

Mark Lyman
Executive Director
Expressions of Culture, Inc.
4401 N. Ravenswood, #301
Chicago, IL 60640

Dear Mark,

Congratulations on your 11th annual SOFA CHICAGO. Your successful show has continued to bring to Navy Pier and our city the very best work bridging decorative and fine arts in an amazingly wide range of media. We are looking forward to another outstanding SOFA, including the exhibits presented by your participating galleries as well as the special exhibits and lectures you offer during the show. They always add so much to the weekend and our city.

On behalf of the members of the Chicago Art Dealers Association, we wish each of your exhibitors a successful and enjoyable visit to Chicago. The best of luck to you, your staff and everyone involved in this outstanding annual event.

Sincerely yours,

Roy Boyd, President
Chicago Art Dealers Association

Le

ectures

Lecture Series

sponsored by SOFA CHICAGO 2004

Admission to the 11th Annual SOFA CHICAGO Lecture Series is included with purchase of SOFA ticket.

Friday
November 5

9:00 – 10:00 AM, Room 305
Against the Grain:
The Wornick Distinguished
Visiting Professor in
Wood Arts at CCA
Visiting professors explore the sculptural and conceptual potential of working in wood; **Michael S. Roth**, president, California College of the Arts

9:00 – 10:30 AM, Room 301
American Fiber Stars
Shine at the "International
Triennial" Part I
Gyöngy Laky, Marcia Docter, Barbara Lee Smith and Joan Lintault discuss their participation in this international fiber art competition. Overview by **Camille Cook**. *Presented by Friends of Fiber Art International*

9:00 – 10:00 AM, Room 309
Taking Flight:
The Journey So Far
The narrative tableaus of metalsmith **Marilyn da Silva** combine symbolic imagery and the nontraditional use of color to tell a story; often using birds as metaphors for human conditions. *Presented by Society of North American Goldsmiths*

10:00 – 11:00 AM, Room 305
A Sense of Place
From basalt and porcelain site specific forms to monumental funerary ware, **Julian Stair** speaks about the relationship between ceramic practice and his historical research into the origins of English studio ceramics.

10:00 – 11:00 AM, Room 309
Albert Paley: Recent Studio
Involvement
Sculptor **Albert Paley** discusses recent public commissions, exhibitions and his involvement in the decorative arts.

10:30 AM – 12:00 PM, Room 301
American Fiber Stars
Shine at the "International
Triennial" Part II
Jon Eric Riis, Rebecca Medel, Emily DuBois, Candace Kling and Michael Rohde present their views of this international fiber art competition. *Presented by Friends of Fiber Art International*

11:00 AM – 12:30 PM
Room 305
Philosophical Legacies in
Contemporary American
Studio Pottery
A discussion of the philosophical, social and artistic choices made by various generations of studio potters and the ongoing impact on their art and careers; **Mark Pharis**, artist and professor, University of Minnesota; **Mark Shapiro**, studio potter; **Mary Barringer**, artist and editor of *Studio Potter Journal*; **Rebecca Sive**, collector

11:00 AM – 12:00 PM
Room 309
Whole Grain
Curators, critics and artists explore the curiosity of artists as they seek to expand the artistic potential of wood as a medium. **Robyn Horn**, artist; **Mark Richard Leach**, deputy director of The Mint Museums, Charlotte, NC; **Arthur Mason**, collector; others TBA. *Presented by Collectors of Wood Art*

12:00 – 1:00 PM, Room 301
Me, Myself, I
British glass artist **Tessa Clegg** discusses her work and influences.

12:00 – 1:00 PM, Room 309
Room of Dreams, Prospero's
Table and Other Stories
British jeweler **Wendy Ramshaw** speaks about her site specific installation and jewelry exploring the realm of the imagination. *Presented by Society of North American Goldsmiths*

1:30 – 3:00 PM, Room 301
Ed Rossbach's
Enduring Legacy
An illustrated discussion of the enduring legacy of Ed Rossbach, one of fiber arts most important figures. **Rebecca A. T. Stevens**, consulting curator of contemporary textiles at The Textile Museum in Washington, DC, **Gyöngy Laky**, professor, University of California, Davis, and former Rossbach student; **Jerry Bleem**, artist and teacher, School of the Art Institute of Chicago

1:30 – 2:30 PM, Room 309
Issues of Civility:
If I Only Had a Brain
Glass artist **William Carlson**

2:30 – 3:30 PM, Room 309
A Dialogue with Don Reitz
Don Reitz, ceramic artist and **Jody Clowes**, curator of the Reitz retrospective, Elvehjem Museum of Art, Madison, WI

3:30 – 5:00 PM, Room 301
Views from the UK:
Three British Ceramists
British ceramists **Edward Hughes**, **Walter Keeler** and **Annie Turner** present illustrated overviews of their work, influences and inspirations.

3:30 – 4:30 PM, Room 309
Views from Up, Over and
Down Under: A Quarter
Century of Glass Art and
Education in Europe,
the US and Australia
Australian glass artist **Klaus Moje** focuses on 25 years of involvement in the American glass scene.

4:30 – 5:30 PM, Room 309
The World According
to Felieke
The jewelry of Dutch artist **Felieke van der Leest** *Presented by Art Jewelry Forum*

Saturday
November 6

10:00 – 11:00 AM, Room 309
Gallery/Artist/Collector:
Perspectives on Jewelry
Collecting
Patricia and **Edward Faber**, of Aaron Faber Gallery, NYC, present informal Rules of Collecting, illustrated by historical and contemporary works; with the perspectives of studio jewelry artists **Michael Zobel**, **Bernd Munsteiner**, and collectors **Marion Fulk** and **Emily Gurtman**. Presented by SNAG

10:00 – 11:00 AM, Room 301
Time & Space:
Artists Working at Watershed
Center for the Ceramic Arts
Chris Gustin, Watershed boardmember, explains the concept behind this internationally recognized ceramics residency, and surveys its 20 year history; Executive Director **Lynn Thompson** speaks to Watershed's distinctive place among arts organizations. *Presented by Watershed Center for the Ceramic Arts*

11:00 AM – 12:00 PM
Room 309
Rupert Spira:
Cardew to Present
British studio ceramist **Rupert Spira** discusses the development of his work, beginning with his apprenticeship with renowned English potter Michael Cardew, through his current series, utilizing text on the vessel.

11:00 AM – 12:00 PM
Room 301
Surface: Looking Beyond
the Material Divide
Using fiber as a point of departure, the speaker will illustrate relationships among surfaces in a variety of works from different disciplines, with historical and/or cultural references. **Patricia Malarcher**, writer/editor, *Surface Design Magazine*. Presented by Surface Design Association

Special Exhibits

12:30 – 1:30 PM, Room 301
Breaking Out/Breaking In: from University to SOFA
Keith and Deanna Clayton look at the evolution of their work in glass, the role that SOFA played and the timeline that brought them where they are today.

12:30 – 2:00 PM, Room 309
Trees Coming/Wood Going
Artist David Nash gives an illustrated talk about the evolution of his ongoing relationship with wood. *Presented by Collectors of Wood Art*

2:00 – 3:30 PM, Room 301
Craft Education: A 75th Anniversary View from Penland School
Honored artists address the various roles of craft – within communities, in the development of intellgences, historical oral traditions, and the role of teaching in an artist's life. Artists Bill Daley, Alida Fish, James Tanner, with Nick Joerling, and Robin Dreyer, Penland. *Presented by Penland School of Crafts, Penland, NC*

3:00 – 4:00 PM, Room 309
Technocraft
Craftsmanship and technology through the ages, with a special focus on contemporary trends. David McFadden, chief curator, Museum of Arts & Design, NYC

3:30 – 4:30 PM, Room 301
The Evolution of Contemporary Baskets
An introduction to the ideas and influences that led to the contemporary basket movement in America, with emphasis on the experimental nature of the movement. Patti Lechman. *Presented by National Basketry Organization*

4:00 – 5:00 PM, Room 309
A Ceramic Legacy: the Stéphane Janssen & R. Michael Johns Collection at ASU
Arizona State University Art Museum's Ceramics Research Center was the recent recipient of a $4M ceramic collection of 686 works by prominent ceramic artists. Peter Held, curator of ceramics at ASU Art Museum, discusses the gift.

5:00 – 6:00 PM, Room 309
The Corning Museum of Glass "Hot Glass Roadshow"
Steve Gibbs, glassblower, Hot Glass Roadshow, talks about how the high-tech mobile glassblowing unit communicates the experience and excitement of hot glass working. *CMOG is the recipient of Art Alliance for Contemporary Glass' annual award to a program or institution that has significantly furthered the studio-glass movement.*

Watershed Center for the Ceramic Arts: Intuitive Balance
Selected works by artists whose experiences at Watershed bear witness to the significant impact which the gift of time can yield in an artist's professional life. *Presented by Watershed Center for the Ceramic Arts, Newcastle, ME*

Whole Grain: Sculptured Wood 2004
An exhibit of wood art featuring artists with widely varying approaches, curated by Mark Leach, deputy director, The Mint Museum, Charlotte,NC. *Presented by Collectors of Wood Art*

Israel2004, Contemporary and Conceptual Art
A curated exhibit of contemporary decorative artwork by artists currently living in Israel. *Presented by the Association of Israel's Decorative Arts in cooperation with Eretz Israel Museum*

Penland School of Crafts: Contemporary Traditions
A curated exhibit of work by artists, including current and former instructors and resident artists, and former students at Penland, in celebration of the institution's 75 years of service to the field of craft. *Presented by Penland School of Crafts, Penland, NC*

Ed Rossbach: Quiet Revolutionary
A pioneer in the fiber arts movement, Ed Rossbach was known for his curiosity about textile structures and his experiments with non-traditional materials. This exhibit of Rossbach's work was drawn from the artist's private collection and spans more than 30 years. *Co-sponsored by browngrotta arts, LongHouse Reserve and SOFA.*

SOFA 2004

Essays

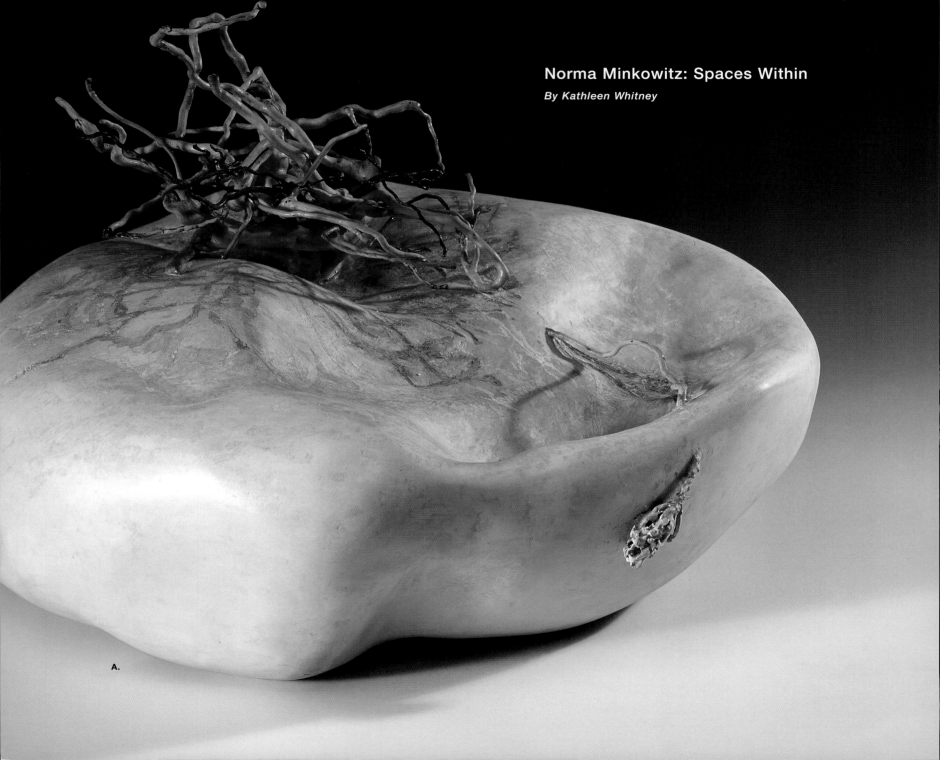

Norma Minkowitz: Spaces Within

By Kathleen Whitney

A.

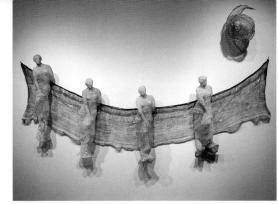

B.

For the past 30 years, Norma Minkowitz has been transforming the traditionally feminine art of crochet into a medium for sculpture. Her work embodies a quality that philosopher Gregory Bateson refers to as "the message of skill." Her skill is in the atmosphere surrounding her work; something invisible yet sensed by the viewer. Minkowitz's skill is the foundation of these objects but not their main point. Rather than make her extraordinary technique the most important issue, she makes her technique transparent, a backdrop for the beauty of her objects and depth of her ideas.

Minkowitz learned to crochet as a child. While in art school she got involved in the making of extremely detailed pen and ink drawings. Her combining the crochet technique with line drawing represents an extraordinarily imaginative cross-breeding. Crochet technique is extremely time-consuming, obsessive and repetitious. Her use of thread or light wire as three-dimensional lines both determines shape and, like handwriting, guarantees that each loop, whorl, stitch will be entirely unique.

Minkowitz begins by crocheting a circular shape and then molding it around an object such as a mannequin, the sculpted head of a child, branches, or an abstract form. In some cases she simply wraps the object in her mesh and stiffens it with shellac. It is important to stress that the pieces are less delicate than they look; the thread, wire and hog gut are stiffened and protected through the application of a variety of strengthening and damage-resistant coatings including resins, shellac and epoxy. The crochet itself is quite strong, its web-like grip controls and defines exterior space and gives shape to the inner structure. In a number of her pieces she uses twigs and roots to form a lattice-like framework for the circling web of fiber.

Not only is the use of crochet an entirely unique way of making sculpture, it also runs counter to notions which have defined sculpture. Sculpture is traditionally considered something opaque and heavy with very apparent weight and mass and little connection to techniques such as drawing. Minkowitz's work is situated between genres, as much drawing as it is sculpture. The ideas that generate her work and the way she fabricates it have strong conceptual and physical origins in the act of drawing; her sculptures can easily be seen as three-dimensional projections of line drawings. The cross-hatching, thickness and thinness, opacity and transparency are all similar to drawing techniques. The thread and light wire she uses form delicate tracings that mimic the hesitations and irregularities of drawing: changes in pressure and direction, erasures and missed areas.

A.
Remembrance, *2001*
wood, paint, pencil, plaster
13.5 x 22 x 21
photo: Joseph Kugielsky

B.
Goodbye Goddess, *2003*
fiber, wire, resin, acrylic paint
51 x 96 x 9
Wadsworth Athenaeum Collection
photo: Richard Bergen

C.
The Rebirth of Venus, *2004*
fiber, resin, paint, leather
70 x 54 x 8

D.
Dreamers Descent, *2004*
fiber, wire, paint
67 x 39 x 8.5
private collection
photo: Richard Bergen

C.

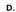

D.

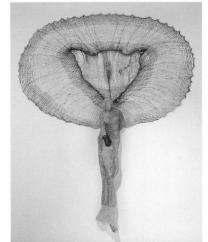

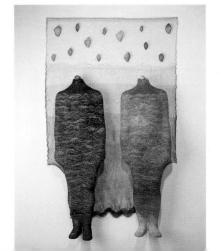

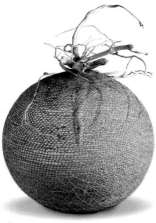

F.

The drawing concept of 'negative space' is especially noticeable in those parts of her sculptures where there is empty space. Minkowitz's use of negative space is closely related to the Zen idea that a bowl's essence is defined by the empty space within it. The shape that emerges from the juxtaposition of something with nothing is created by the contour of the physical (or positive), tangible elements. Her images constantly change areas of focus because of this play between presence and absence, and the way the surfaces shift identity between outside face or inner face of a surface.

Because of these alterations in surface, Minkowitz's sculptures are impossible to see all at once; they change depending on lighting, viewpoint, angle and the way they are displayed. Because they are concerned with skin and surface and never with mass, Minkowitz's sculptures give no sense of solidity and seem about to disappear before our eyes. The greatest contradiction in Minkowitz's work is the importance of the materials she uses juxtaposed with the way she reduces their physical presence.

Since the mid 80's Minkowitz has used both hard and soft materials in her work, many found in nature. The sculptures are powerful metaphors for containment, shelter and confinement, creating forms analogous to human beings, animals and plants. Although some of the associations her work evokes are with the body and others with landscape, the work has wider implications, seeming to refer, through titles and images, to the origins of culture itself. Although 'abstract' in appearance, Minkowitz's work is about communication in its most visual and symbolic forms – the languages of silence, expression and gesture.

In terms of its origins and identity, Minkowitz's work is neither traditional sculpture nor traditional craft, neither realistic nor abstract but a mix of all these elements. Minkowitz's work resembles that of many younger artists in the way she has taken her ideas and techniques from a profusion of cultural options, fusing the arts of Asia, Africa and certain tribal groups with a highly individual American sensibility. This cultural fusion can be seen in her constant play with the idea of 'primitive' and 'sophisticated', and her swing between the poles of totally abstract and somewhat figurative imagery. Her forms are evocative of something seen or dreamt of, but outside of the imagination, have no counterparts in reality.

Wounded is one example of her use of abstraction. It is an extremely elongated, horizontal form with an outer skin of crochet, paint and resin. It is quite dark in color with the exception of a band of ochre crochet ringing part of its thickest section. Its form is ambiguous, possibly recumbent animal or dried pod. Its interior is made from circularly spreading branches that may come from the top half of a small tree or shrub. Most of the branches are inside this nut-like form, giving the piece its roughly ovoid appearance. The piece is lashed to a length of branch as long as its crocheted body. The crochet binds and restrains the outward thrust of these branches, the strength of the engulfing net contradicting its visual delicacy.

Remembrance is unique in that few of Minkowitz's sculptures are integrated onto a pedestal. Minkowitz was attracted to this piece of root because of its beautiful linear form. She has peeled it of its rough bark covering and seated it like an offering on a white plaster base. Minkowitz has painted and penciled pale lines on its surface that are tracings of actual cast shadows. The sole piece of branch cutting through the edge of the bowl is a symbol of regeneration. This quiet and enigmatic object resembles a shrine or open reliquary; its title is meant to elicit a wide-ranging set of emotions and associations.

Root is a particularly beautiful piece – a spherical net of ochre crochet crowned by a corona of roots emerging from an interior stem. Minkowitz's typical fusions of the biological with the botanical are clearly evident here. The exterior of the shell is laced with a grid-like network of threads that are both venous and root-like in appearance. The way the light passes through the sphere, the way the interior merges with the exterior makes it seem weightless and insubstantial.

Minkowitz's 2004 piece, *Chrysalis* resembles the spun carapace concealing the lumpy mass of a soon-to-be-born winged insect. As often occurs in Minkowitz's work, the total abstraction of the object is firmly grounded in the concrete world by its title. This piece combines transparency with opacity, rendering the hidden areas all the more mysterious.

A substantial part of Minkowitz's work can be loosely described as figurative, although only in the broadest sense. This figurative work is rooted in her interest in cultural images and in the way ancient myths resurface in different form in contemporary life.

Ruskya Certza (*Russian Heart*) is a reference to the intricately embroidered, vividly colored, Russian-inspired peasant blouses her mother wore. *Ruskya Certza*, centrally dominated by an opaque heart-like shape, is anatomically complete with painted and stitched veins and aortas. The heart is nestled on and supported by a crocheted coil. It is held within an elaborately crocheted, scallop-edged net form, very delicate and refined in appearance, not unlike an old-fashioned doily.

Boy in a Tree is roughly the scale of a young boy's head and torso. Genderless, legless and armless, the body ends slightly below the buttocks. The crochet is extremely dense and bark-like, allowing only the slightest amount of light to come through. The head is comprised of plant roots formed and stiffened with paint and resins to resemble a nest or a head. Like some character in mythology, this boy seems to be in trapped in transition from human to plant.

F.
Root, *2002*
wood, fiber, paint
19 x 14 x 14
photo: Cathy Vanaria

G.
Chrysalis, *2004*
wood, fiber, resin, acrylic paint
58 x 23.5 x 10
photo: Richard Bergen

H.
Boy in a Tree, *2001*
fiber, roots, wire, paint
29 x 11 x 11.5
private collection
photo: Joseph Kugielsky

I.
Boy in a Puddle, *2002*
fiber, paint, resin
21 x 12 x 8
private collection
photo: Joseph Kugielsky

J.
Ruskya Certza, *2002*
fiber, fabric, paint, resin, wire
6.5 x 15 x 21.5
photo: Cathy Vanaria

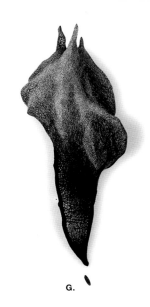

G.

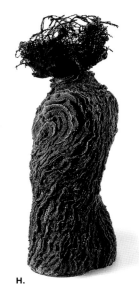

H.

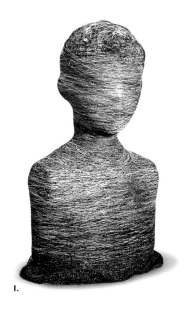

I.

Boy in a Puddle, the most disturbing of these three, is densely wrapped in fiber. A splash of red marks his heart and he is also without arms, torso and legs. His expression is fixed and unfocused, showing neither pain nor discomfort. Similar to *Boy in a Tree* in terms of his general air of inscrutability, the poses of both provide more questions than answers.

Rebirth of Venus is one of many Minkowitz sculptures inspired by classical themes. The title refers to the Venus in Botticelli's painting, *The Birth of Venus*, and Minkowitz has borrowed certain elements from it such as the flowing hair and scallop-shell. Minkowitz's Venus hangs suspended from an enormous scalloped-shaped, transparent form that billows out around her head and shoulders. Her posture is typical of Greek and Roman sculptures of women – contraposto, head slightly turned. The punch line in this pose is far from classical; her lovers may get it right between the teeth from the boxers' glove that adorns her right hand.

Minkowitz creates multi-figure sculptures that illustrate her fascination with mythology, the passage of time and other kinds of transitions. She refers to these groups of forms as 'sequential'. This method sometimes uses juxtaposed figures or brings together slightly modified but similar figures, each originating from the same template. The meaning of the piece is created from sequence and proximity. She has made many of these serial pieces, but *Goodbye Goddess* and *Dreamers Descent* typify her use of this form.

Goodbye Goddess is a series of four nearly identical, smaller than life-sized statuettes hanging off the wall over a long net. They are arranged in an arced line that leads to a fifth shape hanging above them. Their contours are blurred, their features indistinct. Each is dressed in Roman style, in a toga-like outfit that falls well over the feet. The changes in each figure represent symbols of passage. The fifth and final form bears the same impassive features as those on the figures, yet it is now disembodied like a soul departing the body.

Dreamers Descent is similarly sequential. The two wall-hung, life-sized figures hang in front of a delicate scrim of striped crochet that ranges in coloration from light at the top to dark at the bottom. These two figures are headless, arms and legs fused to their torsos. Their features are less important than the content of their dreams, symbolized by a real shell resting at the top of each neck, precisely where their heads would be. Other dreams are arranged like crocheted cartoon speech balloons on the mesh above them. Each of these beautifully transparent shell-like shapes are painted different colors – red, ochre, dark brown.

Every inch of Minkowitz's work bears the visual evidence of her hand. No two pieces are alike although they are often comprised of the same materials, employ serial imagery, and use the same techniques. This astonishing variety and individuality within her body of work is what makes it both fascinating and significant.

A unique aspect of this technique is how it emphasizes and preserves the sense of time it took to make the work. It calls attention to the repetitive nature of her touch on the surfaces and evokes a shared sense of touch with the viewer. These sculptures are among the few objects that remain in our technological culture that generously provide us with answers to the question 'where does the labor go'? The investment of time, energy and touch manifested in her work surrounds her objects like a corona. It is a rare artist who is able to control the juggling act of image, technique and reference. It is Minkowitz's skillful and seemingly effortless ability to perform this feat that makes her work so magnetic, memorable and emotionally charged.

Kathleen Whitney is a contributing editor to *Sculpture Magazine*, and author of the monograph *Norma Minkowitz, The Portfolio Collection*; Telos Art Publishing, Bristol, England.

Norma Minkowitz is represented at SOFA CHICAGO 2004 by Bellas Artes/Thea Burger. All images courtesy of Bellas Artes/Thea Burger.

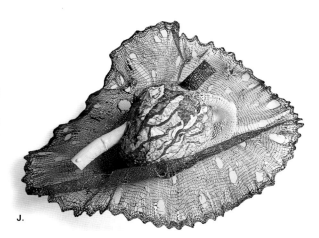

J.

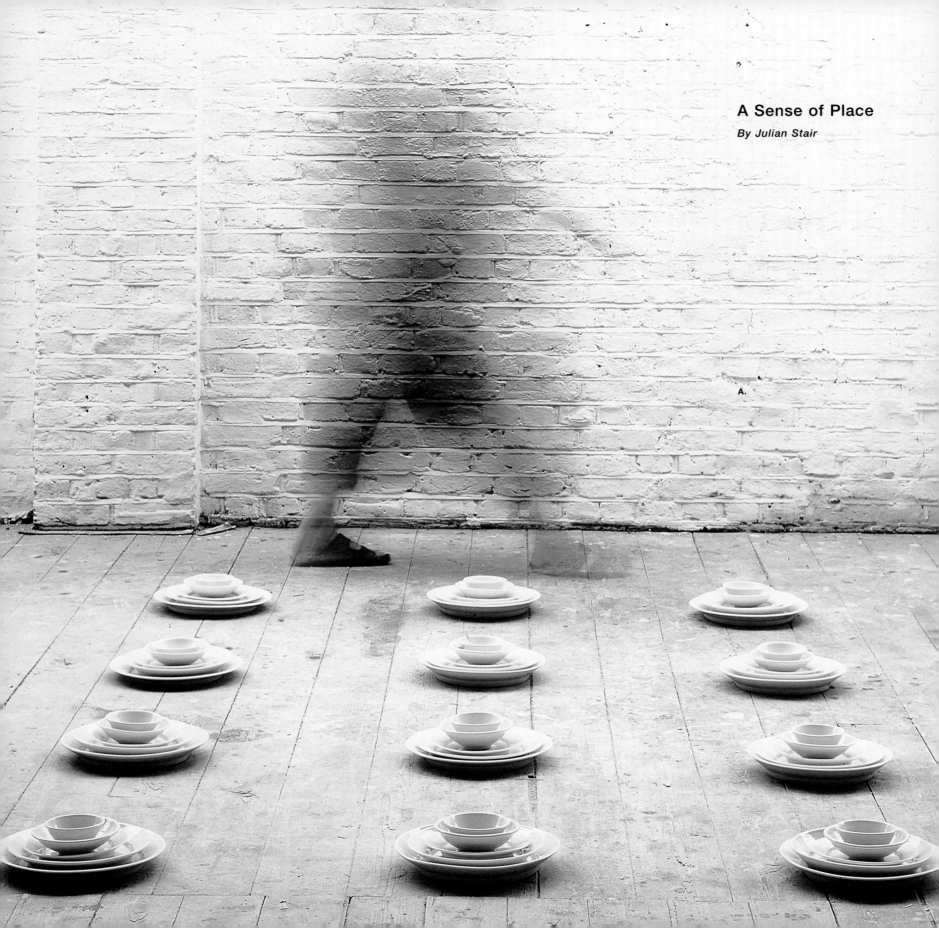

A Sense of Place

By Julian Stair

A.

B.

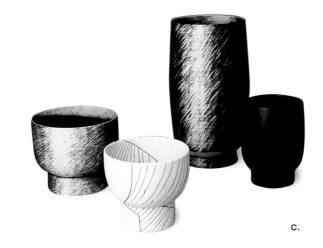

C.

The great English art critic Herbert Read wrote in 1964 that "a renewed contact with tradition may have as much revolutionary significance as any originality in style or technique."[1] Although written 40 years ago by the champion of Modernists such as Henry Moore, this remark in a philosophical essay on the social context of art still has resonance for artists today. In this article, I will attempt to discuss ideas that have shaped the development of my work over the last 30 years using Herbert Read's premise as a starting point. This will include discussion of the way that my critical writing and historical research have influenced the direction of my work, and why I think it is important for artists to directly involve themselves in the critical process, and write.

Within Britain, theoretical debates surrounding ceramics have tended to be polarized between the oppositional forces of radical versus traditional, as outlined above by Read. Thrown pottery versus hand-built pottery, function versus non-function, pot versus vessel, vessel versus sculpture, art versus craft, the list is endless. This push and pull of 'does it pour?' or 'does it belong in the collector's cabinet?' has been a defining feature of English studio ceramics since Bernard Leach published his passionate essay, *A Potter's Outlook*[2] in 1928, attacking the work of William Staite Murray, for his "art" pots.

Half a century later, the critic Ian Bennett compared Ray Finch's pottery and Elizabeth Fritsch's vessels, likening them to the difference between kitchen equipment and art. But criticism flows both ways, even in America. Rose Slivka's 1961 essay on avant-garde ceramics in *Craft Horizons*[3] provoked potter Marguerite Wildenhain to appeal to the magazine to "quit corrupting the young,"[4] while Warren McKenzie equated Harold Myers' sculpture *Big Pile* with cow manure "good only for enriching the fields."[5]

A.
Dinner Service IV, *2003*
thrown porcelain, clear glaze
private collection

B.
Sculptural Relief, *1977*
hand-built basalt
11w
collection of the artist

C.
Shadow Pots, *1980*
thrown porcelain with inlay and sgraffito
various sizes
collection of the artist

Unsurprisingly, for artists working in the narrow space between kitchen equipment and 'big piles,' the atmosphere is rather heated. Nevertheless, this is the place I find interesting, in preference to other areas of ceramics or disciplines in the visual arts. My position is not so much a comment on tradition but a desire to engage with ideas that emerge out of a continuum often classified as traditional. My specific interest in ceramics revolves around the idea that pottery has the ability to engage with critical ideas on a multiplicity of levels, from the visual to the tactile, and from the conceptual to the utilitarian.

Like many of my contemporaries, as a student at Camberwell College in the mid-1970s, I was searching for an identity. My early work was very much a product of the Minimalist era of Carl Andre, Sol Le Wit and Donald Judd. Although I went to art school to make pottery, by 1978 I found myself making relief and sculptural ceramics which explored ideas of illusion and perception. Although intellectually engaging, I had growing doubts about the direction my work was taking, for it was limited by an emphasis on investigating formal problems and aesthetics instead of capitalizing on the subtle energy of pottery. Although I felt little sympathy with the Anglo-Oriental school of stoneware pottery, I did empathize with some of its underlying values, and a year in 1975 with the Cornish potter Scott Marshall, one of the last Leach Pottery apprentices, was a good antidote to the equally orthodox culture of art school education. I then spent a three year post-graduate MA course at the Royal College of Art making vessels. But, the more I worked and the more I thought, the more I realized the realm of ceramics that really interested me lay in the making of pots – not sculpture or even vessels – a train of thought against the tide of the majority of my contemporaries. During the mid-1980s I started making porcelain tableware, coincidentally at the same time as Joanna Constandinidis. This started the throwing revival in England when the critical status of functional pottery was at its lowest point. With thickly thrown, reductive forms and clear glazes, my work referred to the European Modernist models of Otto Lindig and the Bauhaus, continued in spirit by Lucie Rie and Hans Coper who came to Britain as émigrés during the 1930s.

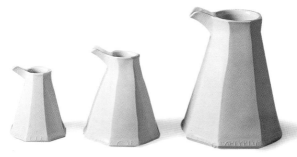

E.

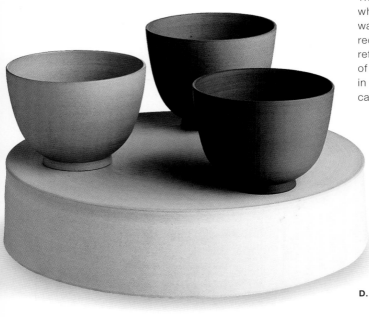

D.

D.
Three Cups, *2003*
thrown basalt and stoneware cups
on a thrown stoneware ground
4.7h
Paisley Museum

E.
Three Jugs, *1989*
thrown and faceted porcelain
various sizes
private collection

F.
Teapot and Two Cups, *2003*
thrown porcelain teapot with wisteria handle,
thrown basalt and stoneware cups on a
hand-built basalt ground
10.6 x 16
private collection

G.
Funerary Jars Installation, *2004*
thrown and constructed Etruria marl and
porcelain funerary jars on hand-built floating
white stoneware grounds
18.8 x 16.9 each
Stoke-on-Trent Museum and
private collections

H.
Sarcophagi Installation, *2004*
thrown and constructed Etruria marl
National Museum of Wales, collection of the artist
and Stoke-on-Trent Museum

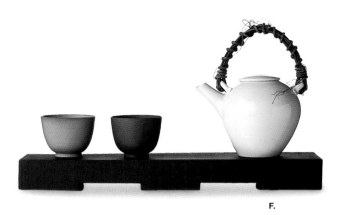

F.

Unfortunately, British ceramics in the 1970s and 80s was very polarized. Pottery was held in low critical esteem by those who saw themselves as radicals, but received unquestioning approbation from traditionalists who wanted a reassuring craft continuum. The irony was that both positions were misleading. It was not that simple. Until recently, we haven't really had a history in ceramics. Of course we had a history of sorts, but such accounts tended to be chronological, revolving around the lives of individuals or based on technical issues. This lack of a systematic investigation into the theoretical position of makers and critics suggested that potters had little of interest to say. As Oliver Watson wrote in 1990, discussion in studio pottery has tended to be "polemic rather than analytic in nature."[6] We had to wait until 1999 for the first comprehensive history of the modern crafts, Tanya Harrod's *The Crafts in Britain in the 20th Century*[7] and until last year for the first biography of Bernard Leach by Emmanuel Cooper.[8]

Only now is an equivalent history on American Craft being researched by Janet Koplos and Bruce Metcalf with a publication date of 2008. For the first time we are seeing an explosion of critical and historical research in the field that we have worked in for decades but barely known.

Indeed it was a frustration with the lack of access to the ideas that shaped studio ceramics that prompted me to start researching a PhD at the Royal College of Art in 1994. I felt the need for a balanced understanding of the critical basis that shaped modern ceramics. If I was to really explore the ideas that interested me in my own work, I needed to relate them to historical precedents. After seven years of reading virtually every magazine, newspaper, book and exhibition catalogue published on ceramics between 1900 and 1940, I realized that the origins of studio ceramics were highly complex, grounded as they were in the London art world before the First World War, and that interest in pottery as a modern art form began in the decade before Leach returned to

England from Japan. The English critics Roger Fry and Clive Bell in particular saw early Chinese pottery and vernacular English pottery as a form of primitive art, and valued it for its purity and expressiveness. Later, Herbert Read wrote eloquently about this new art form, which he saw as expressing ideas of abstraction in advance of sculpture of the same time. This crucial period was described by art historian Charles Harrison as when "the formulation in Britain of a Modernist interpretation of art"[9] took place, a movement which shaped the emergence of art in the 20th century, and which, for a time, included studio pottery in its agenda. In the 1920s Bernard Leach, Staite Murray and Reginald Wells were exhibiting in Bond Street Galleries and selling pots for extremely high prices. Potters exhibited with avant-garde artists such as Ben Nicholson and Henry Moore and were reviewed equally in the national papers and leading journals.

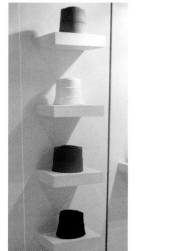

G.

H.

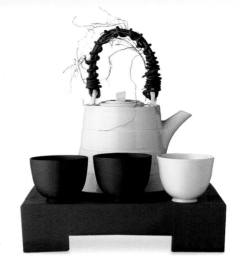

I.

What relevance does this newly discovered history have for contemporary practice? As a writer, the discovery of new material makes it possible to discuss studio ceramics in a more informed manner and contextualise it within the ebb and flow of 20th century English art. But as an artist, the consequences of this new understanding are more significant – it is a liberation. Context is everything. The lesson is that pottery, like filmmaking, sculpture, quilting, or any other discipline within the visual arts is simply a flexible idiom, subject to the critical baggage of the day.

This view of the body as a core element in the identity of ceramics continues to open new possibilities for the future, from the symbolic language of anthropomorphism to the tactile appreciation of handing through use. If one surveys current practice in contemporary art, it becomes apparent that the body is one of the central themes for artists working today. The video and performance work of Bill Viola's *The Messenger* (1996), Bruce Nauman's *All Thumbs Holding Hands* (1998), Damien Hirst's *The Physical Impossibility of Death in the Mind of Someone Living* (1991) and Marc Quinn's *Self* (1991) show the body cast in plaster, filmed, drained of blood or invited into installations as a spectator to engage with the art.

J.

The status of the crafts today is not a reflection of the work or of its ideas, but rather a reluctance to theorize and engage with concepts in an art market built upon the written word. In 1999, as Fellow in Crafts and Criticism at the University of Northumbria, I convened *The Body Politic: The Role of The Body in Contemporary Craft*, a conference which attempted to redress this imbalance. Its aim was "to explore and construct frameworks for the shaping of conceptual rationales where the body is involved in the appreciation of craft."[11] Now, in practice, I am continuing this exploration through material, utilizing familiar objects such as simple cups or more uncommon forms such as sarcophagi intended to contain the body. My interest is in re-contextualizing the role of pottery as a multi-sensory art form that engages the body, and that operates, radically, within the domestic arena.

I.
Teapot and Three Cups, *2003*
thrown and constructed porcelain teapot with
wisteria handle; thrown basalt and stoneware cups
on a hand-built red stoneware ground
13.3 x 10.6
National Museum of Wales

J.
Two Funerary Jars, *2004*
thrown and constructed porcelain funerary jars
on a hand-built floating white stoneware ground
44.4 x 405
collection of the artist

K.
Cup and Saucer, *1992*
thrown red stoneware, grey glaze
4.3h
private collection

By its nature it is neither conservative nor innovative, interesting nor dull. It is the responsibility of the artist to fashion it into something relevant. If it was possible for potters to address radical ideas 70, 80 or 90 years ago, it is possible to do so again today. We only have to re-evaluate what we already do. While at the Royal College of Art, the artist and scholar Philip Rawson helped me to establish ideas I am still working with 25 years later. With his measured and passionate views on the primacy of ceramics, he spoke of pots as a "primal interweaving of matter, human action, and symbol...which at the same time contains so much projected into it from man's daily life and experience at all levels that it can seem to him like a projection of his own bodily identity. It thus becomes an external testimony to his existence."[10]

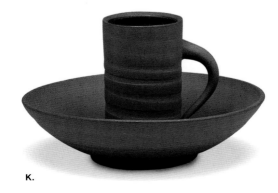

K.

An apparently simple cup and saucer, for example, involves the appraisal of two interrelated, but separate forms, of surface treatment, ergonomics, tactile characteristics, kinesthetic appreciation, architectural site specificity, relationship to other objects, issues of human scale, perceptions of heat and cold, conveyance of taste and smell and of course, aesthetic discernment. The cup and saucer is immediately seen to exist within a long continuum of historical precedents, while its actual use takes place within a world of highly complex social interactions. The cup and saucer also has to exist in a variety of modes, from being static, placed on display or stored away, to becoming animated as it describes the passage of time through ritualized use. Because of its nomadic nature, the cup and saucer is never permanently fixed. This complexity of roles raises issues concerning the process by which art is validated, and the underlying tension between the domestic arena and institutional spaces of galleries and museums.

Currently, I am attempting to balance concerns about a sense of place for pottery through making groups of work that are placed on hand-built ceramic platforms or 'grounds'. I chose the term 'ground' because it evokes the physical support of the platform while alluding to the process of building up an idea in layers; the 'ground' sits on a surface, the pots sit on the ground. The site-specific ground acts as a resting place in the itinerant life of pots, placed on a table, or floating on a wall, and the resultant effect is a change in the mode of space the work is viewed in. When discussing the effect of framing on paintings or prints, E.H. Gombrich wrote about the manner in which the frame is a "disruption of regularity", a device that interrupts real or actual space to facilitate pictorial space. My interest in the positioning of pots is also a reference to the way early English potters displayed their work in the 1920s, itself an emulation of the Oriental practice of placing pots on stands. Reginald Wells, one of the first great studio potters, trailed in the wake of his Sung predecessors, I am trailing in the wake of the pioneers of studio ceramics.

My most recent work has taken some years to come to fruition, for I first thought of the idea following bereavement. Massive in scale and ambition, it could only be made in an industrial environment, and I will be eternally grateful to Baggeridge Bricks in Staffordshire who let me loose in their brick factory and allowed me to use their Etruria marl brick clay (the clay used by Josiah Wedgwood in the 18th century), and massive kilns with their Wagnerian four day long firings. The series of funerary ware that I made at the factory was recently exhibited at the new London art fair, *Collect*, and addressed the theme of containment of the body in death. Consisting of funerary jars for the cremated body, children's and full size adult sarcophagi, this work attempts to develop ideas of engagement and unite concept, material and practice in a mutually reinforcing manner. Utilizing the anthropomorphic language of pottery – foot, neck, lip, belly, etc., the funerary ware takes this symbolic language and turns it full circle through making it tangible. The making of pots which physically house the body reunites symbol and object. The funerary ware is an extension of the approach behind my more familiar work in terms of content and attempts to build on historical precedents. Both are grounded within a social context but deal with different forms of human interaction.

Discussion of death can be a troubling subject within our modern Western and predominantly secular world, but it is the natural conclusion to the cycle of life and an apposite subject for artistic interpretation. And this cycle is reflected in the ceramic process itself. The cremation of the body mirrors the transformation of the pot by fire; inert clay is taken from the ground, fashioned into a container for the body before returning to the ground. I see this work as a celebration of life and an opportunity to reshape the often inadequate rituals surrounding death. If art intends to relate to the driving issues of life, then the job of the artist is to tackle the full gambit of experience and raise questions, however difficult.

I felt a great responsibility with a commission for a funerary jar last summer as it effectively became a summary of a man. It encapsulated the ability of pottery to transcend representation or the merely conceptual, and become part of the narrative of life through a profound pragmatism. We are physical creatures operating in a material world and if art can reflect the nature of our experiential lives, it becomes "a poetry of the actual."[12]

[1] Read, H., The Philosophy of Modern Art, Faber & Faber, London, 1964, p. 20.
[2] Leach, B., 'A Potter's Outlook', New Handworkers Gallery, 1928.
[3] Slivka, R., The New Ceramic Presence, Crafts Horizons, No 4, July/Aug 1961.
[4] Wildenhain, M., letter in Craft Horizons, No 6, Nov/Dec, 1961, p. 6.
[5] McKenzie, W., letter in Craft Horizons, No 6, Nov/Dec, 1961, p. 6.
[6] Watson, O., 'British Studio Pottery : the Victoria and Albert Museum collection, Oxford, Phaidon Christie's in association with the Victoria and Albert Museum, London, 1990, note 9., p. 41.
[7] Harrod, T., The Crafts in Britain in the 20th Century, Yale University Press, 1999.
[8] Cooper, E., Bernard Leach : His Life and Work, Yale University Press, 2003.
[9] Harrison, C., English Art and Modernism 1900 - 1939, New Haven and London, Yale, revised 'ed' 1994, p. 46.
[10] Rawson, P., Ceramics, Oxford University Press, 1971, p. 6.
[11] Stair, J., ed, The Body Politic : The Role of The Body in Contemporary Craft, Crafts Council, London, 2000, p. 8.
[12] Geist, S., The Language of Sculpture, Thames & Hudson, 1974, p.141

Julian Stair is a potter and writer. He has exhibited internationally over the last 23 years and has work in 20 public collections including the Victoria & Albert Museum, British Council, American Museum of Art & Design, Hong Kong Museum of Art and the Boymans Museum, Netherlands.

Julian Stair is represented at SOFA CHICAGO 2004 by the British Crafts Council and is a speaker in this year's lecture series.

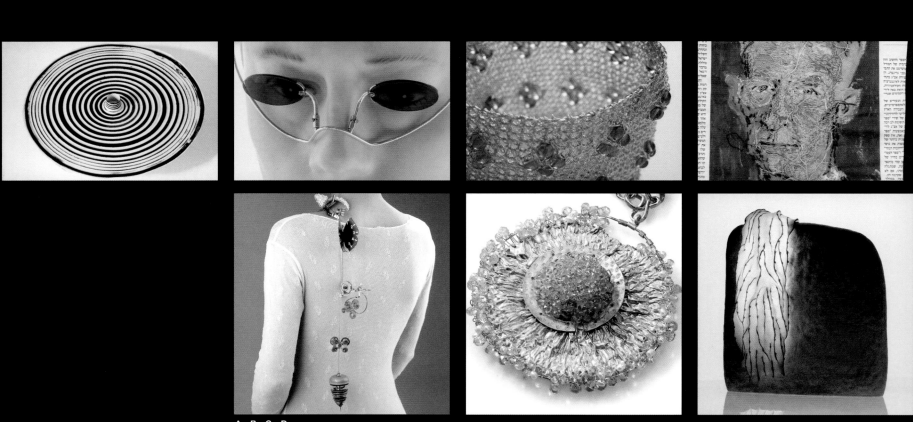

A. B. C. D.
E. F. G.

H.

Last year at SOFA CHICAGO through the wonderful cooperation of Mark Lyman and Anne Meszko, the very active sponsorship of Dale and Doug Anderson and Andrea Bronfman, the financial help of a wonderful group of patrons, and a terrific management team, the AIDA inaugural Special Exhibit at SOFA CHICAGO 2003 was "two thumbs up."

In a nutshell, here's what happened as a result of AIDA's exhibition of work by ten Israeli artists:

• Eight of the ten artists from the 2003 exhibit are currently being represented by U.S. galleries.

• AIDA's success continued at SOFA NEW YORK 2004, where Duane Reed Gallery, St. Louis, MO hit a home run with Michal Zehavi's work. So much so, that they are mounting a show of Michal and Yehudit Katz's work this October. Sienna Gallery, Lenox, MA has been selling Yael Herman and Samuel Barkai's jewelry since SOFA CHICAGO and Snyderman-Works Galleries, Philadelphia, PA have sold several of Lily Poran's shoe sculptures.

• Heller Gallery New York, NY will exhibit work by Dafna Kafferman in September 2004 and Revital Ben-Asher Peretz will be in a group show at Ferrin Gallery, Lenox, MA.

Oftentimes it is difficult for artists who live abroad to find proper facilities in which to pursue their chosen medium. Part of AIDA's goal is to help facilitate opportunities for growth to Israeli artists by providing facilities not available in that country. By creating bridges, we permit artistic expression to flourish.

We are discussing the possibility of a future fellowship program for ceramicists from Israel with The Clay Studio, Philadelphia, PA. Watershed Center for The Ceramic Arts, Newcastle, ME, will support a fellowship program for eight ceramic artists from Israel and match them with an equal number of artists from the U.S. These pilot projects will enable us to assess how Israeli artists can take advantage of existing programs in the U.S.

A very exciting joint venture has developed between the Israel Museum and the Racine Art Museum. In the summer of 2006, a jewelry exhibition (with accompanying catalogue) will explore the impact of Bauhaus jewelers who settled in Israel on contemporary jewelry. Following its stay in Israel, this exhibition will travel to the Racine Art Museum. It will then tour museums in North America and Europe.

In order to get this show up and running, Davira Taragin, Curator of Exhibitions at the Racine Art Museum, was in Israel working with Alex Ward, Curator at the Israel Museum. He, in turn, will visit the U.S. in September. Their travels have been made possible by a grant from the American International Partnerships Among Museums (IPAM). AIDA is delighted and most grateful that it has been able to be of assistance in forging the partnership between these two fine museums.

We are also in discussions with the Corning Museum of Glass, Pilchuck Glass School and Wheaton Village to develop new programs that will provide opportunities to enhance the glass department at the Bezalel Academy of Arts and Design in Jerusalem.

We are working with one of our supporters, a trustee at California College of the Arts, to strengthen their exchange program for Israeli art students.

On the European front, Marion Naggar will present AIDA at the second COLLECT show at the Victoria & Albert Museum, London, in January 2005. Marion was in Israel with Aviva Ben Sira, Rivka Saker and Andy when they visited a number of artists in their studios.

Nothing succeeds like success...
Thus AIDA will return to SOFA CHICAGO in 2004. As this is being written, another group of exciting Israeli artists working in glass, clay, fiber and jewelry is having their work assessed.

Last year we wrote, "The art of the nations from which the artists or their families stem, plus the influence of the history, ancient and modern, of the Middle East, combine to offer both a unique perspective and a new tradition of art and artifact." Such was indeed the case in 2003. We look forward to your welcoming this year's artists and considering their work. We honestly think that last year's excitement will be exceeded this year!

Charles R. Bronfman is Chairman of The Andrea and Charles Bronfman Philanthropies, a family of charitable foundations operating in Israel, the USA and Canada. A Canadian citizen, Mr. Bronfman has been awarded his country's highest civilian honors. Together with his wife, he is an avid collector of decorative arts.

Published in conjunction with the SOFA CHICAGO 2004 special exhibit *Israel2004: Contemporary and Conceptual Art*, presented by the Association of Israel's Decorative Arts in cooperation with Eretz Israel Museum.

A.
Irit Abba
Black and White, *2004*
wheel-thrown porcelain
11.5d

B.
Uri Samet
Untitled (movable lens, blue)
limited edition of 3, *2003*
designed 1996
sterling silver

C. *Sara Shahak*
Amethyst Flower, *2004*
fine silver with
amethyst beads
2.5d

D.
Lotus Peles-Chen
Theology of a Poet, *2004*
newspaper, cotton, thread
6 x 9

E.
Noa Nadir
Frrr, *2003*

F.
Shai Lohover
Aquamarine Sun, *2004*
24k gold, aquamarine
3.5d

G.
Ayala Serfaty
Table Top Piece, *2004*
calliglass, ceramic
14 x 14 x 5

H.
Shlomit Bauman
Interiors, *2004*
casting clay, transparent plastic
6 x 8 x 5

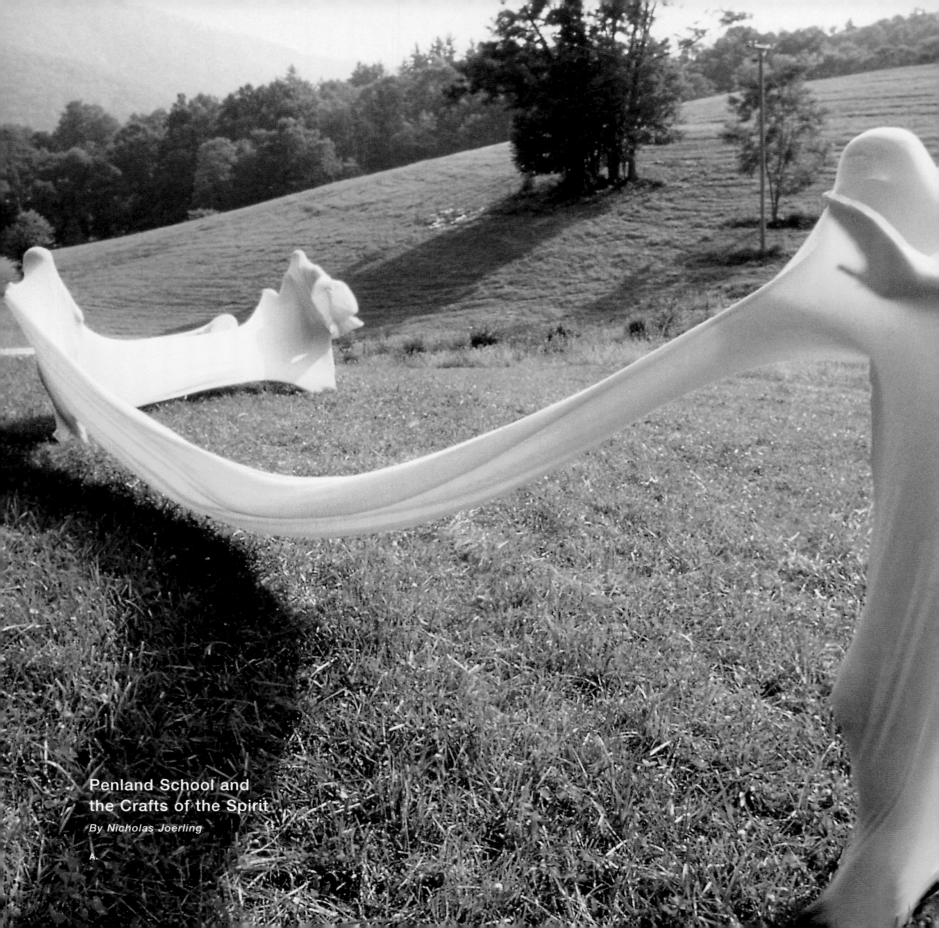

Penland School and
the Crafts of the Spirit

By Nicholas Joerling

A.

B.

C.

A.
*Artist Nick Cave leads his class
in a performance piece
photo: Dana Moore*

B.
*The Craft House at Penland,
built in 1935, is one of the largest
log structures in the southeast
photo: Robin Dreyer*

C.
*A display of student-made
dinnerware in the dining hall
photo: Robin Dreyer*

I've had the good fortune to be associated with craft schools. I've worked at Haystack Mountain School of Crafts in Maine, I live near Penland School of Crafts in North Carolina, and I've been a student and teacher at these schools and others. There are several points of view that form the educational underpinnings of these schools, such as the philosophies of John Dewey and Rudolph Steiner. But I also like this image: we'll toss some people up in the air, have them land in the same place at the same time, and see what happens. It sounds passive, in terms of philosophy, but in truth it's optimistic and trusting. It's a faith in people being and working together. Every two weeks the people make the session. Something good always happens. Oftentimes something extraordinary.

Founded in 1929, Penland School begun with the original intent to preserve tradition and teach economically useful skills. But from the inception, the vision was broader. Penland's founder, Lucy Morgan, wrote, "I am quite convinced that we cannot hold in our hands… our most beautiful and most useful Penland productions. I say these are the Penland intangibles, the wondrous handicrafts of the spirit." While the skills taught at Penland remain fundamental to its purpose, what I want to notice in this essay is the social and cultural environment, the "handicrafts of the spirit," that make craft schools so vibrant today.

Penland's summer classes are typically two weeks long, with a group of students pursuing a single subject with one instructor. Almost everyone lives on campus, eating meals at round tables in a large dining hall. There is no standing faculty; instructors and students all come to the school as guests. Every two weeks the school exhales and inhales a new population.

It's opening night of a new session, with a feeling of horses at the starting gate: a readiness, a tension, a mix of anxiety and excitement. (I once heard anxiety defined as being excited without breathing.) What everyone has in common is anticipation, but more importantly there's an openness to a new place, new people, new techniques. We think we're only directing this attitude to what happens at the session, but that open point of view can spill over into other parts of who we are. So you're likely to have people also reevaluating where they live, what they do – their lives. Couple that openness with the sense of removal that Penland provides, the fact that it's slightly difficult to get there – and spending time at Penland can give a perspective that's hard to come by in the rest of our lives.

D.

E.

F.

The time frame is long enough, all your needs are taken care of, and you can leave your daily life behind. I'm a big fan of the value of that. Daily life has a momentum, a busyness that fills it up. Step away from it, take out that crowdedness, and it's possible to have new thoughts, new perspectives. To have a block of time and be single-minded amongst like-minded people is to be in a unique environment. (We all seem to be living accelerated lives, so I like the way a friend of mine turns a familiar maxim on its head to read "Don't just do something, stand there.") It's why the two week time frame is so important: long enough to leave behind what you're used to, not so long that you fall into inattentive routines. It's the same thing that can make traveling so valuable – going off to see where you're from, looking back to see who you are. I remember some travel writing in which the author distinguished a tourist from a traveler, the former being someone uncomfortable with the unfamiliar, the latter being someone who welcomes it. We all want to monitor our dosage, that balance between security and risk, but craft schools are characterized by people showing up with their arms wide open.

I first came to the Penland area to work at the studio of friends. I knew that there was a school located here, but I didn't know what that meant – the world that it indicated. I was skeptical on hearing that it was common to mix skill levels within the same class, to have professionals seated next to beginners. I've since come to see that it's that mix that lends the particular vitality to the classes. The secret to being able to mix abilities is to provide the highest quality of instruction. What's asked of students is that, whatever their skill level, each person brings the same enthusiasm. The experienced bring commitment and knowledge, the beginners fresh eyes and a way of asking the basic questions, the most important, essential questions: Why that form? Why that material? These are the questions those working over a long period of time can forget to ask.

Another aspect of craft schools is that our categories get left behind. I've helped load cars as a two-week session was ending and only then found out what the person was going back to: a student, a minister, a lawyer. What you do elsewhere is of no consequence. Because of that lack of slotting, you get to have different conversations. And it's not only in the category of career that an equaling happens. The best sessions are the ones that have the widest age, ethnic, and racial diversity.

The absence of grading makes for an atmosphere in which taking chances is encouraged. Failure, the way we commonly think of the term, loses its pejorative connotation and becomes as valuable and instructive as success. We are more likely to find community through activities than in neighborhoods these days, and craft schools are settings where diverse people interact with one another in meaningful ways. We all gather around a material that interests us and lay out our own challenges. The playing field is level because you're not playing against anyone. There's the recognition that getting from here to there, at whatever level, is the reward. We're all in it together.

I want to finish this essay with a modest observation, an attempt to trace what's positive and valuable about crafts back to its source. If we think of the public showcase of fairs, galleries, and marketing as the ocean, then I'd like to work backwards to the river, to the stream, to the creek, and finally to the spring. At that place of origin is the thought that making something with your hands is affirming. The quiet act of starting with raw, unformed material and then transforming that substance has repercussions which can be profound. Not in an egocentric way, but as an individual participating in and influencing his environment. In the process of forming and transforming material comes this phenomenon – the person appears outside of themself. That seems like a small thing, but in a basic, underlying way the consequences in both affirmation and identity can be significant. Ronald Hoffmann in his poem *With, or Against* speaks to this when he says that transforming steel, "is built out of strict desire for the you, that is not you. You."

D.
*Woodworking student
carving a mirror frame*
photo: *Robin Dreyer*

E.
*Student working in
the iron studio*
photo: *Robin Dreyer*

F.
Jewelry student
photo: *Robin Dreyer*

G.
*Penland clay students
unloading a kiln*
photo: *Robin Dreyer*

H.
Stoking the wood kiln
photo: *Robin Dreyer*

I.
*Instructor Ah Leon and
student working on a
rectangular teapot*
photo: *Robin Dreyer*

J.
Bookbinding student
photo: *Robin Dreyer*

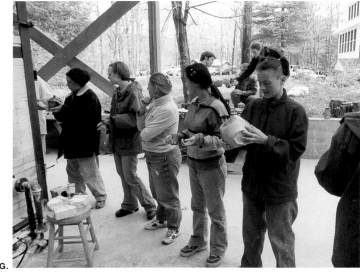

G.

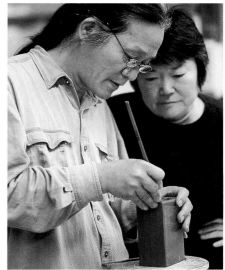

I.

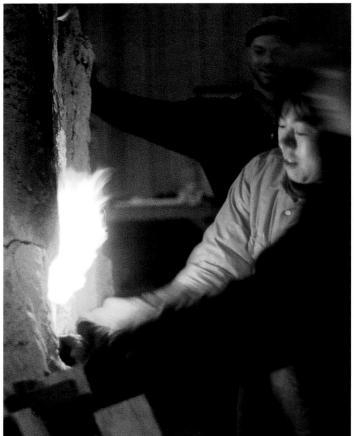

H.

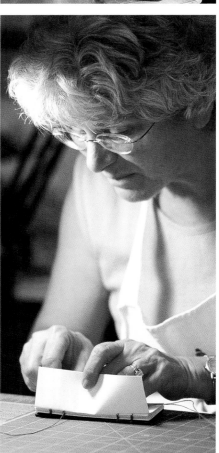

J.

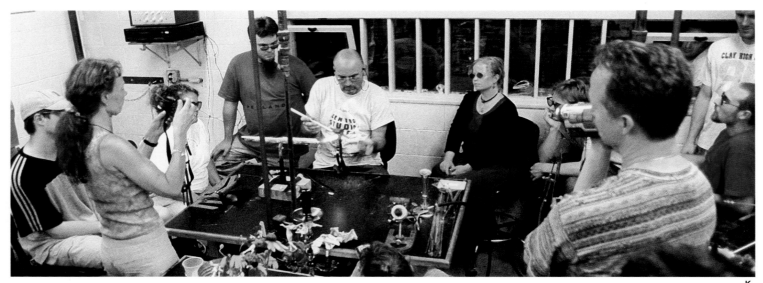

K.

Along with nonverbal communication, this is where the therapy in art therapy comes from. And it's more than a simple reflection in a mirror. It's both recognition and discovery. I see this, in myself and others, at a Penland session when we're unloading a kiln. It's impossible not to search out your own work amongst the cacophony of pots. We're like mothers at a playground, peering through all the other children for our own. It's why I like it when the clay instructor forms long lines and each pot, as it's removed from the kiln, is passed person to person to end up on a table. It slows down the frenetic "me," and places us within a group, a community, of fellow "me's."

Like today's handmade object, which is no longer necessary in a mass machine-produced world, craft schools no longer serve the strict purpose of learning a craft in order to provide an economic income. Both serve a broader and perhaps more valuable purpose. Craft schools are characterized by a generosity in which a community of lifelong friendships are formed. You leave the demands of everyday life in order to understand it, and shift to an environment that includes watching, listening, sharing. Stephen Dunn, in *How to Be Happy: Another Memo to Myself*, reminds us of the fundamental value implicit in the "craft" part of craft schools when he says,

"Beyond this, it's advisable
to have a skill. Learn how to make something;
food, a shoe box, a good day.
Remember, finally, there are few pleasures
that aren't as local as your fingertips."

L.

M.

N.

This essay refers primarily to Penland School of Crafts, however, craft workshops which are similar to Penland's in content and format are offered by a number of schools, including Anderson Ranch Arts Center, Snowmass, CO; Arrowmont School of Arts and Crafts, Gatlinburg, TN; John C. Campbell Folk School, Brasstown, NC; Peters Valley Craft Education Center, Layton, NJ; Pilchuck Glass School, Stanwood, WA; Haystack Mountain School of Crafts, Deer Isle, ME, and others.

Nicholas Joerling is a potter and teacher. He lives and works near Penland School of Crafts and serves on its Board of Trustees.

Published in conjunction with the SOFA CHICAGO 2004 special exhibit *Penland School of Crafts: Contemporary Traditions,* presented by Penland School of Crafts, Penland, NC.

K.
Flameworker Lucio Bubacco
demonstrating in the glass studio
photo: *Robin Dreyer*

L.
An installation at Penland
by artist Dan Engelke
photo: *Robin Dreyer*

M.
An iron student using a hand grinder
photo: *Robin Dreyer*

N.
Flameworker Cesare Toffolo
demonstrating in the glass studio
photo: *Robin Dreyer*

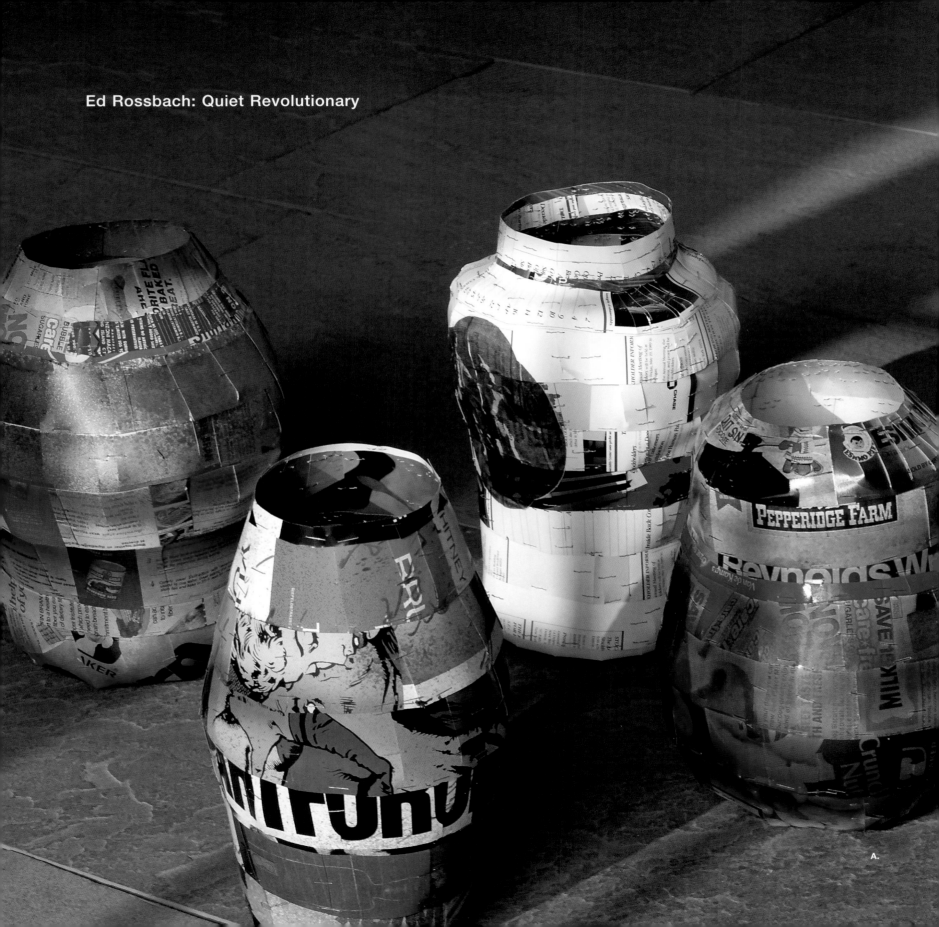

Ed Rossbach: Quiet Revolutionary

A.

B.

C.

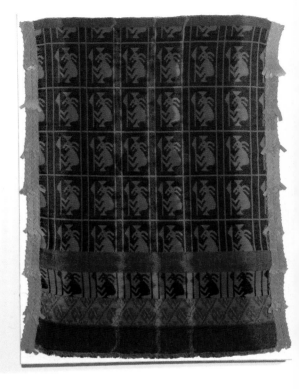

A.
More Fiber, Art Forum,
Korean Shape Staple
(Annual Report Paper),
and Puffed Wheat, 1987
mixed media
various sizes

B.
Bound Palm, 1980
palm fiber, film
30 x 5.5 x 5.5

C.
Twigs and Gut Basket, 1968
8 x 9 x 6.25

D.
Pre-Columbian #2, 1986
jaquard woven
painted tape appliqué
40 x 30

In Context
By Nancy A. Corwin and Rebecca A.T. Stevens

The world of the textile artist in 2004 is far different than it was when Ed Rossbach graduated from Cranbrook with an MFA in ceramics and weaving in 1947. At that time, the predominant aesthetic was Scandinavian Modern, textiles were for use, and most fiber artists designed for industry. Since that time textiles, as part of the post World War II crafts revival, have become an experimental, non-functional, artistic medium and Ed Rossbach is one of the key figures to have shaped these changes. His "understanding of creativity and its relationship to craft has helped bring about the merging of art and craft."[1]

Rossbach was a rebel, a quiet revolutionary with a passionate curiosity and a wonderfully wry sense of humor. The breadth of his interests was extraordinary. He was one of a small number of artists who began in the 1950s to explore fibers as raw material for self-expression. Through his teaching, his research and writing, and his art, he opened new avenues of expression and new ways of thinking that have changed forever the ways in which textiles are considered. He opened minds with his work and caused us to see textiles in a new way. Often that new way of seeing was accomplished through startling changes in scale or context, or ironic juxtapositions of materials and forms. In his use of changes in context and ironic contrast, Rossbach was the Marcel Duchamp of the textile world.

Rossbach led the way in the exploration of textile structures, new materials and imagery, basketry as an expressive art form, and, along with his wife, Katherine Westphal, photo processes in textile art. Rossbach's explorations were remarkably parallel to the free experimentation of Abstract Expressionism, the irony of Pop and Funk Art, and the cerebral qualities of abstraction, Op Art and late 60s minimalist systems art.

He took fiber off the wall and made objects before object making became a popular trend. He made "art about art" when that was a potent new form. He was interested in folk art in the early 1960s before its later popularity. In each of these explorations Rossbach was not concerned with following the latest trend in modern art. To the contrary, he was consistently on the leading edge of art in his time following his own vision.

Adapted from *Rossbach in Context*, by Nancy A. Corwin and Rebecca A.T. Stevens, in *Ed Rossbach: 40 Years of Exploration and Innovation in Fiber Art*, Edited by Ann Pollard Rowe and Rebecca A.T. Stevens (The Textile Museum, Washington, D.C. and Lark Books, Asheville, NC 1990) pp. 116-117.

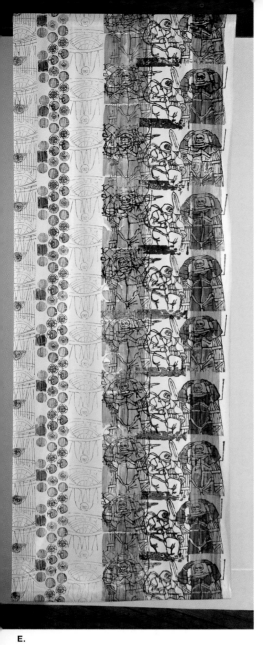

E.

G.

F.

On Baskets and Art
By Ed Rossbach

It seems to me that contemporary artists who undertake the making of baskets become involved (whether intentionally or not) in extraordinary evocations and resonances, in problems of commonness, foreignness, distance, nearness, persistence, impermanence, as well as the conventional problems of materials and construction techniques.

All the meanings and associations that have accrued to the concept "baskets" are to be acknowledged and dealt with. Throughout the basketmaking process the artists keep defining and redefining, inventing and reinventing.

In making baskets, contemporary artists relate themselves to artisans of the past and to the constructional/aesthetic problems that concerned them. Beyond that, they relate themselves to all of today's other artists— painters, sculptors, and the rest—who are reacting to the modern world and creating that world.

Dealing simultaneously with tradition and innovation, basketmakers produce works that are often paradoxical and seemingly anachronistic. Yet, I suppose, all of today's art can be so interpreted.

36

Indian Baskets

Anyone who thinks about baskets as art must sooner or later consider Native American baskets. They are ones that appear most frequently in American museums, secure in relation to other works of art, acknowledged to be the finest art expressions of entire cultures.

Without our being aware of it, Indian baskets have established standards for contemporary basketmakers. They define all baskets. Regardless of how free a person wants to be in thinking about baskets—what they are, and what they can be—the Indian baskets are somewhere in his or her mind, to be dealt with. They are irresistible antecedents of anything a maker of baskets will do. They infuse today's art baskets with a resonance, a sort of reechoing of meaning that is ancient, obscure and mysterious.

I believe that images in baskets occur out of responses to shapes and materials and construction techniques, and also out of intentions brought to the basketmaking, and out of preoccupations that might seem to have nothing to do with basketmaking. Something happens in the conjoining of images and physical matter. Baskets acquire new meanings and so do the images.

An artist using the same images over and over creates his or her own traditions. Such images function as potently on a personal level as tribal images function on a group level.

I have a couple of Indian baskets from the Puget Sound area that keep speaking to me. They're around all the time. I never get tired of them. I also have some little plaited things from Indonesia made for tourists. I never get tired of them either. All these baskets seem so remarkable. I'm amazed that everyone isn't astonished—struck dumb—by their wonder.

Baskets Without Utility

Non-utilitarian baskets are not something new. Yet, always before now they existed in conjunction with the utilitarian baskets of a culture. They were similar to the utilitarian baskets, but more refined, more highly decorated. The most skilled basketmakers were selected to make the most prestigious works. Probably a clear distinction between utilitarian and non-utilitarian was not recognized. The meaning of one was intimately related to the meaning of the other. There were the sumptuous non-utilitarian gift baskets of feathers and beads, just as there were the useful baskets with only a few feathers and a few beads. Both kinds of baskets carried spiritual meaning. There were presentation baskets impeccably worked to satisfy a society's most rigorous aesthetic demands while exhibiting features that evolve from utility. At the same time there were useful baskets of vegetal materials scarcely at all transformed by the manipulations of basketmaking.

Today's art baskets can be perceived as existing in conjunction with the constructions of cardboard and plastic that are replacing baskets. The art can be thought of as arising from baskets remembered and also from all the utilitarian packaging and crating which characterize our society. They can be seen as raising the cardboard/plastic substitutes to expressive levels, with meanings and associations growing out of contemporary life.

They can also be interpreted as essential reactions to the disappearance of baskets; as such they are expressions of deeply felt loss. They can be regarded as the products of a familiarity (for the first time in history) with all the baskets and other art objects made throughout the world and throughout time—creating new conditions in which art basketmakers work.

Baskets that are not intended to satisfy any utilitarian purposes may yet perpetuate utilitarian features. They show handles, supports, legs, closures, eccentric forms borrowed from some long-forgotten time when such features were devised for utility. These features appear in contemporary baskets—as Proust says about literary style—to strengthen "by a tradition that lies concealed behind them."[2] Such survivals, vague and uncertain as they may be, allude to vanished ways of living. They operate with peculiar, undeniable force. According to Proust such survivals evoke feelings, "pensive and secret." Such vague references to past times determine and intensify the non-utilitarian basket. This is a curious phenomenon.

E.
Untitled (Spaceman), circa 1980
stenciled, printed cotton
98 x 36.5

F.
Rabbit, *circa 1973*
mixed cotton, silk; screened
9 x 7 x 7

G.
El Salvador, *1984*
muslin, camouflage netting, sticks,
plastic tape, wire, tied, dyed,
linoleum block printed, constructed
15.5 x 15.5 x 13

Context

For the first time the world of basketry, which has been notably insular, is seen whole. Artists have before them the whole world's baskets, in museums and books. And they have access to the world's traditional materials— raffia from Madagascar, pandanus from Oceania, rattan from Southeast Asia, splints from North Carolina, as well as all the new materials that come on the market. And they have the documentation of the anthropologists, transcribing what basketmakers from other cultures have said about their baskets, their spiritual and symbolic meanings, their standards of judging quality, etc.

Artists have the option—indeed they are encouraged—to explore, discover, invent their own shapes, techniques, materials and motifs. The new awareness of all baskets, and the new options, inform contemporary baskets. If they are to be significant and meaningful, baskets must reflect today's uniqueness. They have to be different from baskets ever before. Artists are on their own, expressing themselves, but of course, they are reflecting the place and time, the circumstances in which they exist. They are challenged by the meanings of baskets— their implications, associations, connotations. As artists, these basketmakers contemplate the idea of a basket. They explore how this object which has been commonplace in lives throughout centuries, can become a vehicle for expressing not only their sense of order, structural logic, sensuous response to materials —but also their playfulness, wit, ingenuity, emotional states, anxieties, concerns.

Museum Baskets

Today the making of baskets has become a bold search for something fresh and individual, quite opposite to the endless repetition that so often occurred in the history of baskets, and opposite, too, modest modifications that were successful in societies where life patterns were relatively stable and slow to change. The new baskets arise, not from the classic conventions but from the uncertainties of a rapidly changing technological society in which the role of baskets is, to say the least, equivocal. The viewer is confronted with forms that speak of a moment, a place, an artist. The results speak of a time different from that in which the artisan knew that he or she was making a basket, and knew pretty well what it would look like without making a sketch, and what it would be used for, and how it would fit into the culture of the society. The basketmaker was not concerned with defining or redefining the basket.

H.

I.

Process

From the beginning, my baskets have had an element of play. I began to make baskets to content myself, and I have continued to do so.

To a large extent the play in my baskets is in incorporating and combining elements without previous plan. Something lying around on the table is handy. I use it. It does unpredictable things. It is a surprise. I always wonder afterwards how I happened to think of that. I don't take all the credit. I acknowledge the elements of chance and convenience.

As I grow older I like, more and more, a relative quickness of the basketmaking process. I try to have the finished basket show spontaneity and a certain speed — not slapdashness, but not the sense of an arduous, labored-over project. Many baskets that I admire, historical and contemporary, look labor intensive. That is part of their wonder. But I want my own works to look easy. It seems important to mention (though I am not sure why) that often my baskets that look most spontaneous and inconsequential have taken days to make. I get so far, and then have to put them aside. Next morning, maybe, I'll be able to go on with pleasure and assurance. Time seems a most important element, not the time at work on the basket, but time doing other things, thinking about other things, not thinking about baskets at all.

Adapted from *Some Random Thoughts About Baskets* and *Ed Rossbach*, by Ed Rossbach in *Baskets: Redefining Volume and Meaning*, (University of Hawaii Art Gallery, Honolulu, HI 1993), pp. 27-39, 68 and from other writings authored by Ed Rossbach in the 1980s.

[1] *Tradition and Change: The New American Craftsman*, Julie Hall (E.P. Dutton, New York, NY 1977), p. 98.

[2] *Remembrance of Things Past*, Marcel Proust (Random House, New York 1982), pp.666-667.

Ed Rossbach (1914-2002) received a B.A. in painting and design from the University of Washington at Seattle in 1940, an M.A. in art education from Columbia in 1941, and an MFA in ceramics and weaving from Cranbrook Academy of Art in 1947. He married artist Katherine Westphal in 1950 and joined the faculty at the University of California, Berkeley in that same year. He retired in 1979 with the rank of Professor Emeritus having included among his students accomplished artists Lia Cook and Gyöngy Laky. He wrote extensively about textiles and basketry, including *Baskets as Textile Act* (1973); *The New Basketry* (1976); and *The Art of Paisley* (1980). His artworks are found in the permanent collections of the Metropolitan Museum of Art, the Museum of Modern Art, the Art Institute of Chicago, the Stedelijk Museum and the Museum of Art and Design. He is the recipient of a Gold Medal from the American Craft Council, an honor that recognizes highest achievement in craftsmanship.

Published in conjunction with the special exhibit *Ed Rossbach - Quiet Revolutionary* presented at SOFA CHICAGO 2004 by browngrotta arts, LongHouse Reserve and SOFA.

H.
Tails Wag, *1981 and*
Dog Chivas Regal, *date unknown*
silk
6 x 10; 8 x 8

I.
After Miro, *1970*
jute, horsehair
65 x 44

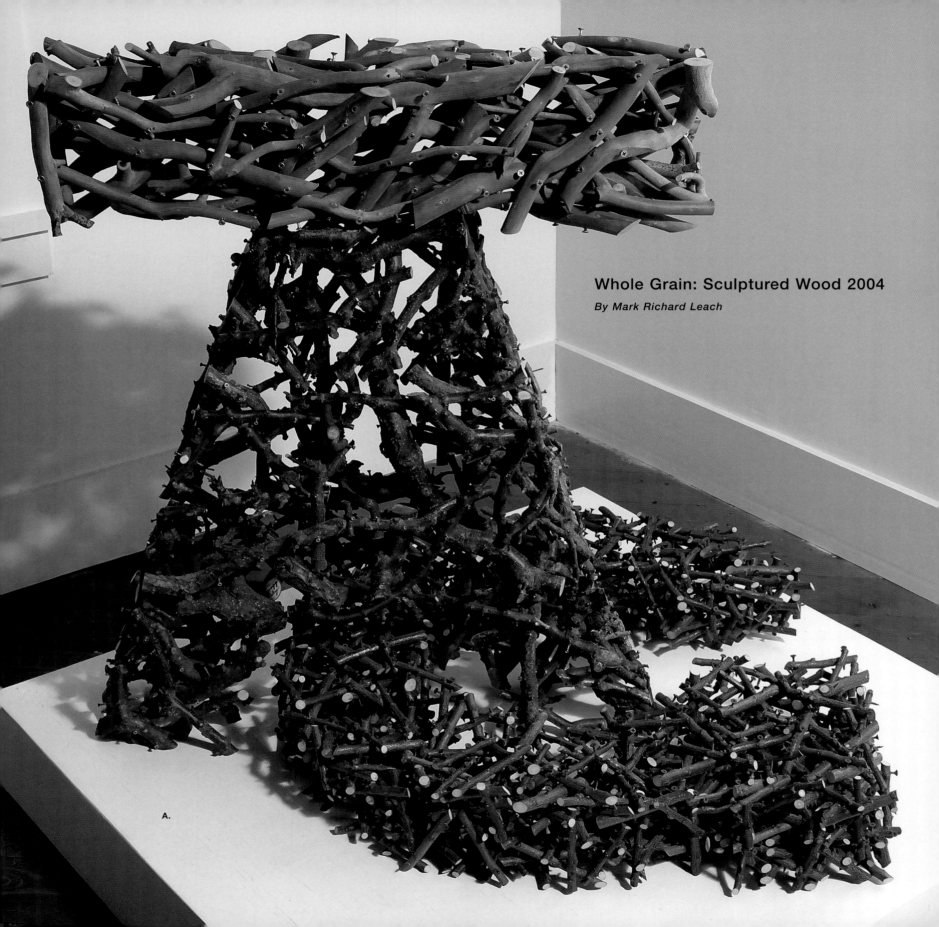

Whole Grain: Sculptured Wood 2004
By Mark Richard Leach

A.

Whole Grain, a special exhibit at SOFA CHICAGO 2004, showcases a selection of contemporary art executed in wood. The emphasis here is principally, though not exclusively, sculptural. Though not exhaustive, this presentation suggests some of the conceptual parameters and technical approaches employed by artists today.

The legacy of wood is extensive. Used throughout the ages for utilitarian purposes ranging from fuel to storage containers, from weaponry and tools to shelter, wood has proved a versatile and durable material. As the techniques to shape the material have improved, new variations have resulted. Shipbuilding, furniture and art have, at different times, become a part of the extended vocabulary that we now associate with wood.

Whole Grain seeks not only to illustrate the variety of sculptural forms being created by contemporary artists working in wood, but also to illuminate their inspired artistic expressions. Artists such as Martin Puryear, Italo Scanga, and Michael Heizer have helped to shape this ever-changing sculptural landscape. Among the areas featured in the exhibit, expressions in sculpture, jewelry and wall relief are highlighted as areas of exploration. Anatomy, architecture, decoration, illusion, nature, process, and the human senses are among the many featured themes.

From the meticulous to the obsessive, attention to detail, piecing, and repetition are processes that result in a dramatic variety of forms and subjects. For example, artists Gyöngy Laky, Christine Joy, Bud Latven, and Emily Wilson use the above techniques achieving very different sculptural results. In *Slowly*, Laky binds twigs of various diameter, length and gesture to create her dimensional forms. Using repetition, carefully pruning each twig and assembling them into desired shapes, Laky creates work that possess structural integrity. Comprising letters of the alphabet, her forms, when randomly arranged, allow the viewer to freely associate each letter and to seek meaning from the possibilities of words that can be formed. Equally compelling is Christine Joy's *Figure*, a quest to scrupulously wind, twist, tie and form her malleable willow branches into a dramatic, whirling vortex whose tightly compressed parts reward the patient, vigilant eye.

B.

C.

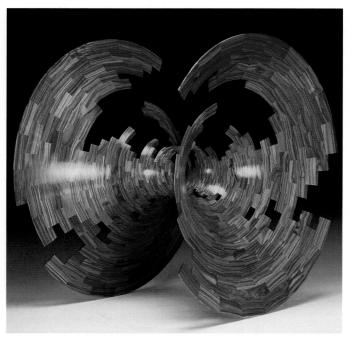

D.

E.

Emily Wilson takes a very different view of nature and landscape in *Lanterns with Spice Finch*. Sensitively carved wooden forms become delicately colored patterned leaves, blossoms and birds. She assembles these forms on a sinewy wire armature, creating an enticing visual field. Such work conjures seasonal change and the passing of time.

In *Tulipwood Torsion*, Bud Latven uses small, meticulously cut pieces of wood that are glued to one another and turned on a lathe to create an impressive, albeit discontinuous form. At a glance, Latven's piece is a simple form. The absence of a contiguous surface creates negative spaces that, together with the wood's grain and color, create a twisting or rotating optical sensation, and the suggestion of movement in an otherwise static object. The thinness of the wooden surface and the form's jagged contours invoke a sense of brittleness and disintegration.

Technical formalism and conceptual depth characterize the works of John Torreano, Liv Blåvarp, David Nash, John Howard Rose and Dorothy Gill Barnes. Works such as Torreano's *Go Grain* are provocative and riddled with irony. For example, by embedding precious pearls into a pest-ridden wooden surface, the artist achieves the exotic. Hardly the kind of mount one would choose for such precious gems, the wood's decaying surface is a stunning conceit, produced by meticulously painting layer upon layer of paint. Beauty and ugliness, seduction and repulsion, materials ostensibly precious and worthless merge into a seamless cultural commentary.

In contrast, Liv Blåvarp creates striking wearable neckpieces that are visibly sculptural in form. They simultaneously possess qualities familiar and alien, alluring and shocking. Despite their seeming awkwardness, these works have been ergonomically designed. In *Memory of Desert*, careful cutting, carving, finishing and assembly are used as a foundation for the delicate sculptural orifices that protrude from below. The inset white cabochons are reminiscent of teeth and stalactites, among other forms. Blåvarp uses double entendre to infer that the neckpiece operates as an orifice on several levels. For example, it also serves as an orifice or surround from which the wearer's neck and head emerge. The artist is conceptually playful, in that she exploits the proximity of the wearer's ears, nose and mouth – also openings – to those of the neckpiece, to create an exotic and intriguing experience between the user and those with whom the user might interact.

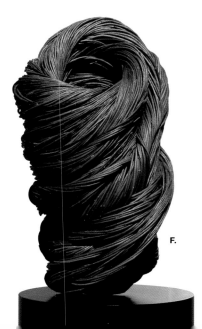

F.

Contrasting the clean vertical lines of an architectonic form with the horizontal slices that comprise the overall form, David Nash's *Crackwarp #2* possesses an inherent, if ironic, structural eloquence. Along with these linear intersections, the tension between exterior shape and interior form establishes a playful rhythm for the eye. For all of the sculpture's simplicity, the form is remarkably complex.

Yet another perspective on line and shape, appears in *Fortune*. Here, John Howard Rose bends wood into an astonishing dimensional line that has no apparent beginning or end. He exploits the viewer's understanding of the spiral and its ability to define internal and external space. The continuous undulating line pulses with energy as it playfully curves up and down, left and right, above and beneath itself in a perpetual rhythm.

In *Mulberry Vessel*, Howard Werner appears to treat pieces of a tree differently, one as a pedestal and the other as a sculpture and object of contemplation. More provocative is the question of whether or not the bark-covered section below is intended to be a display element or part of the art work. The artist's imaginative and playful approach combines visual and physical qualities that are provocative and engaging. Among them, contrasting texture and color, raw and refined, interior and exterior, smaller and larger, and top and bottom.

Dorothy Gill Barnes' *Haystack Spruce* invites us to consider, among other things, the subtlety of gesture in natural form. Cutting the tree in particular places, Barnes reveals the knotty and grainy character of its interior. Barnes has also deeply carved several sections. Her reassembled pieces emphasize volume, dramatize the shape and refer to containment. Rectangles and crescents are among the shapes she draws with her linear cuts. Ultimately, the tension between the artist-imposed straight and curved lines and those inherently organic, establish a subtle and provocative form in which color, volume, texture, light, shade, line and contour become manifest in a visually provocative form.

Still another vein of artistic exploration includes such subjects as material decay, transformation, restoration and preservation. Michael Baumeister, Robyn Horn, George Peterson, Todd Hoyer, Stephanie Janis and Michael Peterson pursue different sculptural approaches, whether additive, subtractive or a combination of the two. Michael Baumeister, for example, makes compelling use of three simple, analogous shapes in *Tripod*. His surfaces are meticulous, multifaceted, and obsessive. The honeycomb-like effect of the decorative surface patterning is enhanced further through the implementation of dark and light colors of varying intensity. The optical illusion created is one in which shapes appear to expand, contract, and come to life.

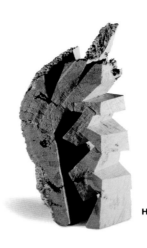

H.

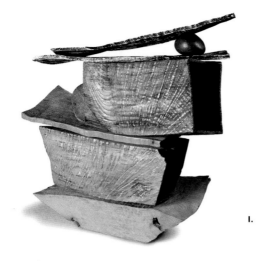

I.

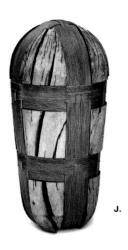

J.

In *On the Precipice*, Robyn Horn explores the compelling formal potential that a wood burl holds by slicing away segments of the original mass. The artist uses a direct, unselfconscious approach, seen foremost in her use of hard angles against the shape's inherently organic contour. She exploits the contrast to be found between the burl's attenuated texture and the adjacent rough-hewn, unfinished cut surface. She also takes advantage of the play amid positive and negative space to fashion a dramatic, edgy form.

George Peterson sees the transformative potential in a piece of wood. *Transition* is comprised of carefully sliced, subtly offset elements. The resulting textures are ripe with metaphor, suggesting a canyon wall weathered by wind and water, the wind-sculpted desert floor, even the lunar surface. Much as amber encapsulates pieces of life past, Peterson's form achieves the status of a natural relic, a fossil, a process frozen in time.

Aged timber, at least outwardly so, compressed and fastidiously wrapped tight with steel wire are dominant visual traits in Todd Hoyer's piece from the *Ringed Series*. The artist's form is curiously nondescript and yet references the vessel tradition. The piece is also reminiscent of weaponry and other industrial containers. In spite of the inwardly exerted pressure, which tightly constricts the steel armature's contents, the weathered appearance of the distressed wood is enticing. Equally rich in allegory, Hoyer's form infers dominance, emasculation, resistance, and durability among other subjects.

Christian Burchard's *Fragments #4* exploits the multiples concept with provocative results. Assembling slices of warped timber into a grid-like composition, Burchard creates works of rich variety and visual character. The language of the timber, including knots, color, grain, warped surface and contour, along with the relationship of individual pieces to each other and to the whole, offer a provocative visual experience.

Precision and all of its aesthetic manifestations is vividly present in Stoney Lamar's *Slipping off the Wire*. So too, are the uncontrolled organic qualities associated with nature. Finely fabricated steel components, including a graceful wedge-like form, are combined with richly machined wooden forms whose scored surfaces are the result of lathe-turning. Circles, both those that are machined and those that occur naturally in the contours of a tree trunk – textures applied by tools and those inherent in wood burl, wood combined with metal, with nature, and with culture, are among the formal and conceptual underpinnings that Lamar explores with dramatic efficacy.

Nature has long informed costume and jewelry design. Stephanie Jendis's *Mushroom Brooch* is a cultural parody that operates simultaneously as body adornment and social critique. The artist uses the mushroom motif, perhaps one of the homeliest of natural forms, as a departure point to reference precious jewels. Here she festoons the surface of a facsimile wooden slat crate with faceted wooden mushroom shapes. Valuable gems such as diamonds, sapphires, and rubies, sparkle when light interacts with their many surfaces. In contrast, the facets of these wooden "gems" don't spark but rather offer different shades of light and dark when illuminated by a light source. Among other things, Jendis asks us to consider the aesthetic qualities of common materials on an equal footing to their precious counterparts.

Michael Peterson carefully carves discrete wooden forms that are loosely reminiscent of weathered driftwood. In *Coastal Boat*, the artist has arranged exquisitely carved and colored wooden elements into a vertical stack that is, in appearance, tenuously balanced – the result of ocean currents, sedimentation and erosion. Peterson's poignant composition has a fossil-like quality in this regard – because environmental forces conspire over time to forge fantastical results that, in languages known to some, betray their making.

Throughout history wood has worked in service of the artistic imagination. Conceptually complex, aesthetically compelling and freighted with the meaning of contemporary society, these works demonstrate the great versatility and depth of artists working in wood. Social commentary, allegory and formalism are imaginatively realized subjects in their hands. *Whole Grain* illustrates the diversity of contemporary wood sculpture today.

Mark Richard Leach is deputy director of The Mint Museums, Charlotte, NC and curator of the special exhibit *Whole Grain: Sculptured Wood 2004*, presented at SOFA CHICAGO 2004 by the Collectors of Wood Art.

The author wishes to thank Melissa Post, Mint Museum of Craft + Design curator of craft and design for her editorial acumen. Thanks to CJ for inspiration and support, and to Anna Sims for her peerless support throughout.

K.

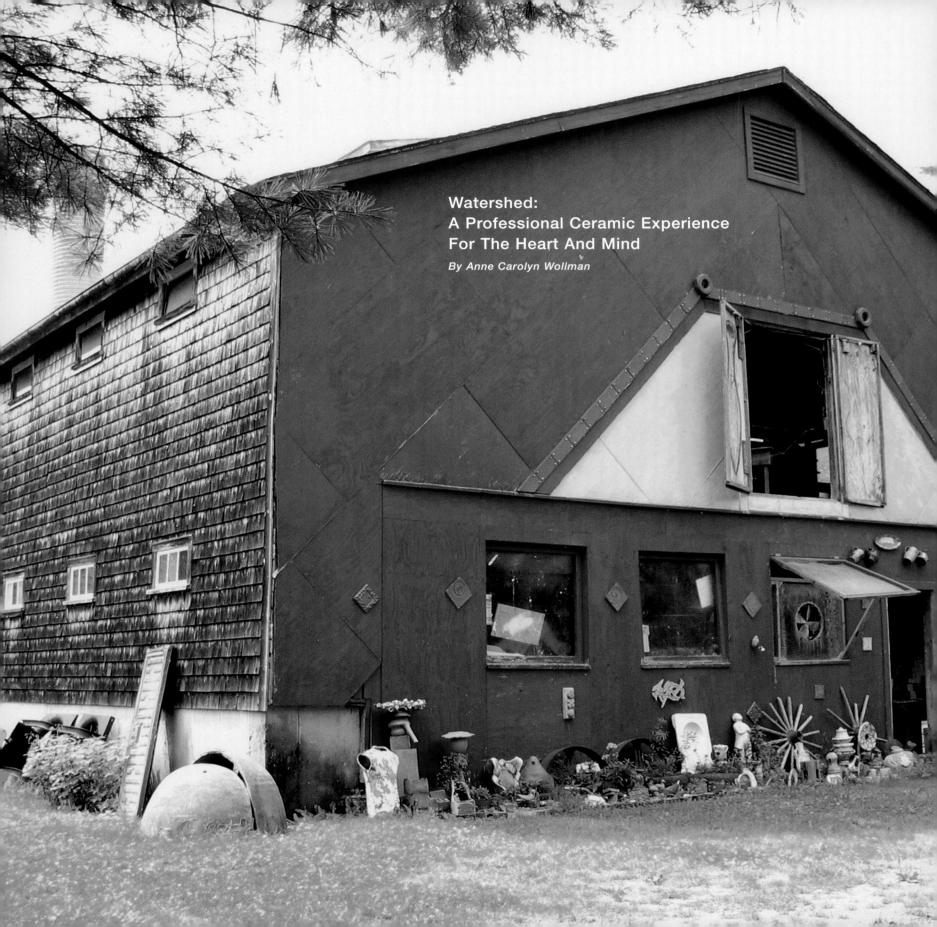

Watershed:
A Professional Ceramic Experience
For The Heart And Mind
By Anne Carolyn Wollman

B.

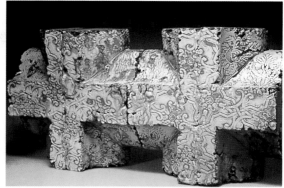

C.

D.

Less than a mile off Route 1 in Edgecomb, Maine, Brick Hill Road leads you to a 32-acre site of rustic, idyllic land. This Oz is the Watershed Center for the Ceramic Arts and the wizard here is Lynn Thompson, the executive director for the past ten years. On one side of the administration building, there is a beautiful meadow, part of a farm where sheep and cows graze; on the other, a grove of birch trees shades the new residential cabins and bathhouse. The road separating the farm from the Center winds its way to the barn-like structure called the factory, now the 16,000-square-foot studio. On the west is the Sheepscot River and Nature Conservancy. In the distant east is Boothbay Harbor, where Lynn moors the boat that will take her back to her Isle of Springs home after a lengthy work day.

During the 19th century, the banks of the rivers of mid-coast Maine yielded a low-fire red clay which was mixed with water to form bricks, known as waterstruck bricks. This clay was dug in the Newcastle/Edgecomb area for brick-making in local factories, and for almost a century was the prime source of income for surrounding communities. In the second half of the 20th century, history and nostalgia sparked a renewed interest in this occupation, and in 1974 the Watershed Brick and Clay Products Company was established, only to close a year later because of high costs.

Margaret Griggs, an artist and investor in the factory, had a dream for a studio where ceramic artists could work alone or in collaboration to make large sculptural pieces. In 1985, Mrs. Griggs asked her old friend, George Mason, a local ceramic artist with his own visionary aspirations, to make their ideas a reality. In the summer of 1986, he invited artists who in turn invited other artists from the United States and Britain to live and work at the site. Watershed clay was easily dug and was, and still is accessible and free to all. Studio artist Lynn Duryea of Portland, Maine and Chris Gustin, now professor emeritus of ceramics at University of Massachusetts, Dartmouth joined this group. Lynn described the experience as "raw and full of potential. It was exciting to be part of the beginnings."

In the fall Gustin brought students and graduate faculty from the Swain School of Design to work in the factory for ten days. Gustin says, "Watching a group of students and faculty work together in a non-academic environment convinced me that this type of studio experience was golden; that there was a need for a place where clay artists could come to do experimental work." During this time, according to George Mason, the social aspect of meals became an important feature of the Watershed experience. The liberating and interactive environment also nurtured a renewed sense of vigor and awareness, and the Watershed philosophy was born and shaped. Thus the mission became simply "to provide serious artists with time and space to create in clay."

To carry out this mission, which has broadened into an educational and developmental vision, Watershed offers a series of residencies divided into two-week summer sessions to which artists invite artists, as they did in the very first session in 1986. During the summer there are also guest artist residencies. In the winter there is a nine-month residency for four artists. All artists are free to work as they please but join in on Slide Nights and special events. Ruth Borgenicht, 2004 guest artist, expressed her thoughts on the program, "There is a dialogue, a cross-fertilization, a chance to use local clay and firing techniques that may not be otherwise accessible, without expectations and no reports." The winter residents work at leisure, but also teach community classes. Artists who attend are picked by a jury of academics, gallery owners, artists and several members of the Board's program committee. There is one standard: QUALITY PROFESSIONAL WORK.

A.
Watershed's
Summer Studio
photo: Ingrid Bathe

B.
Casual composition of bricks
for a woodfiring, 2002
photo: Britta-Lena Lasko

C.
Jason Green
Double Cross, 2001
terra cotta, slip, glaze
13.5 x 27 x 4.5

D.
Liz Quackenbush
Untitled planter built from
Watershed earthenware, 1987

E.

F.

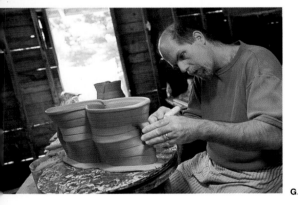

G.

There are necessary costs for housing, meals, studios, materials, clay and firings, but inherent in the Watershed mission is the goal of funding as many artists as possible. An imaginative program titled Kiln Gods was created to fulfill this need. For each contribution of $1500 from a sponsor, one artist is fully funded for one two-week session. Sponsors have the gratification of knowing that they support gifted artists whom they can visit during sessions, bond with and enjoy their progress. Guest artists are fully funded and receive all the same benefits of the Kiln Gods recipients plus a $500 honorarium. For artists for whom Kiln Gods funding is not available, there are partially-funded assistantships. Artists seeking assistantships are asked to identify their general maintenance, meal preparation and daily chore abilities – all skills necessary to keep the facilities in tip-top shape.

The facilities offered must match the skills of professional-level artists. The factory provides room for 20 artists to work, each in their own large space which is not walled off. Artists can interact easily and share thoughts, but can also remain private and reasonably secluded if they wish. A large selection of tools and equipment plus all types of firing are available as well. Former resident Jill Bell commented, "Watershed has everything a ceramicist could want and the fields, farm and woods are perfect for installations or performance pieces."

The administration building, a one-time home for the disabled, a dance hall and a chicken coop, now houses offices, the kitchen, and common dining and socializing rooms. It also serves as a studio during the winter months since the factory is not yet winterized. In addition to the hard work of the staff and winter residents who work in this building, outstanding creations are also made by the kitchen staff who are praised year after year for their superb healthy and nutritious meals, each deserving a perfect 30 from Zagat's. One resident remarked, "The kitchen contains every pot, pan and spice a cook could want to create delicious and exotic food."

Watershed has not overlooked the local community in its efforts to share its ceramic resources throughout the year. A summer feature is the Slide Nights/Open Studio series offering dinner with the artists and presentations in which residents and staff participate. The traveling Mudmobile offers clay art workshops with instruction in pottery and sculpture for all age groups. Included are discussions about the historical, geological, ecological and economic importance of clay in Maine. Professional development workshops for teachers include clay projects, teaching strategies and ceramic curriculum development.

An on-going capital campaign for $3,000,000 has raised, in its first phase, funds for six new cabins which house up to 12 individuals in the summer and six in the winter, relieving the cramped quarters in the common areas of the administration building. Monies from the first phase were also used to stabilize the foundation of the studio building, which in the next major phase will undergo winterizing and other structural repairs. Near-future projects include a kiln pad for new, more efficient gas, electric and atmospheric kilns.

To sustain Watershed's bubbling artistic activity there are four full-time staff members. The indefatigable and fully-committed executive director, Lynn Thompson, is responsible for oversight, development, grants, marketing and public relations, and partnering with other organizations and coming up with great ideas for events. She is chair of the Public Art Committee of the Maine Arts Commission, and recently-appointed advisor to the Maine International Trade Council. She is also a spokesperson for the Creative Economy Initiative to make business and government aware of the economic impact of the arts in New England. Fulltime support staff are assistant director Ingrid Bathe, program director Tyler Gulden, and facilities director Mark Urbanik. All work tirelessly as a team and respond willingly to each others needs, as well as find time to create their own ceramics.

H.

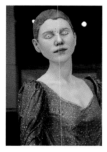

I.

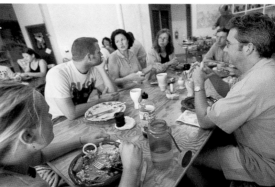

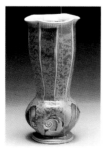

J.

K.

L.

M.

N.

O.

The Watershed Board is a very engaged and congenial group of artists, collectors, educators, curators, and gallery directors from across the country. They meet twice a year, once in July in Maine and again in January in a major city on the east or west coast. They are the backbone of the philanthropic effort behind the capital campaign's site improvement goals and the marketing and public relations effort to promote visibility. Some fascinating fundraising efforts have crystallized and grown because of the efforts of this well-informed body, with Lynn's brilliant assistance. Cooperation, brainstorming, and hard work produced Salad Days, Paper Pots, Clay Days/Glaze Nights, the Collector's Workshop, and Spring Collector Tours to the ceramic strongholds of Los Angeles, the San Francisco Bay area, and Phoenix.

Salad Days, a ten-year tradition in July, is a buffet of 50 salads, breads, drinks, and desserts served on plates selected from the 500 made by one winter resident. The credit for this event is Lynn's who, after observing Maine's pre-dilection for growing vegetables and fruits, suggested the title Salad Days, the expression used by Shakespeare's Cleopatra in referring to her "green youth." At $25 a plate, it draws a huge crowd who come not only for the ceramics and salad, but also to enjoy music, the annual pottery sale, a curated exhibit of fine functional and sculptural ceramics, and this year, the wood-fire kiln opening lottery, where lucky draws get first choice of pieces.

During Salad Days weekend, the Collector's Workshop offers an introduction to working with clay led by prominent artists, and gives visitors an opportunity to create and learn about clay, and become more knowledgeable about their collections. Ed Kerson, a 2004 participant, commented, "It is hard to imagine a better introduction to ceramic arts than the Collector's Workshop, and hard to imagine a collector whose understanding would not be improved by it."

H.
Peter Gourfain
Some Wanted Gold & Power, 1989
ceramic relief
in progress at Watershed
42.5 x 27

I.
Todd Shanafelt
Serie 9, 2001
stoneware
7 x 6 x 5

J.
Nan Smith
Visionary, detail, 1995
airbrushed glazed
earthenware, steel, wood
84 x 32 x 48

K.
Steven Roberts
Vase, 2002
porcelain
13h

L.
Phyllis Kudder-Sullivan
working in the Watershed
summer studio.

M.
The Salad Days ritual of
"selecting the plate"
photo: Britta-Lena Lasko

N.
Lunchtime
photo: Britta-Lena Lasko

O.
Gail Kendall at the kilns
during the Artists Invite
Artists Mentors Session, 2002
photo: Britta-Lena Lasko

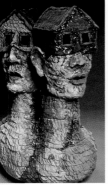
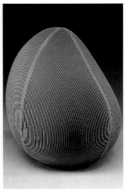

Q. R.

Another fundraising endeavor entitled Paper Pots was a sale of drawings by well-known ceramic artists, which was successful in attracting print and drawing collectors. Paper was supplied by Watershed and the drawings were raffled with the help of several generous ceramic galleries in New York City.

In 2002, the Board hatched a popular program for fundraising and cultivation entitled Clay Daze/Glaze Nights, a series of events taking place at board members' homes and studios, offering children's clay and play classes during the day; and adult gourmet dinners, talks, and ceramic entertainment focused on distinctive collections in the evening. One host offered a Show and Tell Ceramics Roadshow and encouraged participants to bring a favorite or perplexing piece to be discussed by an invited expert.

During its 18-year life, Watershed has attracted over 700 professional artists from 45 states and 18 countries. This impressive array of stars represents many of the current leaders, teachers and innovators in the field of ceramics internationally. They come to Watershed for the freedom and energy it generates. They come because it is a land of wonders, a land for all dreamers who seek an environment totally focused on the possibilities of clay without stress. As Marc Leuthold, former Watershed resident said, "No other clay organization gives this gift on this scale. For me the opportunity to work without attention to day-to-day distractions enabled me to make significant innovations in my work."

P.

The Board is invigorated and enthused by the challenging, worthwhile, and stimulating role the Watershed experience offers. One of the satisfactions of service as Nancy Selvin, 2000-2004 Board Chair, points out, "is seeing the support we have not only from clay artists, but from the national ceramic community when we take our meetings on the road."

Artists, board members, staff, and friends are always looking forward to new exhibits and projects. This year they will include a tile program to commemorate the Damariscotta River Project; an exhibit of Kiln Gods awardees at the 2004 National Council on Education for the Ceramic Arts (NCECA) in Baltimore; an invitation to a group of Israeli artists to come to Watershed; an exhibit of Watershed residents at the Port Chester Clay Art Center; and a tour of ceramic treasures in Seattle.

Endless creativity and the energy, freedom and courage to pursue it are the gifts that Watershed awards to every professional artist. In this exhilarating and serendipitous environment, all who come have a chance to experiment and seek their own contribution to the ceramic world - and the public is graciously invited to become involved.

Anne Carolyn Wollman is a Watershed Trustee, independent curator, consultant and collector.

Published in conjunction with the SOFA CHICAGO 2004 special exhibit Watershed Center for the Ceramic Arts: Intuitive Balance, presented by Watershed Center for the Ceramic Arts, Newcastle, ME.

S.

T.

P.
Tyler Gulden
Plate, 2003
1.5 x 11

Q.
Cheryl Tall
House of Heads, 1996
28 x 20 x 13

R.
Gregory Roberts
Mango, 1998
carved honeycomb
ceramics, low fire glaze
12 x 11 x 12

S.
Nancy Selvin
Triptych, 2003
earthenware
28 x 24 x 6

T.
Susan Beiner
Hair-do Vessel, 2003
15 x 22 x 14

U.
Robert Harrison
Brickpot Arches,
constructed on site
at Watershed, 1989

U.

SOFA 2004

Ex

hibitors

Tom Munsteiner, **Pendant***, 2004*
18k gold, platinum, tourmaline 20.59 cts., spirit sun diamond 0.165 cts., 1.75 x .5
photo: Arnold Katz

Aaron Faber Gallery

Jewelry Design and Style 1904-2004

Staff: Edward Faber; Patricia Kiley Faber; Felice Salmon; Jackie Wax; Jerri Wellisch; Sabrina Danuff

666 Fifth Avenue
New York, NY 10103
voice 212.586.8411
fax 212.582.0205
info@aaronfaber.com
aaronfaber.com

Representing:
Carrie Adell
Jo Adell
Glenda Arentzen
James Barker
Margaret Barnaby
Whitney Boin
Michael Bondanza
Marco Borghesi
Wilhelm Buchert
Ute Buchert-Buge
Claude Chavent
Françoise Chavent
Namu Cho
Angela Conty
Marilyn Druin
Joseph English
Pat Flynn
Michael Good
Christine Hafermalz-
 Wheeler
Barbara Heinrich
Marianne Hunter
Janis Kerman
Richard Kimball
Bernd Munsteiner
Jutta Munsteiner
Tom Munsteiner
Earl Pardon
Tod Pardon
Larissa Podgoretz
Linda Kindler Priest
Kent Raible
Eric Russell
Gayle Saunders
Susan Kasson Sloan
Caroline Streep
Jeff Wise
Susan Wise
Michael Zobel

Michael Zobel, **Brooch**
sterling silver, 24k gold, diamonds, 2 x 2

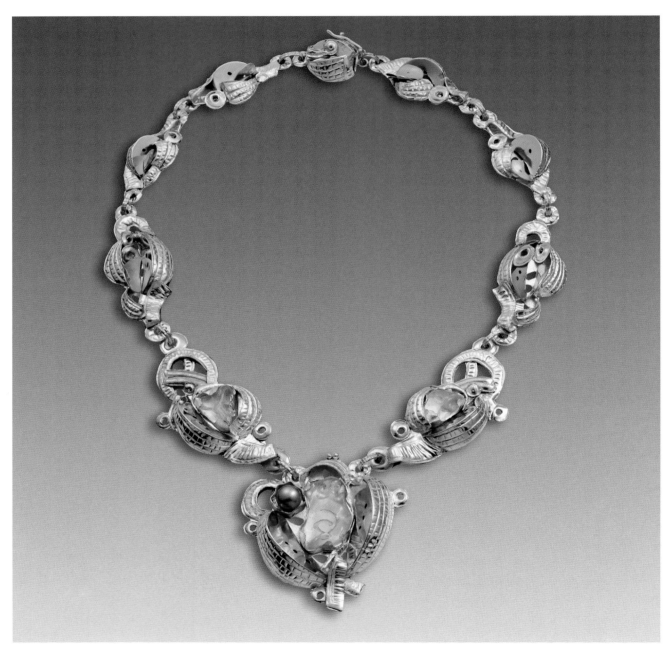

Margaret Barnaby, **Necklace**
18k gold, fire opals, pearls
photo: Arnold Katz

Special Focus: Aaron Faber Gallery celebrating 30 Years

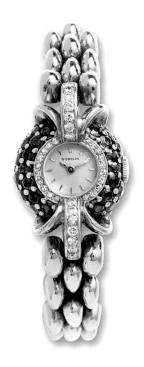

E. Gubelin, Lucerne Switzerland, **Retro-Modern Ladies Cocktail Watch**, *c. 1948*
18k rose gold, diamonds, sapphires
photo: Arnold Katz

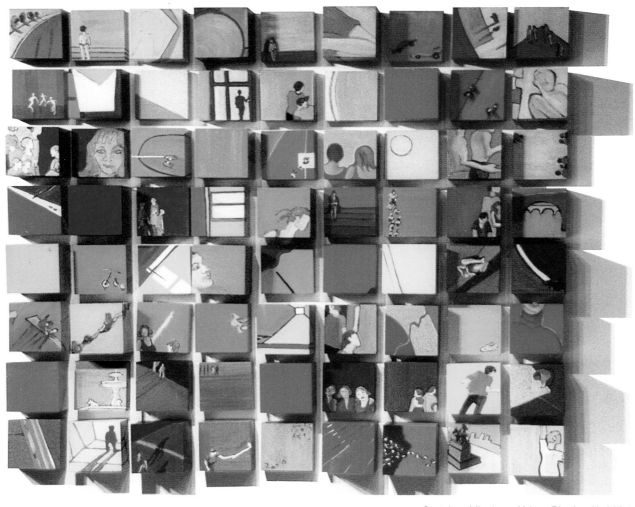

Gretchen Minnhaar, **Urban Rhythm X***, 2004*
oil on wood, 72 boxes each 7 x 7 x 7

Adamar Fine Arts

A fine art contemporary gallery representing internationally recognized American, European, and Latin American artists
Staff: Tamar Erdberg, owner/director; Adam Erdberg, owner; Carlos Garibello, gallery director

177 NE 39th Street
Miami, FL 33137
voice 305.576.1355
fax 305.576.0551
adamargal@aol.com
adamargallery.com

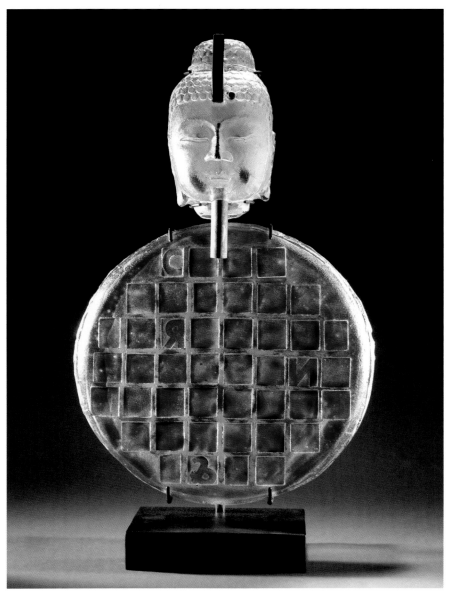

Marlene Rose, **Crowned Buddha,** *2004*
glass, copper, 37 x 21 x 8

Representing:
Brad Howe
Gretchen Minnhaar
Niso
Rene Rietmeyer
Marlene Rose
Tolla

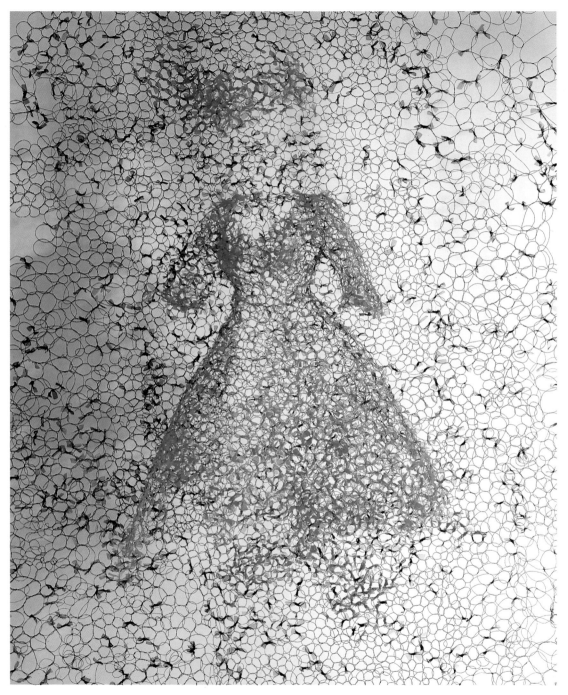

KeySook Geum, **Little Red Riding Hood in the Black Forest,** *1996*
black paper wrapped wire, colored silk ribbon, 140 x 88 x 15 variable

Andrew Bae Gallery

Contemporary Asian art with emphasis on Korean and Japanese works
Staff: Andrew Bae, owner

300 West Superior Street
Chicago, IL 60610
voice 312.335.8601
fax 312.335.8602
info@andrewbaegallery.com
andrewbaegallery.com

Representing:
KeySook Geum
Jae-Heung You

Jae-Heung You, **Report 2004-4,** *2004*
stone, 13 x 13 x 15

Gordon Chandler, **Kimonos,** *2004*
steel drums, paint, 60 x 36 x 6

Ann Nathan Gallery

Artist-made furniture, sculpture and paintings by prominent and emerging artists
Staff: Ann Nathan, director; Victor Armendariz, assistant director; Sarah Coffey, assistant

212 West Superior Street
Chicago, IL 60610
voice 312.664.6622
fax 312.664.9392
nathangall@aol.com
annnathangallery.com

Representing:
Gordon Chandler
Cristina Cordova
Gerard Ferrari
Krista Grecco
Michael Gross
Chris Hill
Jesus Curia Perez
Jim Rose
John Tuccillo
Jerilyn Virden

Jim Rose, **Sewing Desk,** *2003*
steel, natural rust patina, 42 x 34 x 26

John Tuccillo, **Peoria Foundry,** *2004*
cast resin, acrylic paint, 34 x 34 x 2

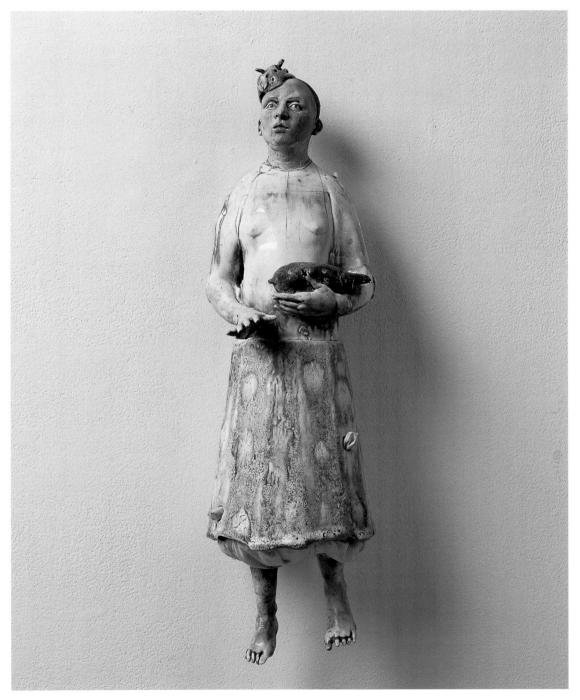

Cristina Cordova, **Figura con Cabeza de Dragon***, 2004*
earthenware, etched glaze, encaustic, silver leaf, resin, 22 x 7 x 7

Maria Alejandra Tolosa, **The Boat,** *2003*
carved wood, painting, 35 x 22 x 2

Artempresa

Latin American artistic expressions
Staff: Mariá Elena Kravetz, director; Raúl Nisman; Matías Alvarez, assistant

San Jerónimo 448
Córdoba 5000
Argentina
voice 54.351.422.1290
fax 54.351.427.1776
artempresa@arnet.com.ar

Representing:
Luis Bernardi
Leonardo Cabral
Jorge Chaij
Faba
Elizabeth Gavotti
Sol Halabi
Idith Levy
Celia Marco del Pont
Ana Mazzoni
Silvia Parmentier
Gabriela Perez Guaita
Salvador Susarte
 Molina
Maria Alejandra Tolosa

Idith Levy, **Venus I,** *2003*
metal, wood, 19.5 x 20

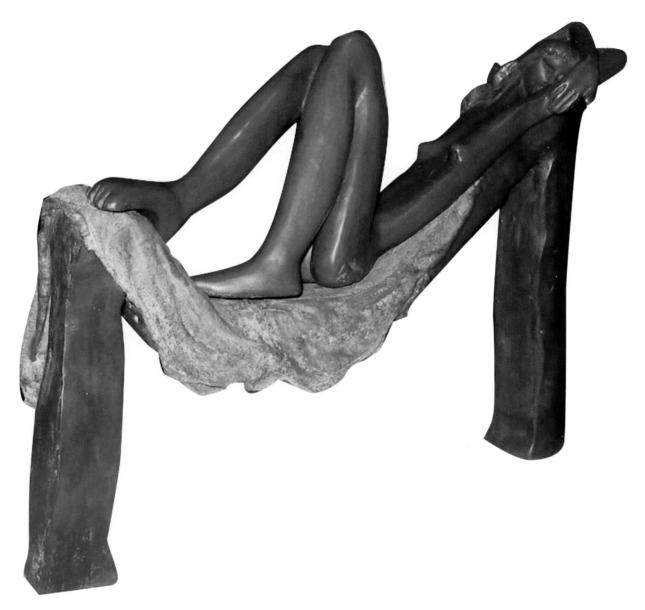

*Elizabeth Gavotti, **Eve**, 2004*
bronze, 18 x 16 x 4

Faba, **Self Portrait,** *2003*
silver, enamel, 10 x 4

Tim Edwards, **Resound #3**, *2004*
glass, 12 x 23 x 2
photo: Grant Hancock

Australian Contemporary

Australian contemporary craft and design
Staff: Stephen Bowers, managing director; Pauline Griffin, curator

19 Morphett Street
Adelaide
South Australia
voice 61.8.8410.0727
fax 61.8.8231.0434
auscontemporary@jam
factory.com.au

Representing:
Tim Edwards
Marian Hosking
Belinda Newick
Benjamin Sewell

Belinda Newick, **Nuwara Eliua - City of Light,** *2002*
jewelry, 2 x 1.75
photo: Grant Hancock

Robert Marsden, **Open to Possibility,** *2004*
patinated brass, 6.75 x 15.75 x 10
photo: Philip Sayer

Barrett Marsden Gallery

Staff: Juliana Barrett; Tatjana Marsden

17-18 Great Sutton Street
London EC1V 0DN
England
voice 44.20.7336.6396
fax 44.20.7336.6391
info@bmgallery.co.uk
bmgallery.co.uk

Representing:
Gordon Baldwin
Alison Britton
Caroline Broadhead
Tessa Clegg
Ken Eastman
Philip Eglin
Chun Liao
Robert Marsden
Steven Newell
Lawson Oyekan
Sara Radstone
Nicholas Rena
Michael Rowe
Richard Slee
Martin Smith
Maria van Kesteren
Emma Woffenden

Chun Liao, **Installation***, 2004*
clay, wooden box, 2.75 x 15 x 9
photo: Philip Sayer

Tessa Clegg, **Apsides Box with mauve insert,** *2003*
glass, 16.75 x 12.25 x 4.75
photo: Philip Sayer

Ken Eastman, **Back to the Country,** *2004*
clay, 14.5 x 19 x 17.5
photo: Philip Sayer

Erwin Eisch, **Picasso Head — Nature,** *1990*
glass; blown in a mold, manipulated while hot with enamel decoration, 17.5 x 11.5 x 15

Barry Friedman Ltd.

Contemporary decorative arts, including glass, ceramics, furniture, wood and metal
Staff: Barry Friedman; Carole Hochman; Erika Brandt

32 East 67th Street
New York, NY 10021
voice 212.794.8950
fax 212.794.8889
contact@barryfriedmanltd.com
barryfriedmanltd.com

František Vízner, **Untitled**, *2003*
cut, polished and sandblasted glass, 10.25d

Representing:
Giles Bettison
Jaroslava Brychtová
Tessa Clegg
Laura de Santillana
Ingrid Donat
Erwin Eisch
Michael Glancy
William Hunter
Stanislav Libenský
Massimo Micheluzzi
Joel Philip Myers
Yoichi Ohira
František Vízner
Toots Zynsky

Beatrice Wood, **Blue Matte Plate with Cat Decoration,** *1952*
glazed earthenware, 11.5d
photo: Tony Cunha

Beatrice Wood Studio

Ceramics and works on paper
Staff: Martin Gewirtz; Janat Dundas; Michael Castelo

Postal address:
PO Box 804
Ojai, CA 93024

8560 Ojai-Santa Paula Road
Ojai, CA 93023
voice 805.646.3381
info@beatricewood.com
beatricewood.com

Representing:
Myra Toth
Beatrice Wood

Beatrice Wood, **Moment of Truth***, c. 1973*
glazed earthenware, 15 x 6.5 x 15
photo: Tony Cunha

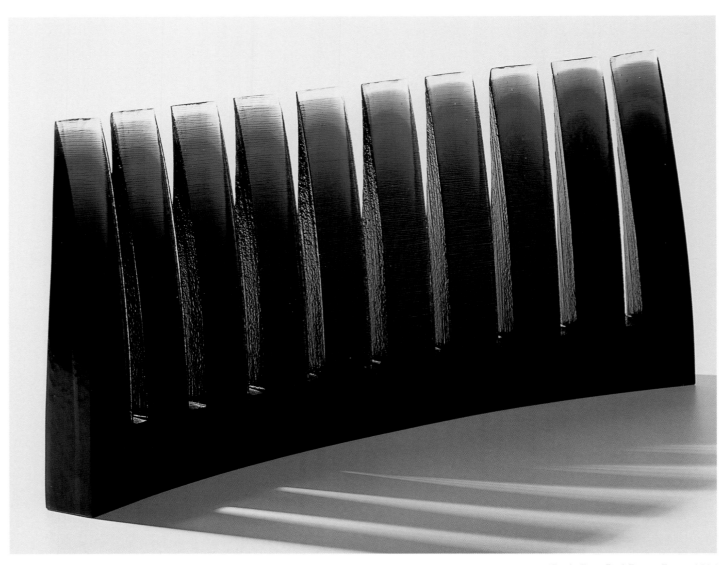

Kirstie Rea, **Red Fence Form**, *2004*
kilnformed, engraved and wheel cut glass, 9.5 x 14.25 x 1.5
photo: Rob Little

Beaver Galleries

Contemporary Australian paintings, sculpture, glass, ceramics, jewelry and wood
Staff: Martin Beaver, director

81 Denison Street, Deakin
Canberra, ACT 2600
Australia
voice 61.2.6282.5294
fax 61.2.6281.1315
mail@beavergalleries.com.au
beavergalleries.com.au

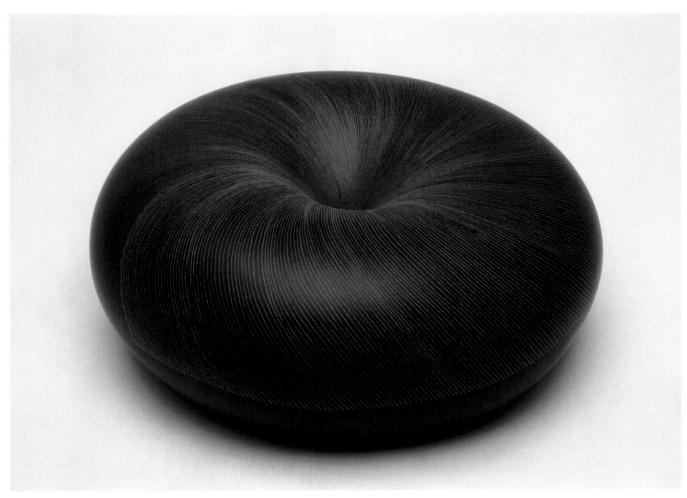

Representing:
Scott Chaseling
Mel Douglas
Kirstie Rea

Mel Douglas, **This Way,** *2004*
blown, engraved and coldworked glass, 6 x 13.75 x 13.75

Ruth Duckworth, **Untitled No. 834704,** *2004*
porcelain, 20.5 x 6.25 x 7.75
photo: Jim Prinz

Bellas Artes/Thea Burger

Staff: Thea Burger; Charlotte Kornstein

653 Canyon Road
Santa Fe, NM 87501
voice 505.983.2745
fax 505.983.1271
bc@bellasartesgallery.com
bellasartesgallery.com

39 Fifth Avenue, Suite 3B
New York, NY 10003
voice 802.234.6663
fax 802.234.6903
burgerthea@aol.com

Representing:
Olga de Amaral
Richard DeVore
Ruth Duckworth
Norma Minkowitz
Judy Pfaff

Olga de Amaral, **Umbra Oro 32,** *2003*
fiber, gold leaf, acrylic, 40 x 80

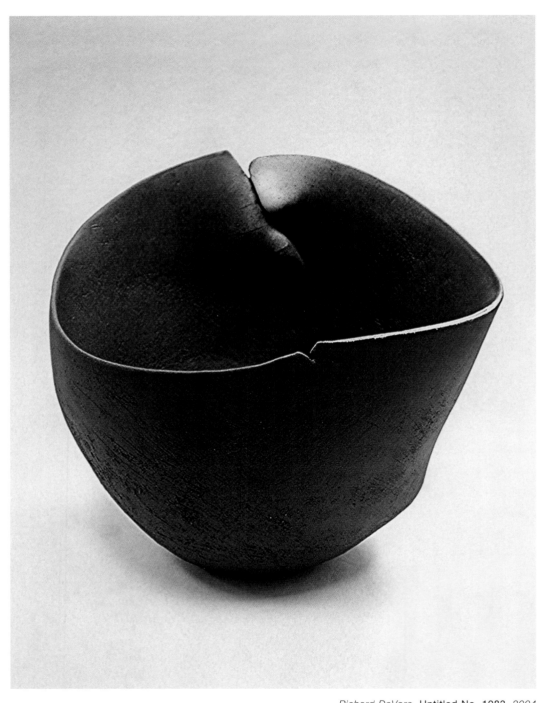

Richard DeVore, **Untitled No. 1083,** *2004*
stoneware, 12.25 x 13 x 12

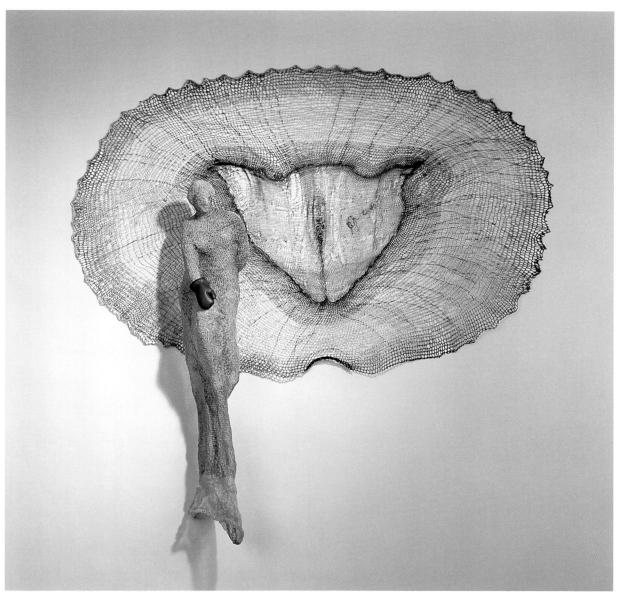

Norma Minkowitz, **The Re-Birth of Venus,** *2004*
fiber, resin, paint, leather, 58 x 54 x 8
photo: Richard Bergen

Marya Kazoun, **Torre***, 2004*
steel, glass, 82 x 19 x 19
photo: F. Ferruzzi

Berengo Fine Arts

A selection of contemporary art in glass
Staff: Adriano Berengo; Hans Van Enckevort

Fondamenta Vetrai 109/A
Murano, Venice 30141
Italy
voice 39.041.739453
fax 39.041.527.6588
adberen@berengo.com
berengo.com

Juan Ripolles, **Totem de las Palomas**
glass, metal, 104 x 29 x 17

Representing:
Luigi Benzoni
Dusciana Bravura
Pino Castagna
Marya Kazoun
Riccardo Licata
Bengt Lindström
Giulio Martini
Irene Rezzonico
Juan Ripolles
Lolita Timofeeva
Silvio Vigliaturo
Robert Zeppel-Sperl

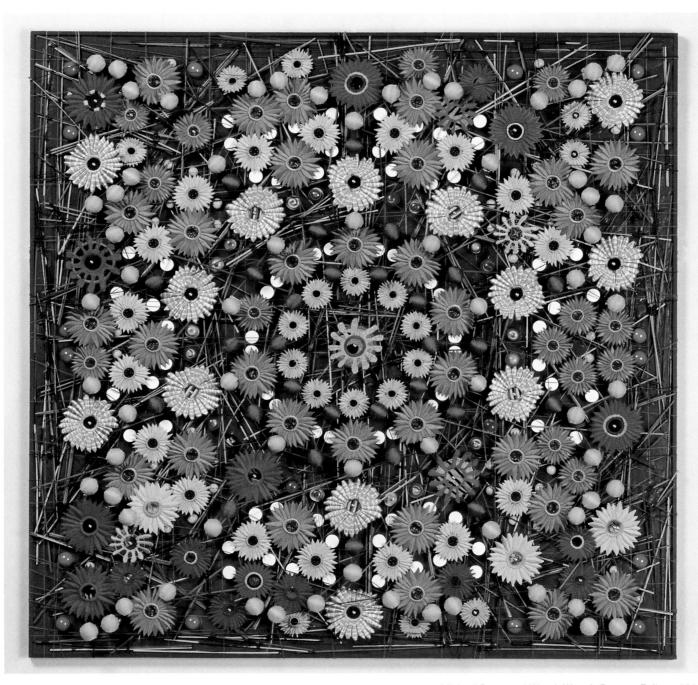

Michael Brennand-Wood, **Wasn't Born to Follow**, *2004*
mixed media, 35 x 35 x 2

Bluecoat Display Centre

Inspirational British applied art
Staff: Maureen Bampton, director; Samantha Rhodes, assistant director

Bluecoat Chambers
School Lane
Liverpool L1 3BX
England
voice 44.151.709.4014
fax 44.151.707.8106
crafts@bluecoatdisplaycentre.com
bluecoatdisplaycentre.com

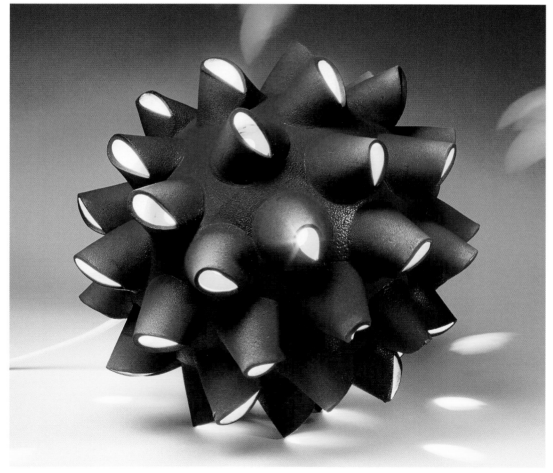

Representing:
Michael Brennand-
 Wood
Thomas Hill
Rachael Howard
Ruth Moilliet
Junko Mori
Catrin Mostyn Jones
Emma Rodgers

Catrin Mostyn Jones, **Spiky Light,** *2004*
ceramic, 11 x 11 x 11
photo: Richard Weltman

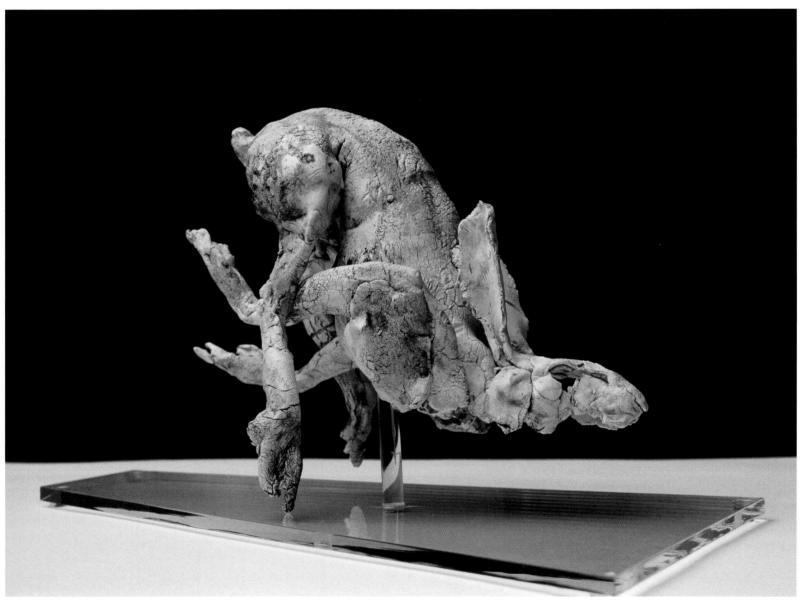

Emma Rodgers, **Running Hare,** *2004*
ceramic, 7 x 8.5 x 6
photo: Peter Raymond

Junko Mori, **#107 Organism,** *2003*
metal, 67 x 67 x 55

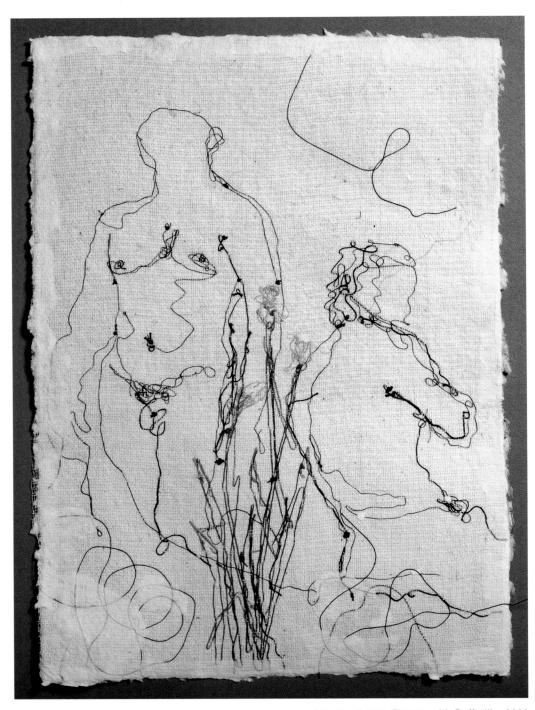

Shizuko Kimura, **Figures with Daffodils,** *2002*
wool, synthetic and cotton thread on cotton muslin
and handmade Japanese paper, 12 x 8.25
photo: Frank Thurston

British Crafts Council

Promoting excellence and innovation in craft
Staff: Abigail Branagan; Kathleen Slater

44a Pentonville Road
London N1 9BY
England
voice 44.20.7806.2557
fax 44.20.7837.6891
trading@craftscouncil.org.uk
craftscouncil.org.uk

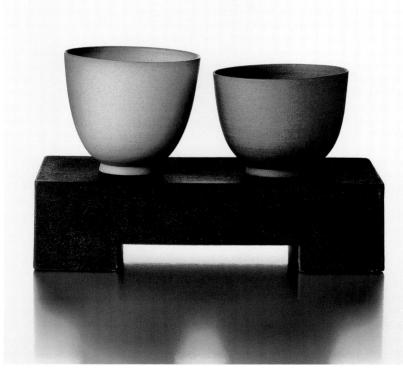

Representing:
Lin Cheung
Carina Ciscato
Ruth Dupré
Dawn Emms
Nora Fok
Shizuko Kimura
Carol McNicoll
Julian Stair
Ann Sutton

Julian Stair, **Two Cups,** *2003*
thrown ochre and grey stoneware cups on hand-built basalt ground, 4.25 x 7.5
photo: Sara Morris

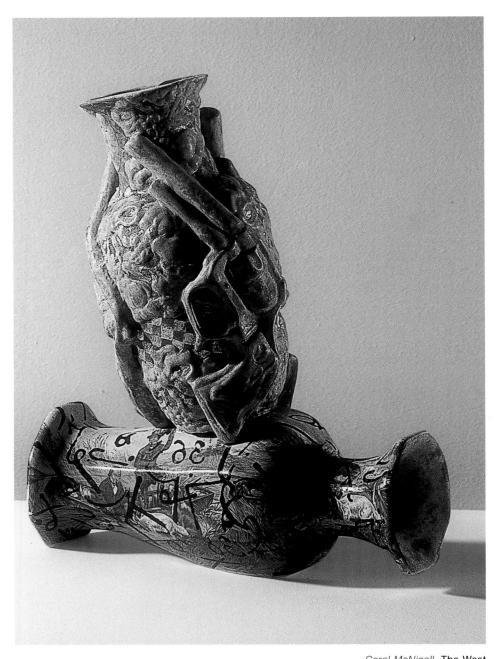

Carol McNicoll, **The West**
earthenware with stoneware glaze, hand-built from slip cast elements, decals, 10.25 x 8
photo: David Cripps

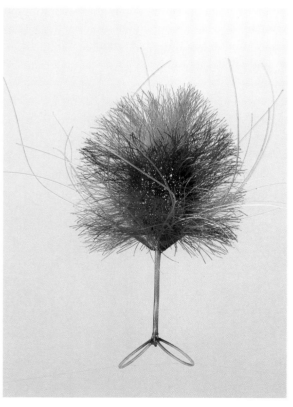

Nora Fok, **Teasel** *ring, 2002*
knitted, knotted, woven, dyed and pigmented nylon, 5.75h
photo: Stephen Brayne

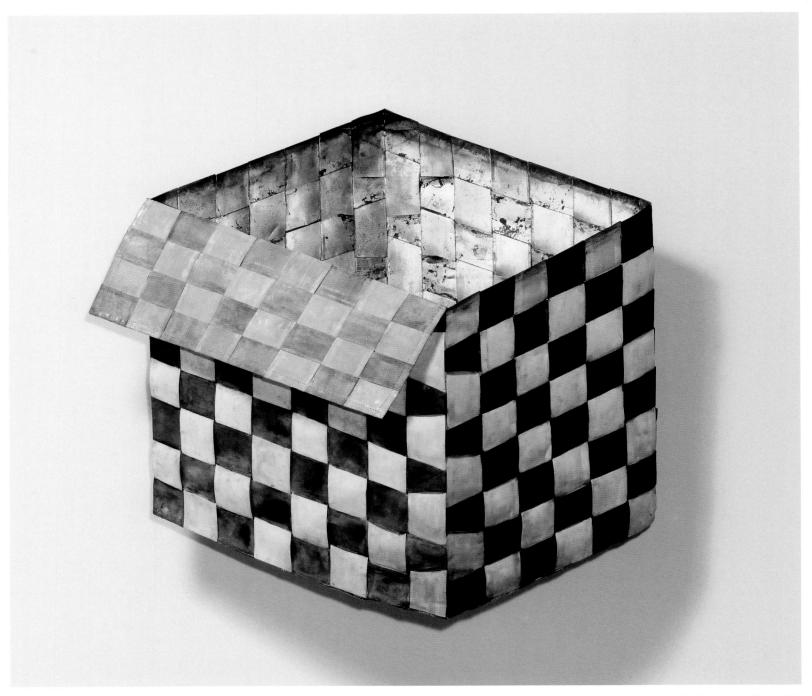

Jin-Sook So, **Big Empty Box**, *1998*
steel mesh band with electroplated silver and gold, painted, glued, handwoven, with gold leaf, 26 x 28 x 10
photo: Tom Grotta

browngrotta arts

Focusing on art textiles and fiber sculpture for 17 years

Staff: Rhonda Brown and Tom Grotta, co-curators; Roberta Condos, associate

Wilton, CT
voice 203.834.0623
fax 203.762.5981
art@browngrotta.com
browngrotta.com

Representing:

Adela Akers	Gyöngy Laky
Dona Anderson	Inge Lindqvist
Jeanine Anderson	Åse Ljones
Marijke Arp	Astrid Løvaas
Jane Balsgaard	Dawn MacNutt
Jo Barker	Ruth Malinowski
Dorothy Gill Barnes	Mary Merkel-Hess
Caroline Bartlett	Judy Mulford
Dail Behennah	Leon Niehues
Nancy Moore Bess	Keiji Nio
Birgit Birkkjaer	Simone Pheulpin
Sara Brennan	Valerie Pragnell
Jan Buckman	Ed Rossbach
Pat Campbell	Scott Rothstein
Chris Drury	Mariette Rousseau-Vermette
Lizzie Farey	
Mary Giles	Debra Sachs
Linda Green	Toshio Sekiji
Françoise Grossen	Hisako Sekijima
Norie Hatekayama	Kay Sekimachi
Ane Henricksen	Carol Shaw-Sutton
Maggie Henton	Hiroyuki Shindo
Helena Hernmarck	Karyl Sisson
Sheila Hicks	Britt Smelvær
Marion Hildebrandt	Jin-Sook So
Agneta Hobin	Grethe Sørenson
Kazue Honma	Kari Stiansen
Kate Hunt	Noriko Takamiya
Kristín Jónsdóttír	Chiyoko Tanaka
Christine Joy	Hideho Tanaka
Glen Kaufman	Tsuroko Tanikawa
Ruth Kaufmann	Blair Tate
Tamiko Kawata	Lenore Tawney
Anda Klancic	Jun Tomita
Lewis Knauss	Deborah Valoma
Mazakazu Kobayashi	Claude Vermette
Naomi Kobayashi	Ulla-Maija Vikman
Nancy Koenigsberg	Kristen Wagle
Yasuhisa Kohyama	Wendy Wahl
Irina Kolesnikova	Katherine Westphal
Markku Kosonen	Jiro Yonezawa
Kyoko Kumai	Masako Yoshida

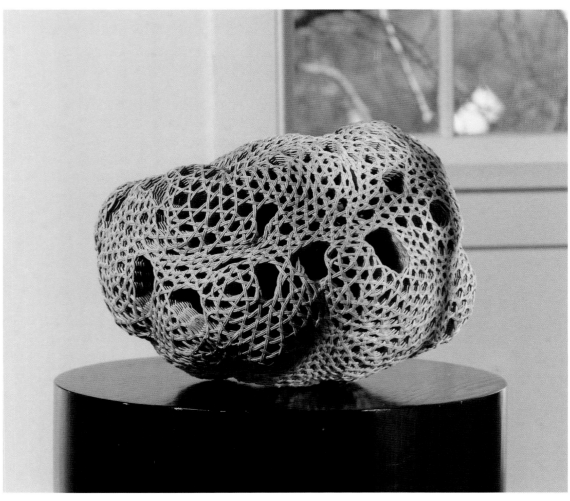

Norie Hatakeyama, **Complex Plaiting Series, Two Holes,** *2003*
paper, fiber strips; plaited, 10 x 12 x 12
photo: Tom Grotta

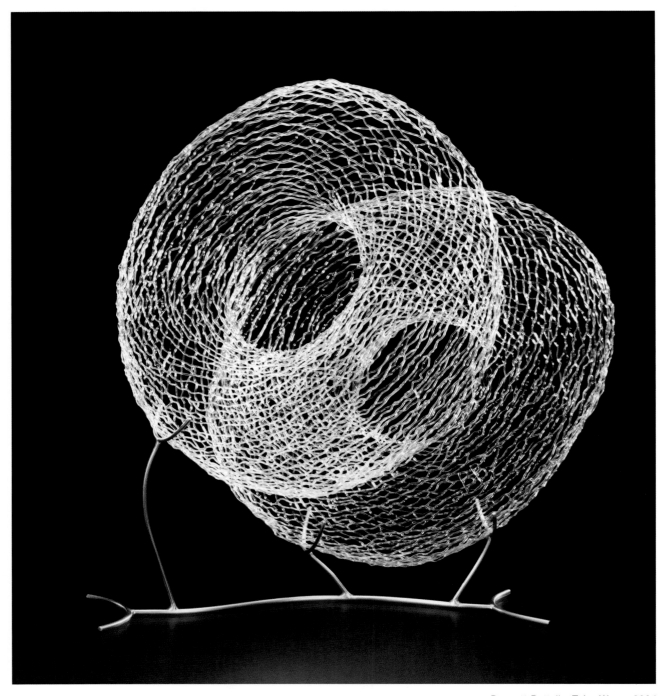

Bennett Battaile, **Tube Wave,** *2004*
flameworked glass, stainless steel, 17 x 15 x 8
photo: Bill Bachhuber

Bullseye Connection Gallery

Established and emerging masters of Bullseye glass
Staff: Lani McGregor, director; Rebecca Rockom, sales associate; Chris McNelly, office manager

300 NW Thirteenth Avenue
Portland, OR 97209
voice 503.227.0222
fax 503.227.0008
gallery@bullseyeglass.com
bullseyeconnectiongallery.com

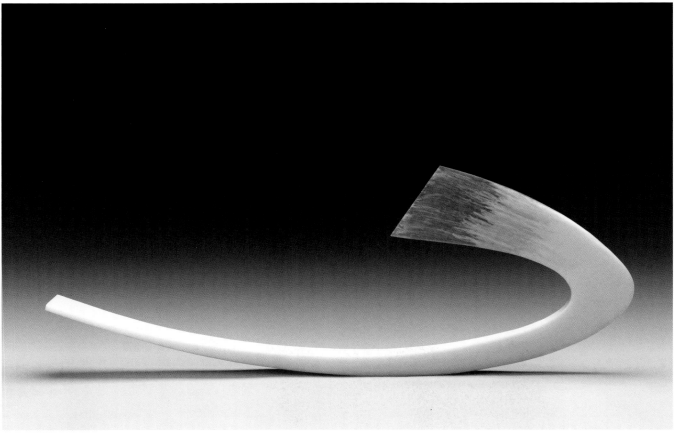

Representing:
Catherine Aldrete-
 Morris
Galia Amsel
Bennett Battaile
Giles Bettison
Nicole Chesney
Matthew Curtis
Jun Kaneko
Steve Klein
Alicia Lomné
Jessica Loughlin
Catharine Newell
Richard Whiteley

Galia Amsel, **Frost 2,** *2004*
kiln-cast glass, 11.5 x 31.25 x 3
photo: Bill Bachhuber

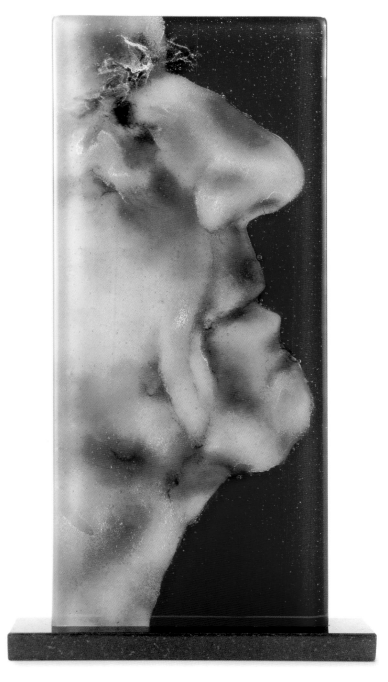

Catharine Newell, **Close Up 5,** *2004*
kilnformed glass, steel base, 18.5 x 10.25 x 4
photo: Bill Bachhuber

Jun Kaneko, **Tower/Triptych #26,** *2002*
kilnformed glass, 48 x 18 x .5 each panel
photo: Bill Bachhuber

Gisela Sabokova, **White Torso,** *2004*
cast and cut glass, 33.50 x 15.75 x 15.75
photo: Karel Bartonicek

Caterina Tognon Arte Contemporanea

Contemporary glass sculpture by European and American artists
Staff: Caterina Tognon, director

San Marco 2671
Campo San Maurizio
Venice 30124
Italy
voice 39.041.520.7859
fax 39.041.520.7859

Via San Tomaso, 72
Bergamo 24121
Italy
voice 39.035.243300
fax 39.035.243300
caterinatognon@tin.it
caterinatognon.com

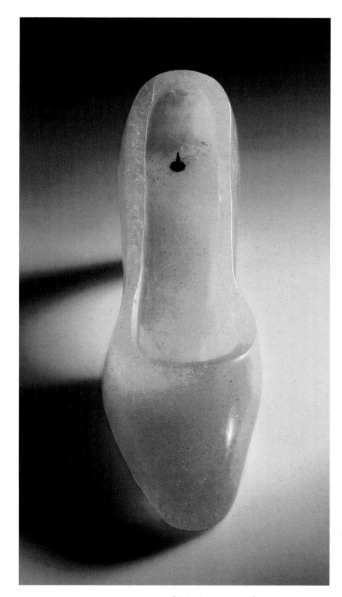

Representing:
Silvia Levenson
Richard Marquis
Gisela Sabakova

Silvia Levenson, **Cinderella,** *2000*
pâte de verre, copper nail, 4 x 3 x 8
photo: Cristiano Vassalli

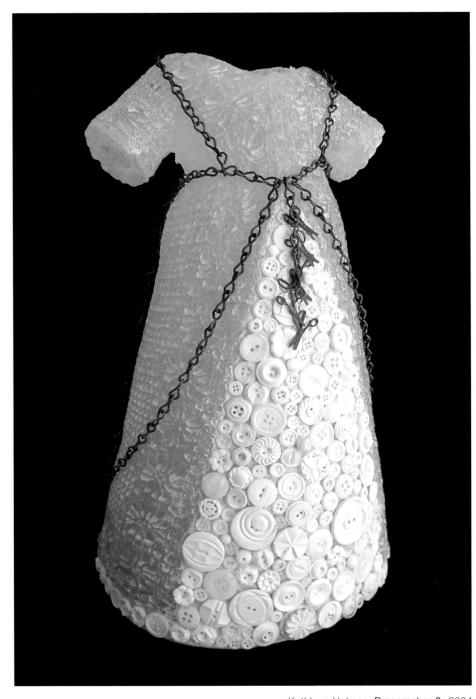

Kathleen Holmes, **Dressmaker 3**, *2004*
cast glass, mixed media, 16 x 10 x 8

Chappell Gallery

Contemporary glass sculpture
Staff: Alice M. Chappell, director; Vivienne A. Bell, gallery manager and curator, New York; Carol L Chappell, direct maketing manager

14 Newbury Street
Boston, MA 02116
voice 617.236.2255
fax 617.236.5522

526 West 26th Street, #317
New York, NY 10001
voice 212.414.2673
fax 212.414.2678
amchappell@aol.com
chappellgallery.com

Representing:
Maryann Babula
Vivienne Bell
Alex Gabriel Bernstein
Lyndsay Caleo
Stanislava Grebeníčová
Maki Hajikano
Kathleen Holmes
Toshio Iezumi
Makoto Ito
Yoko Kuramoto
Pipaluk Lake
Anna Matoušková
David Murray
Kait Rhoads
Takeshi Sano
Youko Sano
Gale Scott
Lada Semecká
Naomi Shioya
Shinji Yonehara
Sasha Zhitneva

Toshio Iezumi, **Forms,** *2004*
laminated plate glass, 9 x 16 x 20

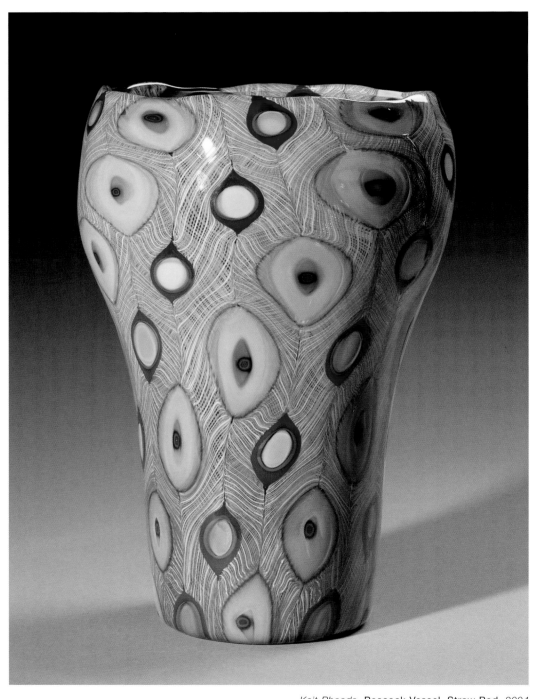

Kait Rhoads, **Peacock Vessel, Straw Pod,** *2004*
yellow zanfirico cane with red/gold and gold/red murrine, 15 x 10 x 10

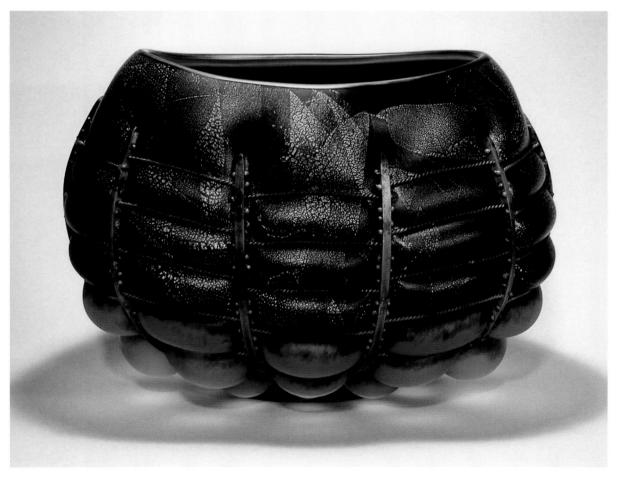

Gale Scott, **Cage #24**
blown glass, metal, 10.5 x 15 x 10

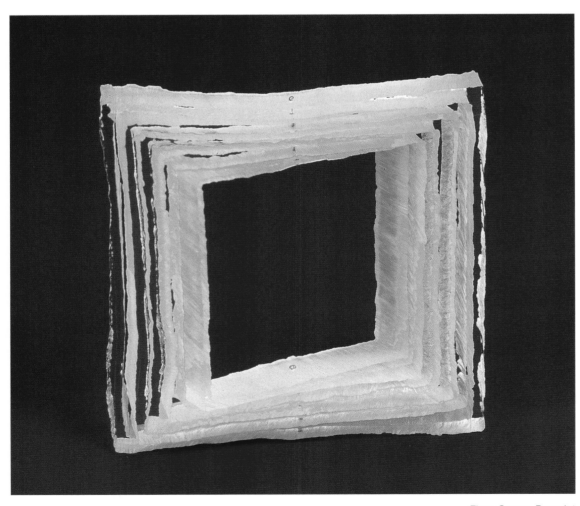

Elena Spano, **Bracelet**
Plexiglas, gold
photo: Karen Bell

Charon Kransen Arts

Contemporary innovative jewelry from around the world
Staff: Adam Brown; Lisa Granovsky; Charon Kransen

By Appointment Only
456 West 25th Street
New York, NY 10001
voice 212.627.5073
fax 212.633.9026
chakran@earthlink.net
charonkransenarts.com

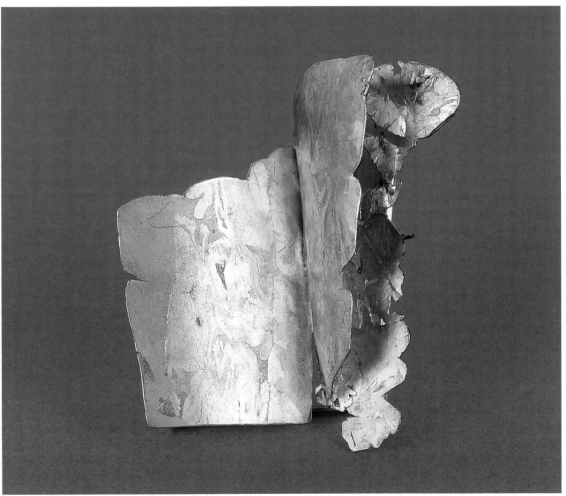

Representing:

Efharis Alepedis	Bruce Metcalf
Ralph Bakker	Miguel
Rike Bartels	Naoka Nakamura
Ela Bauer	Evert Nijland
Michael Becker	Barbara Paganin
Harriete Estel Berman	Gundula Papesch
Liv Blavarp	Anya Pinchuk
Julie Blyfield	Natalya Pinchuk
Antje Braeuer	Amie Louise Plante
Anton Cepka	Annelies Planteydt
Yu Chun Chen	Kaire Rannik
Cathy Chotard	Jackie Ryan
Petra Class	Lucy Sarneel
Giovanni Corvaja	Fabrice Schaefer
Simon Cottrell	Sylvia Schlatter
Claudia Cucchi	Renate Schmid
Peter de Wit	Claude Schmitz
Sam Tho Duong	Biba Schutz
Peter Frank	Vannetta Seecharran
Ursula Gnaedinger	Verena Sieber Fuchs
Sophie Hanagarth	Marjorie Simon
Valerie Hector	Jin-Sook So
Anna Heindl	Elena Spano
Herman Hermsen	Claudia Stebler
Yasuki Hiramatsu	Dorothee Striffler
Piret Hirv	Barbara Stutman
Meiri Ishida	Hye-Young Suh
Reiko Ishiyama	Tore Svensson
John Iversen	Janna Syvanoja
Hiroki Iwata	Salima Thakker
Hilde Janich	Ketli Tiitsar
Alina Jay	Terhi Tolvanen
Karin Johansson	Henriette Tomasi
Ike Juenger	Martin Tomasi
Yeonmi Kang	Silke Trekel
Martin Kaufmann	Catherine Truman
Ulla Kaufmann	Erik Urbschat
Yael Krakowski	Felieke van der Leest
Deborah Krupenia	Peter Vermandere
Dongchun Lee	Robean Visschers
Nel Linssen	Karin Wagner
Peter Machata	Jin-Soon Woo
Stefano Marchetti	Annamaria Zanella
Christine Matthias	Erich Zimmermann
Elisabeth McDevitt	

Stefano Marchetti, **Brooch**, *2004*
gold, silver
photo: Karen Bell

Claire Curneen, **Catherine and Her Wheel,** *2004*
porcelain, 25h
photo: Claire Curneen

Clay

Promoting the best of British ceramics
Staff: Charles Dimont; Cheryl Dimont; Sarah Edwards

226 Main Street
Venice, CA 90291
voice 310.399.1416
fax 301.230.9203
info@clayinla.com
clayinla.com

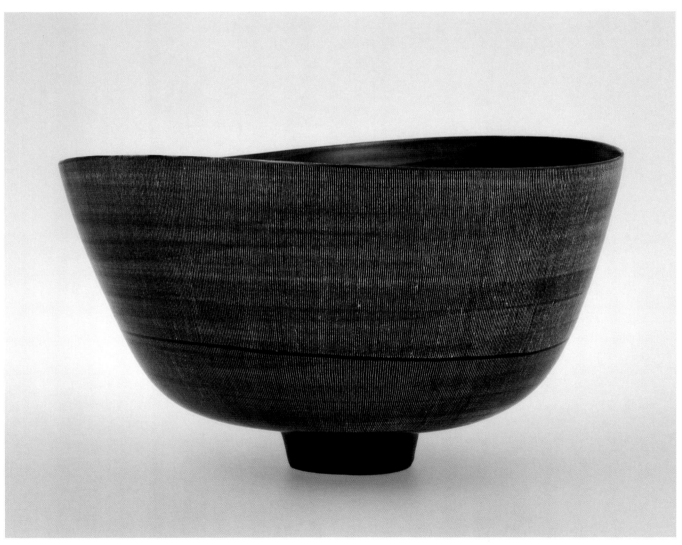

Representing:
Felicity Aylief
Jane Blackman
Christie Brown
Sandy Brown
Robert Cooper
Claire Curneen
Robert Dawson
Steve Dixon
Gabriele Koch
Craig Mitchell
David Roberts
Rupert Spira
Janice Tchalenko
Takeshi Yasuda

Rupert Spira, **Deep Bowl with Incised Lines,** *2004*
ceramic, 10 x 19
photo: James Austin

Lydia Hirte, **Neckpiece,** *2003*
dark gray and orange cardboard
photo: Karen Bell

The David Collection

International fine arts with a specialty in contemporary studio jewelry
Staff: Jennifer David, director

44 Black Spring Road
Pound Ridge, NY 10576
voice 914.764.4674
fax 914.764.4675
jkdavid@optonline.net
thedavidcollection.com

Representing:
Mikiko Aoki
Tomomi Arata
Sara Basch
Alexander Blank
Beate Brinkmann
Barbara Christie
Carol De Both
Martina Dempf
Joachim Dombrowski
Valerie Dubois
Nina Ehmck
Kyoko Fukuchi
Tania Gallas
Gill Galloway-
 Whitehead
Ursula Gnaedinger
Michael Good
Masako Hayashibe
Marion Heilig
Lydia Hirte
Mari Ishikawa
Yoko Izawa
Kyung Shin Kim
Heide Kindelmann
Ingrid Larssen
Wilheim Tasso Mattar
Grainne Morton
Martina Muhlfellner
Kathie Murphy
Suzanne Otwell Negre
Helge Ott
Maria Phillips
Alexandra Pimental
Sabine Reichert
Kayo Saito
Jan Smith
Kyoko Urino
Silvia Waltz
Beate Weiss

Akexander Blank, **Skelegon 1***, 2004*
iron wire
photo: Karen Bell

Judy Mulford, **Mother Blocks,** *2003*
waxed linen, silver, beads, Plexiglas base, 9 x 32 x 4.5
photo: Bill Dewey

del Mano Gallery

Turned and sculptured wood, fiber, teapots and jewelry
Staff: Jan Peters; Ray Leier; Kirsten Muenster

11981 San Vicente Boulevard
Los Angeles, CA 90049
voice 310.476.8508
fax 310.471.0897
gallery@delmano.com
delmano.com

William Hunter, **Garden Songs,** *2004*
cocobolo, 17 x 8
photo: Alan Shaffer

Representing:

Gianfranco Angelino	Bud Latven
Michael Bauermeister	Ron Layport
Brenda Behrens	Michael Lee
Christian Burchard	M. Joan Lintault
David Carlin	John Macnab
Jean-Christophe	Alain Mailland
Couradin	Sam Maloof
Robert Cutler	Thierry Martenon
Leah Danberg	Malcolm Martin
Gaynor Dowling	Marilyn Moore
Paul Drexler	Matt Moulthrop
David Ellsworth	Philip Moulthrop
Harvey Fein	Judy Mulford
J. Paul Fennell	Dennis Nahabetian
Ron Fleming	David Nittman
Liam Flynn	Nikolai Ossipov
Clay Foster	Sarah Parker-Eaton
Donald E. Frith	Michael Peterson
Dewey Garrett	Binh Pho
Steven Goetschius	Graeme Priddle
Louise Hibbert	Vaughn Richmond
Michelle Holzapfel	Merryll Saylan
Robyn Horn	Betty Scarpino
Todd Hoyer	David Sengel
Peter Hromek	Michael Shuler
William Hunter	Steve Sinner
John Jordan	Jack Slentz
Donna Kaplan	Hayley Smith
Steven Kennard	Alan Stirt
Ron Kent	Ema Tanigaki
June Kerseg-Hinson	Curt Thoebald
Leon Lacoursier	Grant Vaughan
Stoney Lamar	Jacques Vesery
Merete Larsen	Hans Weissflog

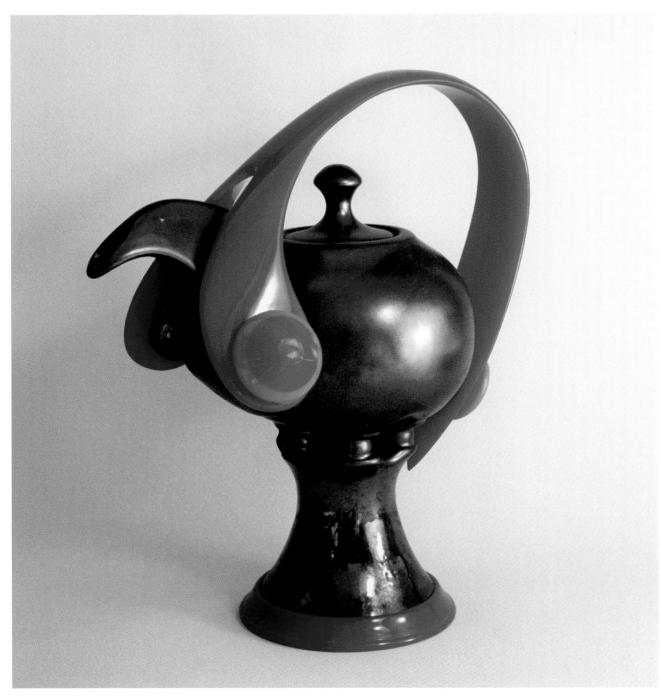

Donald E. Frith, **Teapot #620,** *2004*
porcelain, acrylic, 8 x 3d
photo: Donald E. Frith

del Mano Gallery

Jacques Vesery & Michael Lee, **Kai Kaina Uhane,** *2004*
cherry, pigment, gold leaf, 3 x 6 x 4
photo: R. Diamante

Michael Lucero, **A Pair of Spaniels (front),** *2004*
embroidered painted ceramic, 29 x 16 x 11
photo: Eva Heyd

Donna Schneier Fine Arts

Modern masters in ceramics, glass, fiber, metal and wood
Staff: Donna Schneier; Leonard Goldberg; Jesse Sadia

By Appointment Only
New York, NY
voice 212.472.9175
fax 212.472.6939
dnnaschneier@mhcable.com

Representing:
Jaroslava Brychtová
Wendell Castle
Dale Chihuly
Rick Dillingham
Shoji Hamada
Stanislav Libenský
Harvey K. Littleton
Michael Lucero
William Morris
Mary Shaffer
Bertil Vallien
František Vízner
Peter Voulkos
Betty Woodman

Michael Lucero, **A Pair of Spaniels (back)**, *2004*
embroidered painted ceramic, 29 x 16 x 11
photo: Eva Heyd

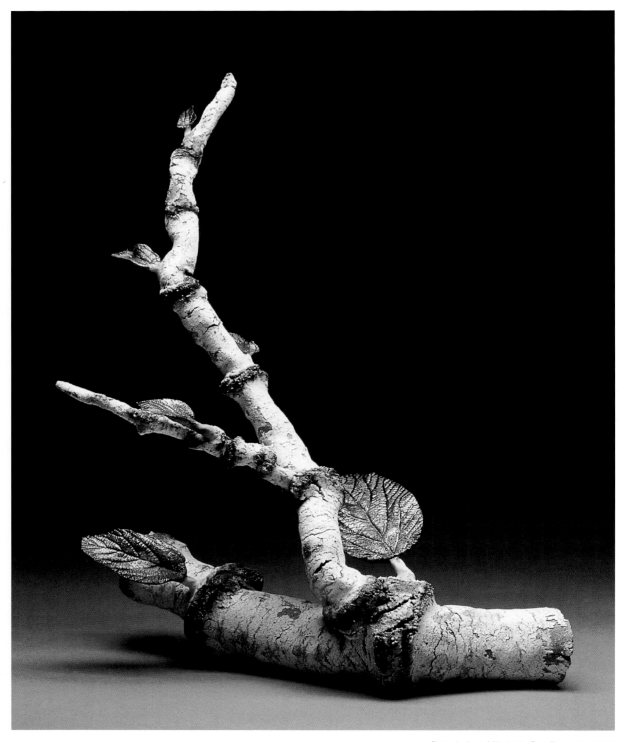

Dennis Lee Mitchell, **Cut Branch**, *2004*
welded clay, 18 x 14 x 9

Dubhe Carreño Gallery

Contemporary ceramic art by international artists
Staff: Dubhe Carreño, director

1841 South Halsted Street
Chicago, IL 60608
voice 312.666.3150
fax 312.577.0988
info@dubhecarrenogallery.com
dubhecarrenogallery.com

Representing:
Nikki Anderson
Tanya Batura
Sadashi Inuzuka
Ron Kovatch
Noemi Márquez
Dennis Lee Mitchell
Mariana Monteagudo
Patricia Rieger
Michaelene Walsh
Susan York

Tanya Batura, **Pinky Junior, Pinky Senior,** *2004*
clay, glaze, china paint, 11 x 7 x 8; 13 x 9 x 11

Russell Biles, **The Passion of Andy: Faith,** *2004*
porcelain, 17.5 x 8 x 10

Ferrin Gallery

Contemporary ceramic art and studio pottery
Staff: Leslie Ferrin; Donald Clark; Michael McCarthy; Scott Norris

69 Church Street
Lenox, MA 01240
voice 413.637.4414
fax 914.271.0047
info@ferringallery.com
ferringallery.com

Representing:
Russell Biles
Jim Budde
Laura DeAngelis
Mark Hewitt
Ilya Isupov
Sergei Isupov
Kathryn McBride
Marc Petrovic
Karen Portaleo
Mark Shapiro
Micah Sherrill
Linda Sikora
Jason Walker
Red Weldon-Sandlin

Jason Walker, **Playing with Fire: Dumb Bomb Revisited,** *2004*
porcelain, 20 x 10 x 7

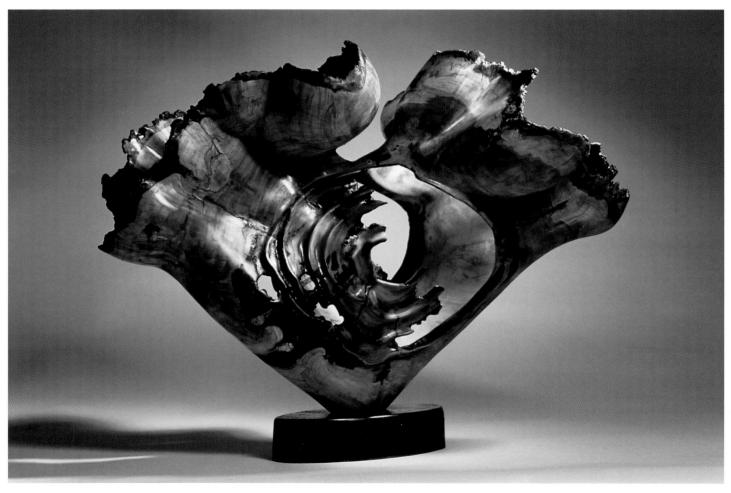

Brad Sells, **Cherry Bomb,** *2004*
cherry, 22 x 16 x 34

Finer Things Gallery

Wall constructions, sculpture and studio furniture
Staff: Kim Brooks, director

1898 Nolensville Road
Nashville, TN 37210
voice 615.244.3003
fax 615.254.1833
kkbrooks@bellsouth.net
finerthingsgallery.com

Representing:
Doug Chamblin
Sylvia Hyman
Charles Kegley
Tami Kegley
Alan LeQuire
Brad Sells
Joël Urruty
Rusty Wolfe

Rusty Wolfe, **Conversation,** *2004*
lacquer, MDF, wood, 62 x 30 x 5

John Cederquist, **Hiroshige's Attempt at Film Noir,** *2003*
various woods and inks, 84 x 44 x 14
photo: Mike Sasso

Franklin Parrasch Gallery

Contemporary art

Staff: Franklin Parrasch; Kate Simon; Holly Brown

20 West 57th Street
New York, NY 10019
voice 212.246.5360
fax 212.246.5391
info@franklinparrasch.com
franklinparrasch.com

Representing:
Robert Arneson
John Cederquist
Stephen DeStaebler
Richard DeVore
Viola Frey
John Mason
Beverly Mayeri
Ron Nagle
Ken Price
Peter Voulkos
Betty Woodman

Beverly Mayeri, **Braid***, 2003*
low-fire acrylic, 19 x 12 x 18
photo: Lee Fatheree

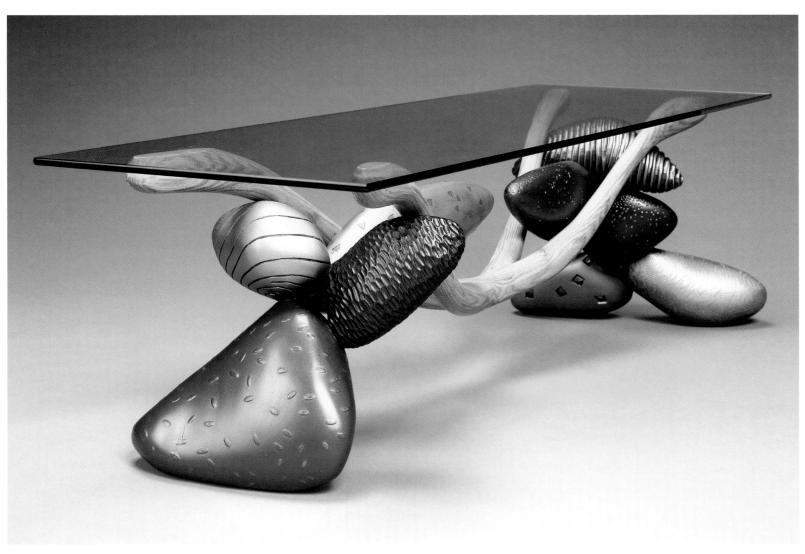

Brent Skidmore, **Slung Boulder Coffee Table,** *2004*
basswood, ash, steel, brass, glass, acrylic paint, 17 x 56 x 24

Function + Art/prism Contemporary Glass

Studio furniture + fine craft + sculptural lighting studio glass

Staff: D. Scott Patria, director; Amy Hajdas

1046-48 West Fulton Market
Chicago, IL 60607
voice 312.243.2780
info@functionart.com
functionart.com

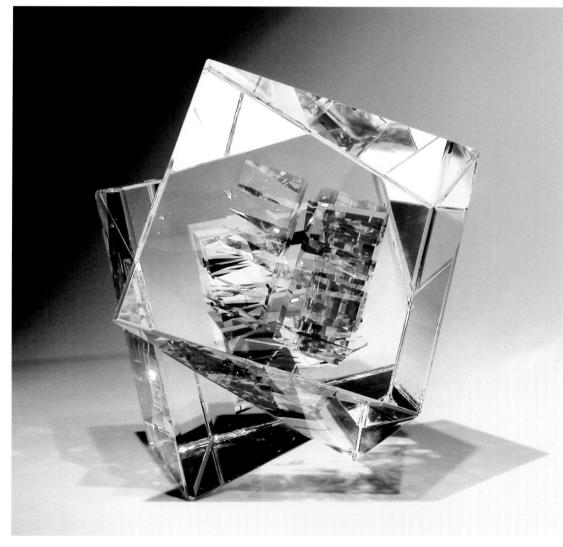

Representing:
Bonnie Bishoff
Jenna Goldberg
Martin Rosol
Toland Sand
Brent Skidmore
JM Syron

Toland Sand, **Isis Cube: Redux,** *2004*
laminated optical and dichroic glass, 11 x 11 x 11

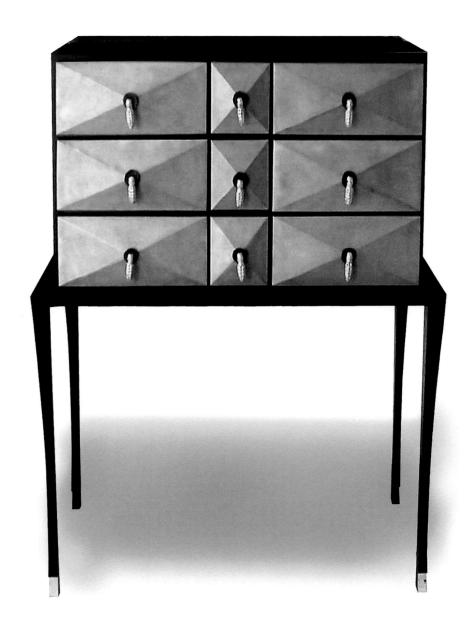

François Belliard, **Cabinet,** *2004*
wood, zinc, 48 x 43 x 17

Galerie Ateliers d'Art de France

Work by contemporary artists in a variety of media
Staff: Marie-Armelle de Bouteiller; Anne-Laure Roussille

4 Passage Roux
Paris 75017
France
voice 33.1.4401.0830
fax 33.1.4401.0835
galerie@ateliersdart.com
createdinfrance.com

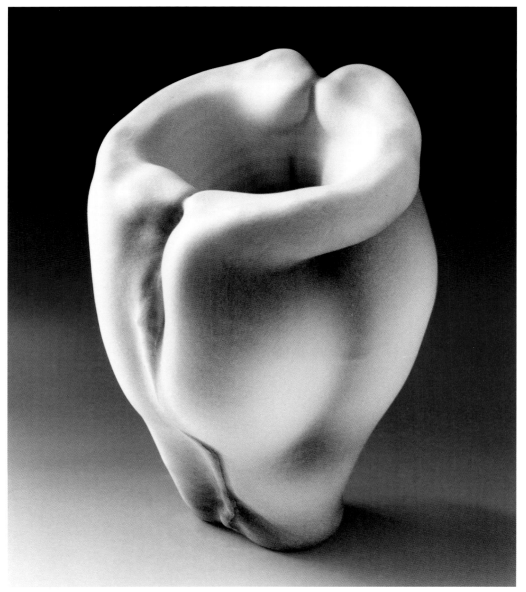

Representing:
François Belliard
Daphné Corregan
Patrick Crespin
Wayne Fischer
Christophe Nancey
Céline Tiellet
Gérald Vatrin

Wayne Fischer, Untitled, *2003*
porcelain, 11.8 x 7.9 x 6.7

Shozo Michikawa, **Tall Tanka Pot,** *2004*
charcoal-fired stoneware, 21.25 x 4.25
photo: Yoshinori Seguchi

Galerie Besson

International contemporary ceramics
Staff: Anita Besson, owner; Matthew Hall; Louisa Vowles

15 Royal Arcade
28 Old Bond Street
London W1S 4SP
England
voice 44.20.7491.1706
fax 44.20.7495.3203
enquiries@galeriebesson.co.uk
galeriebesson.co.uk

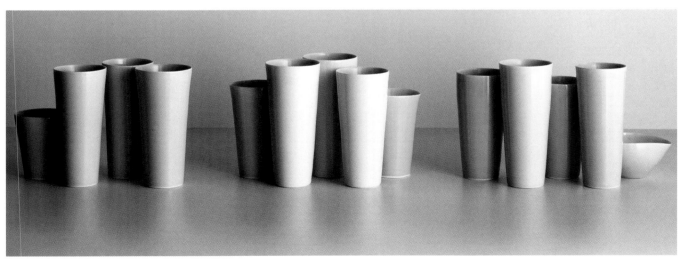

Representing:
Hans Coper
Ruth Duckworth
Ryoji Koie
Jennifer Lee
Jim Malone
Shozo Michikawa
Gwyn Hanssen Pigott
Lucie Rie
Annie Turner

Gwyn Hanssen Pigott, **Chord***, 2004*
translucent porcelain, 7.25 x 39.5 x 6
photo: Brian Hand

135

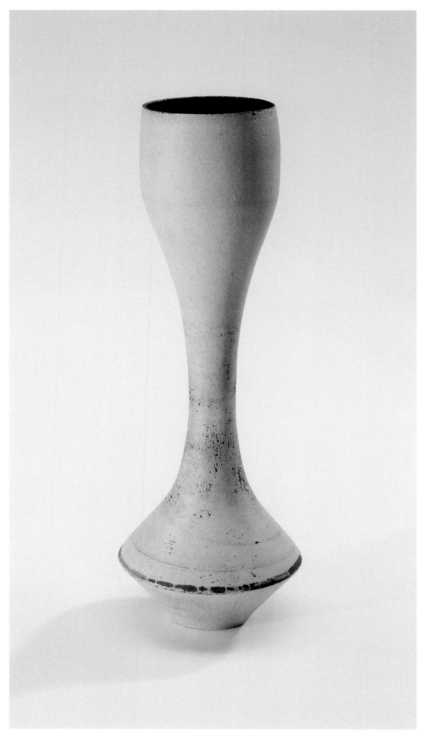

Hans Coper, **Hourglass**, *c. 1965*
stoneware, 12h
photo: Michael Harvey

Lucie Rie, **Yellow Footed Bowl,** *c. 1970*
porcelain, 5 x 10.25
photo: Michael Harvey

*Yan Zoritchak, **Eclipse**, 2004*
optical glass, 28 x 23 x 4
photo: Michel Wirth

Galerie Daniel Guidat

Contemporary art gallery; glass and painting by international artists
Staff: Daniel Guidat; Albert Feix, III

142 Rue d'Antibes
Cannes 06400
France
voice 33.4.9394.3333
fax 33.4.9394.3334
gdg@danielguidat.com
danielguidat.com

Representing:
Alain Bégou
Francis Bégou
Marisa Bégou
Goudji
Nad Vallée
Yan Zoritchak
Czeslaw Zuber

Goudji, **Zebu in the River**, *2003*
silver, ebony, green agate, 11 x 16 x 5
photo: Marc Alfieri

Natasha St. Michael, **Piles,** *2003*
glass beads, nylon thread, 12 x 8.5 x 1
photo: Paul Litherland

Galerie des Métiers d'Art du Québec

Works by contemporary artists in a variety of media

Staff: France Bernard, gallery director; Chantale Clarke, exhibitions coordinator; Margerie Lorrain Cayer; Jeròme Bleton

350 St. Paul East
Montreal, Quebec H2Y 1H2
Canada
voice 514.861.2787, ext. 310
fax 514.861.9191
france.bernard@metiers-
 d-art.qc.ca
galeriedesmetiersdart.com

Representing:
Sylvie Bèlanger
Maude Bussières
Annie Cantin
Laurent Craste
Elyse De Lafontaine
Roland Dubuc
Susan Edgerley
Carole Frève
Bruno Gérard
Monique Giard
Chantal Gilbert
Antoine Lamarche
Christine Larochelle
Louise Lemieux Bérubé
Paula Murray
Claudio Pino
Donald Robertson
John Paul Robinson
Natasha St. Michael

Susan Edgerley, **Threadlet** *detail, 2003*
flameworked glass, metal, 15 x 3

141

Folon, **Le Voyageur,** *2002*
bronze, 78.75 x 40 x 31.5

Galerie Mark Hachem

Contemporary art gallery with an emphasis on sculpture and optic art
Staff: Mark Hachem; Moussa Hachem; Paola Cancian

10 Place des Vosges
Paris 75004
France
voice 33.1.4276.9493
fax 33.1.4276.9466
mark@galerie-markhm.com
galerie-markhm.com

Representing:
Arman
Berrocal
Cruz-Diez
Folon
Perez-Flores
Polles

Polles, **Dalia,** *2004*
bronze, 19 x 10.25 x 10.25

Carsten From Andersen, **Serving Set,** *2004*
gilded 925 silver, 8.5 x 8.5 x 6.25
photo: Dorte Krogh

Galerie Metal

Experimental jewelry and hollowware of 12 Danish artists
Staff: Nicolai Appel, director; Else Nicolai Hansen and Karina Noyons, sales managers

Nybrogade 26
Copenhagen K, 1203
Denmark
voice 45.33.145540
fax 45.33.145540
galeriemetal@mail.dk
galeriemetal.dk

Louise Hee Lindhardt, **Dream Flower**, 2004
18k gold, plastic, 1.5 x 1.5 x 1.25
photo: Dorte Krogh

Representing:
Carsten From
 Andersen
Nicolai Appel
Gitte Bjørn
Yvette Bredsted
Margaret Bridgwater
Else Nicolai Hansen
Mette Laier Henriksen
Louise Hee Lindhardt
Karina Noyons
Camilla Prasch
Trine Trier Rosendahl
Lene Wolters

Barbora Krivská, **Sounds,** *2004*
glass, painting, 20 x 20
photo: Barbora Krivská

Galerie Pokorná

The most important European contemporary art in glass and emerging artists

Staff: Jitka Pokorná, director

Janský Vrsek 15
Prague 1, 11800
Czech Republic
voice 420.222.518635
fax 420.222.518635
office@galeriepokorna.cz
galeriepokorna.cz

Representing:
Jaroslava Brychtová
Václav Cigler
Patrik Illo
Barbora Křivská
Stanislav Libenský
Štěpán Pala
Zora Palová
Jindra Vikova
Dana Zamečníkova

Stanislav Libenský & Jaroslava Brychtová, **Table***, 1988-91*
glass, 16 x 8.7 x 29
photo: Gabriel Urbanek

Hiroshi Suzuki, **Ka-La II** *vase, 2004*
999 fine silver, 11.5 x 8 x 8

Galerie Tactus

Contemporary European hollowware and a touch of jewelry
Staff: Lina Falkesgaard; Peter Falkesgaard

12 St. Regnegade
Copenhagen 1110
Denmark
voice 45.33.933105
fax 45.35.431547
tactus@galerietactus.com
galerietactus.com

Representing:
Claus Bjerring
Kim Buck
Lina Falkesgaard
Torben Hardenberg
David Huycke
Sidsel Dorph Jensen
Tina Kronhorst
Allan Scharff
Per Suntum
Hiroshi Suzuki

Allan Scharff, **150 West 11 South** *plate, 2003*
sterling silver, 18k gold, 15 x 15

149

Stig Persson, **Wrap Dish,** *2003*
glass, 27.5d
photo: Ole Akjøj

Galleri Grønlund

Special focus on glass inspired by the sea
Staff: Anne Merete Grønlund, director; Kirstine Grønlund

Birketoften 16a
Vaerloese 3500
Denmark
voice 45.44.442798
fax 45.44.442798
groenlund@get2net.dk
glassart.dk

Representing:
Steffen Dam
Trine Drivsholm
Torben Jørgensen
Jørgen Karlsen
Micha Maria Karlslund
Tobias Møhl
Stig Persson

Tobias Møhl, **Glass Weaver,** *2004*
glass, 20.5h
photo: Anders Sune Berg

Bodil Manz, **Cylinders,** *2004*
porcelain, various sizes
photo: Søren Nielsen

Galleri Nørby

Contemporary Danish ceramics
Staff: Bettina Køppe, director; Jeanette Hiiri, assistant

Vestergade 8
Copenhagen 1456
Denmark
voice 45.33.151920
fax 45.33.151963
info@galleri-noerby.dk
galleri-noerby.dk

Representing:
Karen Bennicke
Michael Geertsen
Nina Hole
Steen Ipsen
Martin Bodilsen
 Kaldahl
Bodil Manz
Malene Müllertz
Peder Rasmussen
Bente Skjøttgaard

Nina Hole, **Ring Around,** *2004*
stoneware, 8.5 x 19
photo: Søren Nielsen

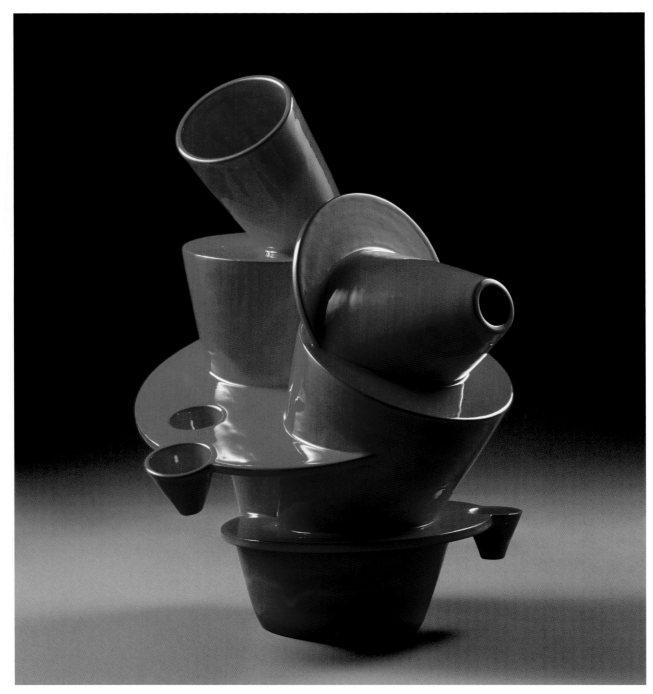

Michael Geertsen, **Red Object,** *2004*
earthenware, 20.5 x 16
photo: Søren Nielsen

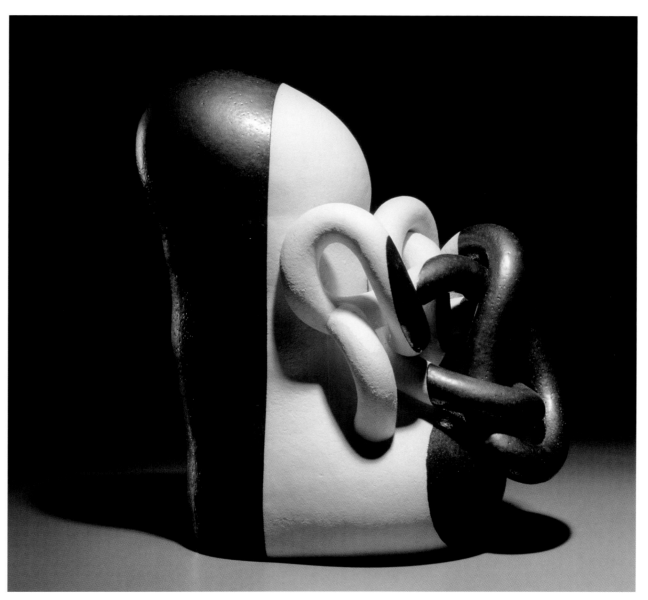

Martin Bodilsen Kaldahl, **Knotpot V**, *2004*
stoneware, 20.5 x 16.5
photo: Søren Nielsen

Mark Chatterley, **Two Figures,** *2004*
clay, crater glaze, 78 x 18 x 12
photo: Dave Olds

Gallery 500 Consulting

Promoting excellence and creativity in all media
Staff: Rita Greenfield, owner

3502 Scotts Lane
Philadelphia, PA 19129
voice 215.849.9116
fax 215.849.9116
gallery500@hotmail.com
gallery500.com

Carolyn Morris Bach, **Rabbit with Bird** *brooch/pendant, 2004*
18 and 22k gold, cow bone, ebony, rutilated quartz, 3.25 x 2
photo: Hap Sakwa

Representing:
Carolyn Morris Bach
Mark Chatterley
John Dewitt
Dale Gottlieb
Christopher Gryder
Cynthia Minden

157

Susan P. Cochran, **The Great Ant,** *2004*
bronze, 92 x 75 x 115
photo: Rick Morrison

Gallery Biba

Contemporary artists working in bronze, wood and stone
Staff: Biba St. Croix; Jeanette Gonzalez; Sybil de Bourbon; William Church

1400 Alabama Avenue
West Palm Beach, FL 33401
voice 561.832.3933
fax 561.835.1819
robertstcroix@prodigy.net
gallerybiba.com

Representing:
Susan P. Cochran
Robert St. Croix

Robert St. Croix, **Tulips in Purple Vase,** *2003*
bronze, 21.5 x 27 x 27
photo: Rick Morrison

159

Grethe Wittrock, **Aqua**, *2004*
knotted nylon fishing line, 55 x 51
photo: Anders Sune Berg

Gallery DeCraftig

Contemporary Danish textile art
Staff: Grethe Wittrock, director

Søpassagen 14, 3.th.
Copenhagen 2100
Denmark
voice 45.2712.3451
grethe.wittrock@post.tele.dk

Representing:
Thea Bjerg
Lisbeth Friis
Helle Graabæk
Jette Hartvig
Bitten Hegelund
Charlotte Houmann
Gitte-Annette Knudsen
Astrid Krogh
Puk Lippmann
Ane Lykke
Anne Fabricius Møller
Kirsten Nissen
Tina Ratzer
Louise Sass
Grethe Wittrock

Thea Bjerg, **Black-spotted Coral Snail,** *2004*
hand-printed silk organza, folded and hand-pleated, 6.75 x 20 x 22
photo: Jeppe Gudmundsen-Holmgreen

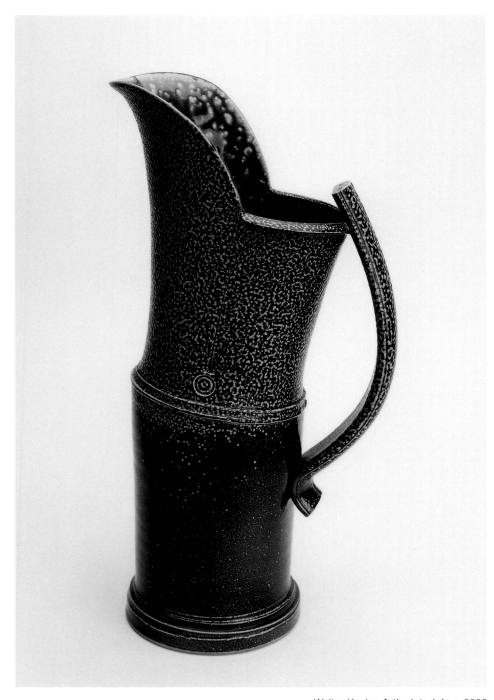

Walter Keeler, **Articulated Jug**, *2003*
salt-glazed ceramic, 15.5h
photo: Dewi Tannatt Lloyd

The Gallery, Ruthin Craft Centre

Contemporary craft and applied art from Wales
Staff: Philip Hughes, director; Jane Gerrard, deputy director; Ceri Jones, Wales Arts International

Park Road
Ruthin, Denbighshire LL15 1BB
Wales, UK
voice 44.1824.704774
fax 44.1824.702060
thegallery@rccentre.org.uk

Representing:
Daniel Allen
David Binns
Christine Jones
Walter Keeler
Kathleen Makinson
Eleri Mills
Audrey Walker

Kathleen Makinson, **Snake bangle***, 2002*
white and yellow precious metal, 4d
photo: Brian Podschies

David Binns, **Standing Form,** *2004*
ceramic, glass with aggregates, 13 x 20 x 3
photo: David Binns

Eleri Mills, 'Yn Y Caeau Gwair' Rhif II (In the Hayfields II), *2004*
paint, handstitching and appliqué on cloth, 27 x 37
photo: Eleri Mills

Kiwon Wang, **Jewel Container/outside N#9**, *2004*
14k gold, pearls, New York Times, *sterling silver*
photo: James Beards

Gallery Yann

Exceptionally crafted jewelry works by internationally recognized artists
Staff: Yann Woolley; Edith Robertson; Donella Lubig; Susan Hwang

106 East Oak Street
Chicago, IL 60611
voice 312.337.5861
fax 312.337.5895
galleryyann@sbcglobal.net

Kiwon Wang, **Waterdrop #P2** *pin, 2004*
14k gold, New York Times, *pearls, sterling silver, 3 x 4 x 1*
photo: James Beards

Representing:
Elizabeth Garvin
Barbara Heinrich
Ulla Kaufmann
Gudrun Meyer
Norbert Muerrle
Heidi Nahser
Niessing
Cornelia Roethel
Ursula Scholz
Georg Spreng
Kiwon Wang

Deb Cocks, **Blue Loop,** *2004*
reverse painted and engraved glass, 19.5 x 4
photo: Andrew Stewart

Glass Artists' Gallery

Australia's foremost contemporary glass gallery supporting established and emerging artists since 1982
Staff: Maureen Cahill, gallery director; Miranda Rooney, gallery coordinator

70 Glebe Point Road, Glebe
Sydney, NSW 2037
Australia
voice 61.2.9552.1552
fax 61.2.9552.1552
mail@glassartistsgallery.com.au
glassartistsgallery.com.au

Representing:
Simon Butler
Deb Cocks
Rod Coleman
David Hay
Keith Rowe
Tim Shaw

Rod Coleman, **Revealed,** *2004*
overlaid and cage-blown glass, 14 x 10 x 10
photo: Adrian Lambert

Eric Hilton, **Vesica**, *2004*
glass, marble, stainless steel, 80 x 19 x 14

Habatat Galleries

The finest in contemporary glass from around the world

Staff: Ferdinand Hampson, president; Kathy Hampson; John Lawson, director; Corey Hampson

4400 Fernlee Avenue
Royal Oak, MI 48073
voice 248.554.0590
fax 248.554.0594
info@habatat.com
habatat.com

Petr Hora, **Charon**, *2004*
cast glass 18d
photo: Miroslav Vojechovsky

Representing:
Herb Babcock
Martin Blank
Latchezar Boyadjiev
Emily Brock
Eric Hilton
Tomas Hlavicka
Petr Hora
David Huchthausen
Clifford Rainey
Barry Sautner
Jack Schmidt
Mary Shaffer
Leah Wingfield
Ann Wolff
Toots Zynsky

Albert Paley, **Construct,** *2001*
steel, stainless steel, glass, 31 x 25.5 x 17
photo: Bruce Miller

Hawk Galleries

Museum-caliber, contemporary sculpture in glass, metal and wood
Staff: Tom Hawk; Tyler Steele; Kami Meighan; Susan Janowicz

153 East Main Street
Columbus, OH 43215
voice 614.225.9595
fax 614.225.9550
tom@hawkgalleries.com
hawkgalleries.com

Representing:
Luis Montoya
Leslie Ortiz
Albert Paley
Flo Perkins
Christopher Ries
Paul Schwieder

Christopher Ries, **Celebration,** *2001*
cut, ground and polished optical crystal, 14.5 x 4.5 x 18

173

Paul Schwieder, **Cobalt Flame,** *2004*
sandblasted blown glass, 17 x 8 x 8

Flo Perkins, Terra Firma, *2004*
blown glass, 11 x 6 x 7

Luis Montoya & Leslie Ortiz, **Dessert Is Served,** *2003*
patinated bronze, 21.5 x 25 x 15

Dan Dailey, **The Receivers Wall Sconces,** *2001*
bronze, blown glass, crystal, 20.5 x 14.5 x 7 female, 21 x 12.5 x 7 male
photo: Bill Truslow

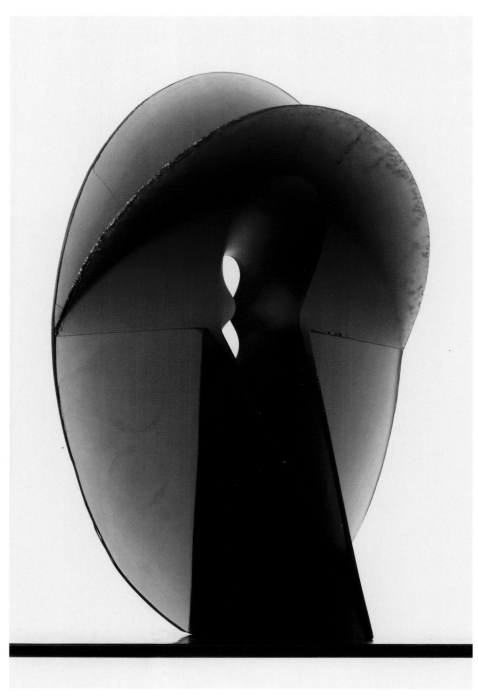

Vladimira Klumpar, **Attendant,** *2004*
kiln-cast glass, 28 x 21 x 10

Heller Gallery

Exhibiting sculpture using glass as a fine art medium since 1973
Staff: Douglas Heller; Katya Heller; Michael Heller

420 West 14th Street
New York, NY 10014
voice 212.414.4014
fax 212.414.2636
info@hellergallery.com
hellergallery.com

Representing:
Nicole Chesney
Robin Grebe
Vladimira Klumpar
Beth Lipman
Sean Mercer
Klaus Moje

Klaus Moje, **Tumbling Lines II**, *2004*
kiln-fused glass, 20.75 x 3

Laurie Hall, **No Rules Applied,** *2004*
found objects, aluminum, bronze, 14 x 12 x .25

Hibberd McGrath Gallery

Contemporary American fiber, ceramics, glass and jewelry
Staff: Martha Hibberd, partner; Terry McGrath Craig, partner

101 North Main Street
PO Box 7638
Breckenridge, CO 80424
voice 970.453.6391
fax 970.453.6391
terry@hibberdmcgrath.com
hibberdmcgrath.com

Representing:
Jean Cacicedo
Laurie Hall
Tom Lundberg
Marcia Macdonald
John Nickerson
Beth Nobles
Sang Roberson
Carol Shinn
Missy Stevens

Carol Shinn, **Red Speed,** *2004*
machine-stitched canvas, 14.25 x 20.5

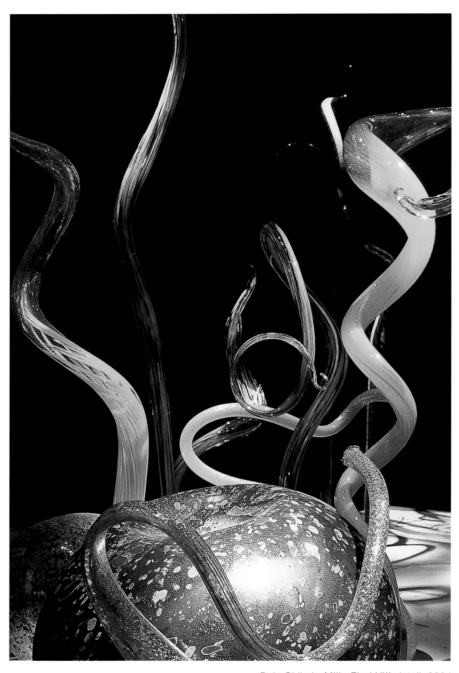

Dale Chihuly, **Mille Fiori VIII** *detail, 2004*
blown glass, 84 x 144 x 96
photo: Jack Crane

Holsten Galleries

Contemporary art glass
Staff: Kenn Holsten, owner; Jim Schantz, director; Mary Childs, associate director; Joe Rogers, preparator; Stanley Wooley, associate

3 Elm Street
Stockbridge, MA 01262
voice 413.298.3044
fax 413.298.3275
artglass@holstengalleries.com
holstengalleries.com

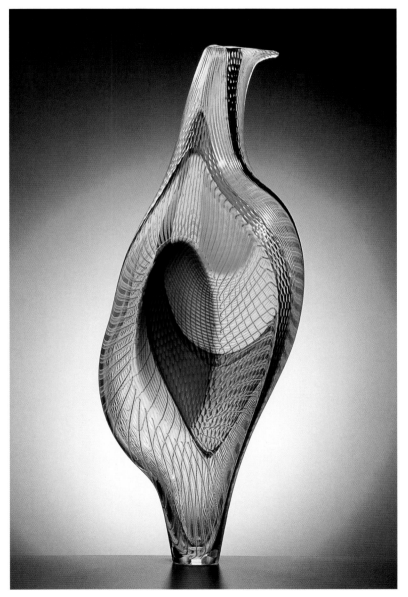

Representing:
Dale Chihuly
Lino Tagliapietra

Lino Tagliapietra, **Bilbao,** *2004
blown glass, 24.5 x 9.5 x 6.5
photo: Russell Johnson*

183

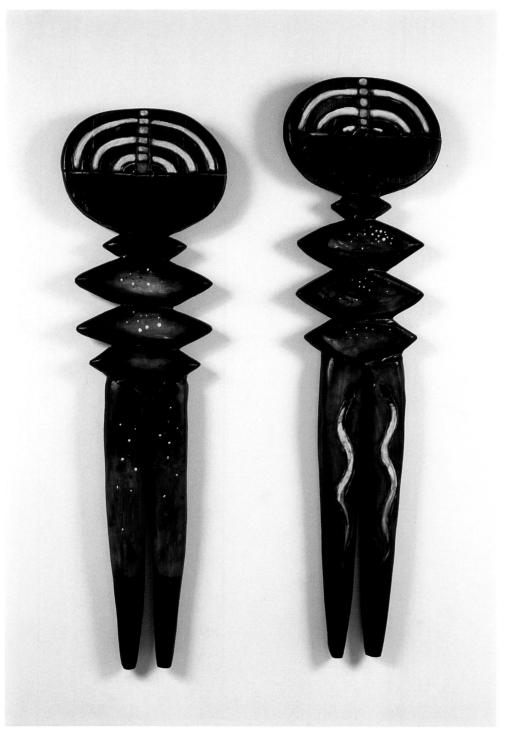

John Geldersma, **Shamans,** *2004*
burned and painted wood, 58h female; 62h male
photo: William Bengston

Jean Albano Gallery

Contemporary painting, sculpture and constructions
Staff: Jean Albano Broday; Sarah Kaliski; Merry-Beth Noble; Jen Lavender

215 West Superior Street
Chicago, IL 60610
voice 312.440.0770
fax 312.440.3103
jeanalbano@aol.com
jeanalbanogallery.com

Representing:
Greg Constantine
Diane Cooper
Claudia DeMonte
John Geldersma
Sandy Swirnoff
John Torreano
Robert Walker

Robert Walker, **Escape Only,** *2004*
extruded acrylic on wood panel, 24 x 30 x 2

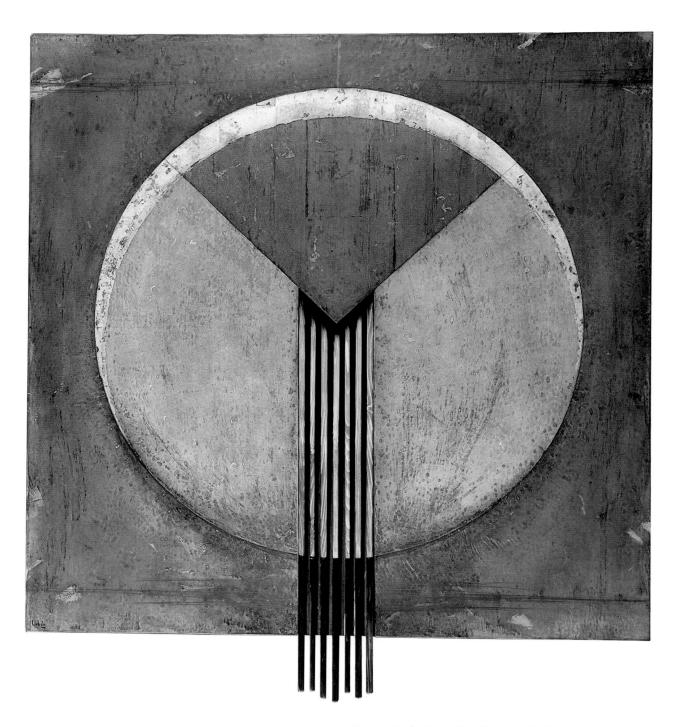

Ramon Urbán, **Estandarte Para una Belleza Tenebrosa**, *2003*
mixed media on wood construction, 43.5 x 39.5 x 2

Jerald Melberg Gallery

Late 20th century and contemporary painting, sculpture, and objects
Staff: Jerald Melberg; Mary Melberg; Gaybe Johnson; Chris Clamp

625 South Sharon Amity Road
Charlotte, NC 28211
voice 704.365.3000
fax 704.365.3016
gallery@jeraldmelberg.com
jeraldmelberg.com

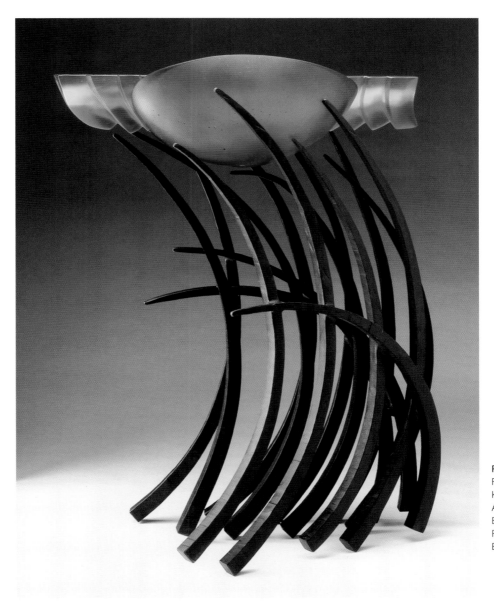

Representing:
Faustino Aizkorbe
Kimo Minton
Albert Paley
Brian Russell
Ramon Urbán
Emily Wilson

Brian Russell, **Hemisphere 93 Germination,** *2004*
cast glass, steel, 31 x 24 x 14

Daniel Fisher, **Flame Bowl,** *2004*
porcelain, 12 x 10 x 10
photo: Daniel Fisher

Joanna Bird Pottery

Studio pottery by contemporary artists and past masters
Staff: Joanna Bird, owner; Fredrika Teale, Charlotte Claridge, George Bird, assistants

By Appointment
19 Grove Park Terrace
London W43QE
England
voice 44.208.995.9960
fax 44.208.742.7752
joanna.bird@ukgateway.net
joannabirdpottery.com

Representing:
Svend Bayer
Michael Cardew
Thíebaut Chagué
Hans Coper
Edmund de Waal
Daniel Fisher
Elizabeth Fritsch
Shoji Hamada
Edward Hughes
Chris Keenan
Bernard Leach
David Leach
John Maltby
Paul Philp
William Plumptre
Lucie Rie
Tatsuzo Shimaoka
Jason Wason
Takeshi Yasuda

Elizabeth Fritsch, **Counterpoint Vase,** *2004*
stoneware, 14.75 x 5.25 x 3
photo: Rodney Todd-White

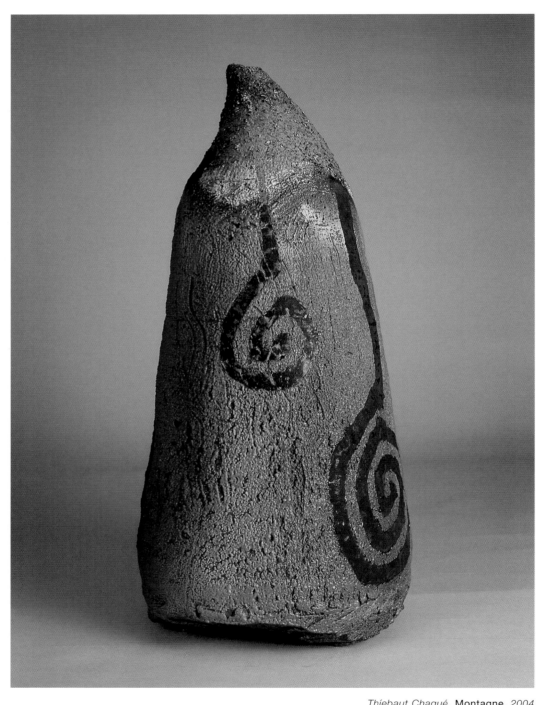

Thíebaut Chagué, **Montagne,** *2004*
stoneware, 27 x 33 x 33
photo: Francis Bourgeur

Shoji Hamada, **Bamboo Bowl,** *1963*
stoneware, 2.75 x 9 x 9
photo: Robert Teed

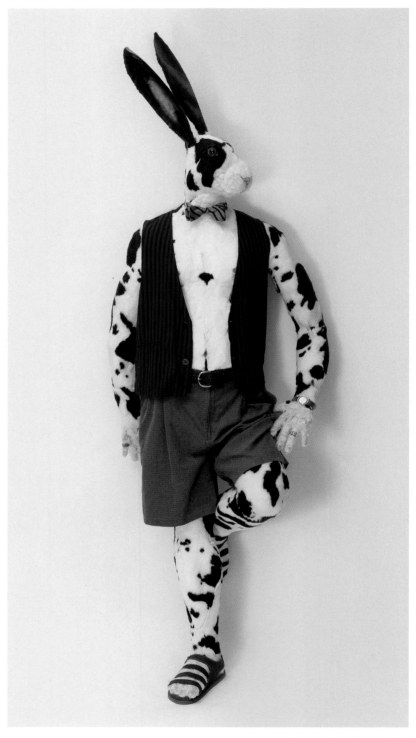

Gerald Heffernon, **Rabbinoid,** *2004*
mixed media, life size

John Natsoulas Gallery

West Coast figurative ceramics, California funk and beat art movements

Staff: John Natsoulas

521 First Street
Davis, CA 95616
voice 530.756.3938
fax 530.756.3961
art@natsoulas.com
natsoulas.com

Representing:
Robert Arneson
Vicky Chock
Victor Cicansky
Roy De Forest
David Gilhooly
Gerald Heffernon
Temo Moreno
Richard Newman
Richard Shaw
Esther Shimazu
I.M. Skuja-Braden
Victor Spinski
Peter VandenBerge

Victor Spinski, **Paint Box,** *2003*
ceramic, 15 x 9 x 14

Kaiser Suidan, **Ceramic Cube Installation,** *2004*
ceramic, 6 x 6 each
photo: Beth Singer

Kaiser Suidan/Next Step Studio and Gallery

Promoting young and upcoming talent with a vision

Staff: Kaiser Suidan

By Appointment Only
530 Hilton Road
Ferndale, MI 48220
voice 248.414.7050
fax 248.414.7050
kaisersuidan@nextstepstudio.com
nextstepstudio.com

Representing:
Rebecca Myers
Michael J. Schunke
Scott Strickstein
Kaiser Suidan
Scott Webb

Rebecca Myers, **Eucalyptus neckless**, *2004*
18 and 22k gold inlay, 14k yellow gold, 16d

Laura Foster Nicholson, **Pink Cakes,** *2004*
fiber; handwoven brocade, 23.5 x 27
photo: Garry Henderson

Katie Gingrass Gallery

Contemporary art and fine craft
Staff: Katie Gingrass, owner; Elaine Hoth, curator; Sarah Gingrass, sales

241 North Broadway
Milwaukee, WI 53202
voice 414.289.0855
fax 414.289.9255
katieg@execpc.com
gingrassgallery.com

Colin Schleeh, **Sargasso**, 2004
wood, 20 x 14
photo: Colin Schleeh

Representing:
Jackie Abrams
Stephen Beal
Susan Colquit
Lucy Feller
Linda Fifield
Ty Gillespie
Ron Isaacs
William Jauquet
Patti Lechman
David Lory
Laura Foster Nicholson
Junco Sato Pollack
Tom Queoff
Tom Rauschke
Joanne Russo
Colin Schleeh
Sandy Shaw
John Skau
Frasier Smith
Polly Adams Sutton
Elizabeth Whyte-
 Schulze
Kaaren Wiken
Jiro Yonezawa

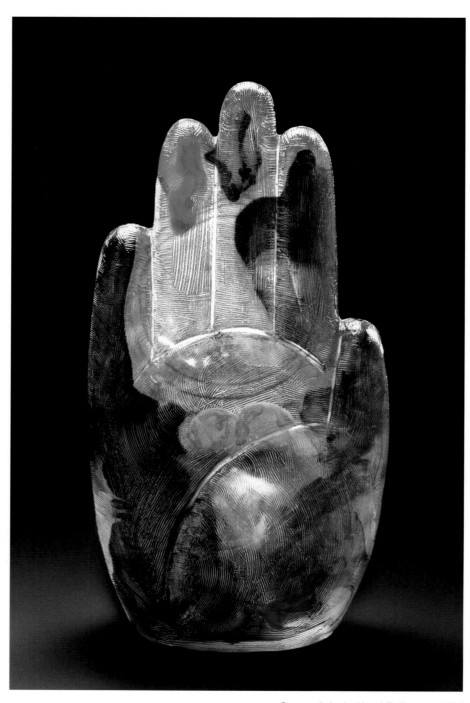

George Aslanis, **Hand Reliquary,** *2004*
cast furnace glass, 25 x 13 x 4

Kirra Galleries

Leaders in the Australian contemporary glass movement
Staff: Suzanne Brett, gallery manager; Vicki Winter, administration manager

Shop M11 (mid level)
Southgate Arts & Leisure Precinct
Southbank, Victoria 3006
Australia
voice 61.3.9682.7923
fax 61.3.9547.2277
kirra@kirra.com
kirra.com

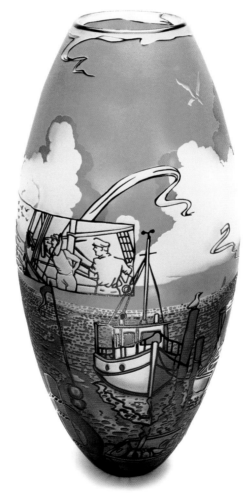

Tony Hanning, **Nau**, *2003*
engraved glass, 17.5 x 8
photo: Terence Bogue

Representing:
Christian Arnold
George Aslanis
Marcus Dillon
Alasdair Gordon
Rish Gordon
Tony Hanning
Noel Hart
Paul Kelsey
Simon Maberley
Elizabeth Mavrick
Chris Pantano
Phillip Stokes
Crystal Stubbs
Patrick Wong

Doug Fogelson, **Window #7,** *2001*
glass with wood base, 17 x 11.5 x .25
photo: Doug Fogelson

Kraft Lieberman Gallery

Modern and contemporary art in all media by national and international artists
Staff: Jeffrey Kraft and Paul Lieberman, owners/directors; Laurie Lieberman; Galya Kraft

835 West Washington
Chicago, IL 60607
voice 312.948.0555
fax 312.948.0333
klfinearts@aol.com
klfinearts.com

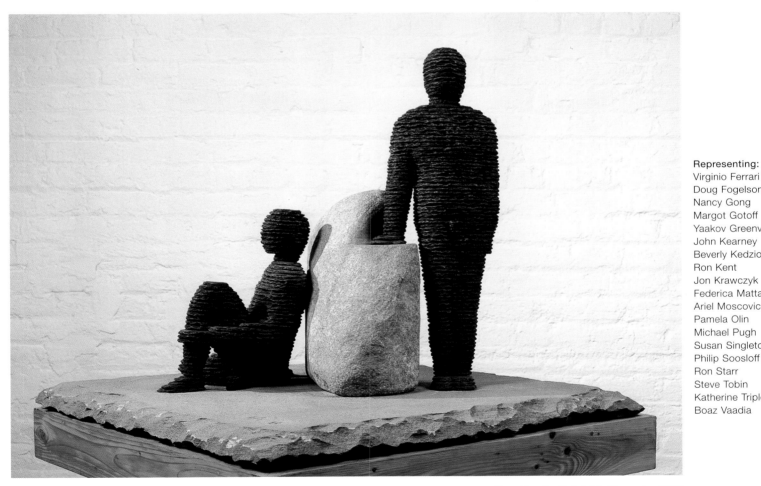

Representing:
Virginio Ferrari
Doug Fogelson
Nancy Gong
Margot Gotoff
Yaakov Greenvurcel
John Kearney
Beverly Kedzior
Ron Kent
Jon Krawczyk
Federica Matta
Ariel Moscovici
Pamela Olin
Michael Pugh
Susan Singleton
Philip Soosloff
Ron Starr
Steve Tobin
Katherine Triplett
Boaz Vaadia

Boaz Vaadia, Ge'u'el & Binyamin, *2002*
bronze, bluestone, boulder, 23 x 28 x 28

Nancy Gong, **Autumn,** *2003*
glass, steel, lead, 27 x 15 x 12
photo: Don Cochran

Michael Pugh, **Untitled,** *2004*
ceramic, wood, silver leaf, 43.25 x 19 x 13
photo: Michael Pugh

Philip Soosloff, **The Blue Journey,** *2004*
painted wall construction, mixed media, 35 x 81 x 11
photo: Steve Pitkin

Ron Starr, **R2Cologne***, 2004*
ceramic, glass, 38 x 22

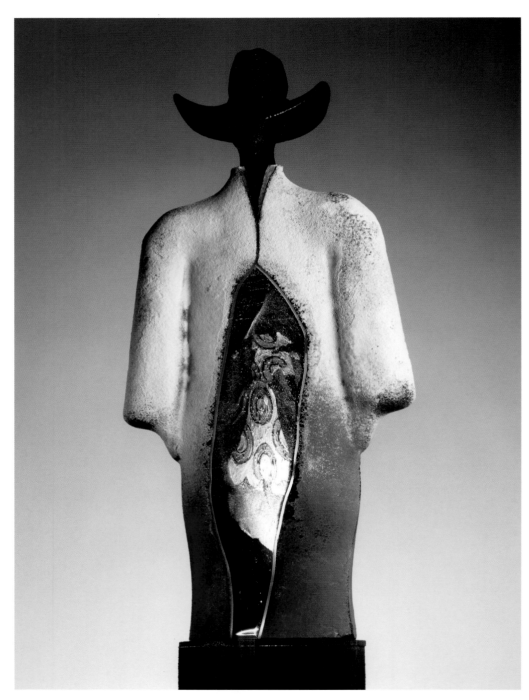

Kjell Engman, **Man in Trench Coat**, *2004*
cast and hand-painted glass, 31 x 10 x 7

Leif Holmer Gallery AB

Contemporary art and glass
Staff: Leif Holmer, president; Marcus Holmer, vice president

Storgatan 19
Box 20
Nässjö 5-57121
Sweden
voice 46.380.12490
fax 46.380.12494
leif@holmergallery.com
marcus@holmergallery.com
holmergallery.com

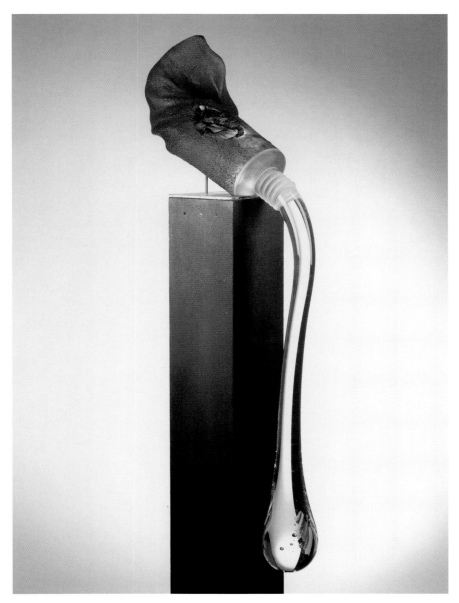

Representing:
Kjell Engman

Kjell Engman, **Tube**, *2004*
free handmade, cast and hand-painted glass, 40 x 17 x 8

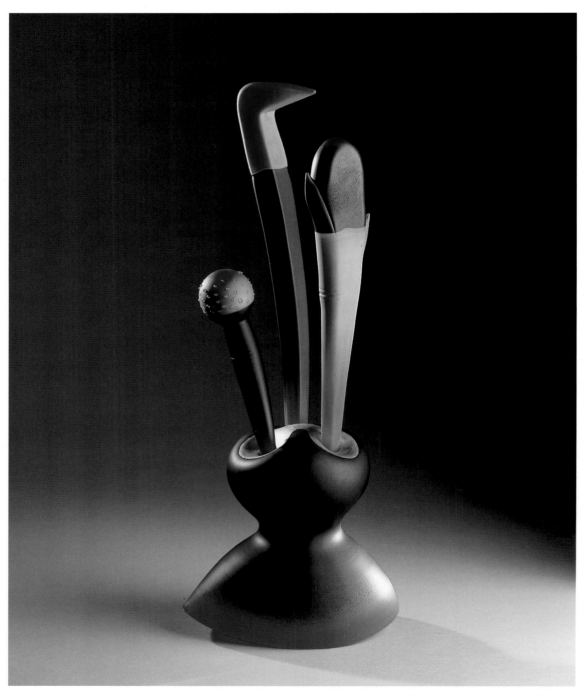

José Chardiet, **The Headdress #2,** *2004*
glass, 33.5 x 10 x 10
photo: Martin Doyle

Leo Kaplan Modern

Established artists in contemporary glass sculpture and studio art furniture
Staff: Scott Jacobson; Terry Davidson; Lynn Leff; Courtney Fox

41 East 57th Street
7th floor
New York, NY 10022
voice 212.872.1616
fax 212.872.1617
lkm@lkmodern.com

Representing:
Garry Knox Bennett
Greg Bloomfield
Yves Boucard
William Carlson
José Chardiet
Scott Chaseling
KéKé Cribbs
Dan Dailey
David Huchthausen
Richard Jolley
Kreg Kallenberger
John Lewis
Thomas Loeser
Linda MacNeil
Paul Seide
Tommy Simpson
Jay Stanger
Michael Taylor
Cappy Thompson
Gianni Toso
Mary Van Cline
Steven Weinberg
Ed Zucca

Jay Stanger, **At the Opening,** *2004*
polane paint aluminum, leather, fiberglass, 72 x 36 x 18
photo: Dean Powell

Joel O'Dorisio, **Wild Cherry Pyramid,** *2004*
cast glass, 16 x 14 x 6
photo: Frank J. Borkowski

Lost Angel Glass

Cultivating an appreciation for the medium of sculptural glass
Staff: Mary Pollack, owner; Meghan D. Bunnell, director; Ashley E. Hupe, assistant

79 West Market Street
Corning, NY 14830
voice 607.937.3578
fax 607.937.3578
meghan@lostangelglass.com
lostangelglass.com

Representing:
Barry Entner
Joel O'Dorisio

Barry Entner, **Amphora Vessels,** *2004*
cast and blown glass, 36 x 10 x 10
photo: Bob Barrett

Dante Marioni, **Colored Vessel Display #8,** *2004*
blown glass, 27 x 19 x 5

Marx-Saunders Gallery LTD

Contemporary glass sculpture created by prominent international artists
Staff: Bonnie Marx; Ken Saunders; Donna Davies; Dan Miller; James Geisen

230 West Superior Street
Chicago, IL 60610
voice 312.573.1400
fax 312.573.0575
marxsaunders@earthlink.net
marxsaunders.com

Representing:
Rick Beck
Lene Bodker
Ken Carder
William Carlson
KéKé Cribbs
Benjamin Edols
Kathy Elliott
Sidney Hutter
Jon Kuhn
Dante Marioni
Joel Philip Myers
Mark Peiser
Stephen Rolfe Powell
Richard Ritter
David Schwarz
Thomas Scoon
Paul Stankard
Janusz Walentynowicz
Hiroshi Yamano

William Carlson, **Pervello** *detail, 2002*
cast glass, oil, 31 x 43 x 8

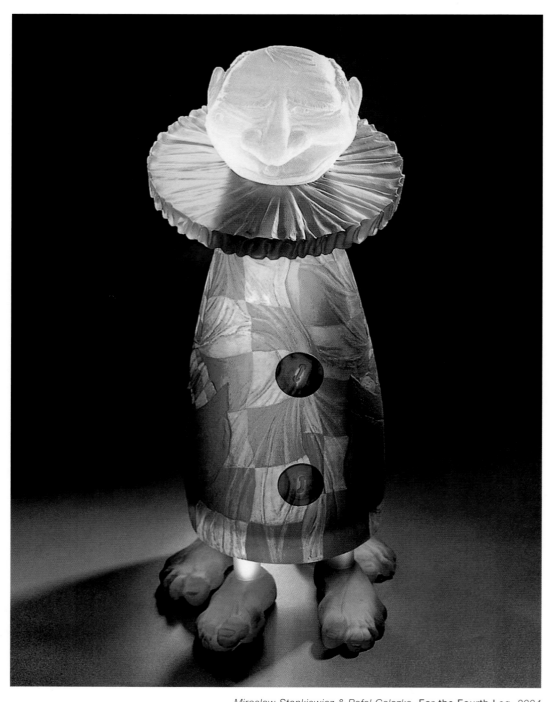

Miroslaw Stankiewicz & Rafal Galazka, **For the Fourth Leg,** *2004*
glass, 15 x 6.5 x 6

Mattson's Fine Art

Contemporary glass creations using old world techniques
Staff: Gregory Mattson, director; Skippy Mattson; Walter Mattson

2579 Cove Circle NE
Atlanta, GA 30319
voice 404.636.0342
fax 404.636.0342
sundew@mindspring.com

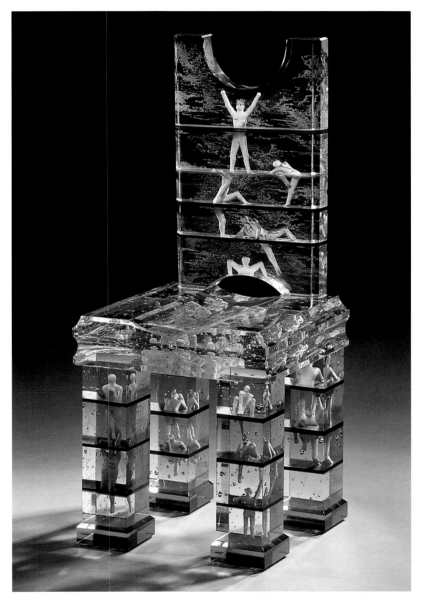

Representing:
Rafal Galazka
Grzegorz Staniszewski
Miroslaw Stankiewicz
Maciej Zaborski

Maciej Zaborski, **Chair**, *2002*
crystal, 14.5 x 6.75 x 6

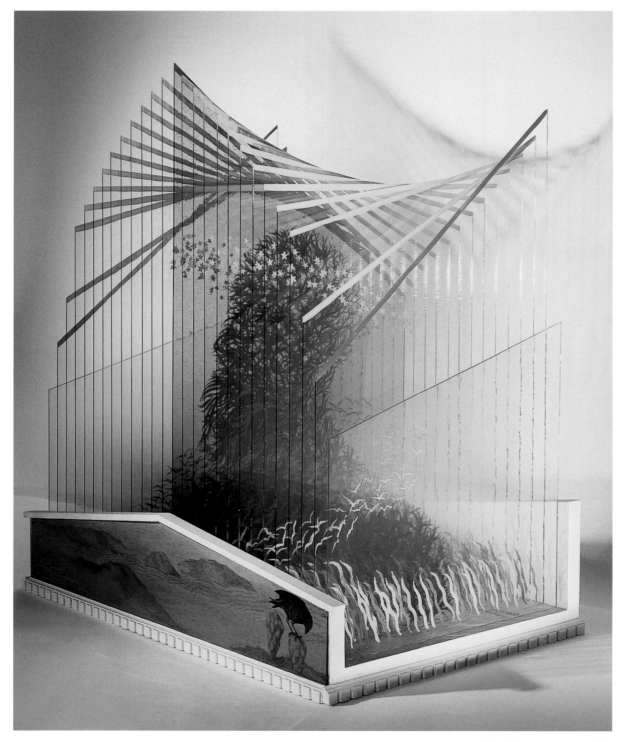

Carol Cohen, **Darwin**, *2004*
glass, mixed media, 31.5 x 29 x 18
photo: Carol Cohen

Maurine Littleton Gallery

Sculptural work of contemporary masters in glass and ceramics
Staff: Maurine Littleton, director; Susan Apollonio; Seth Campbell; Zach Vaughn

1667 Wisconsin Avenue NW
Washington, DC 20007
voice 202.333.9307
fax 202.342.2004
littletongallery@aol.com

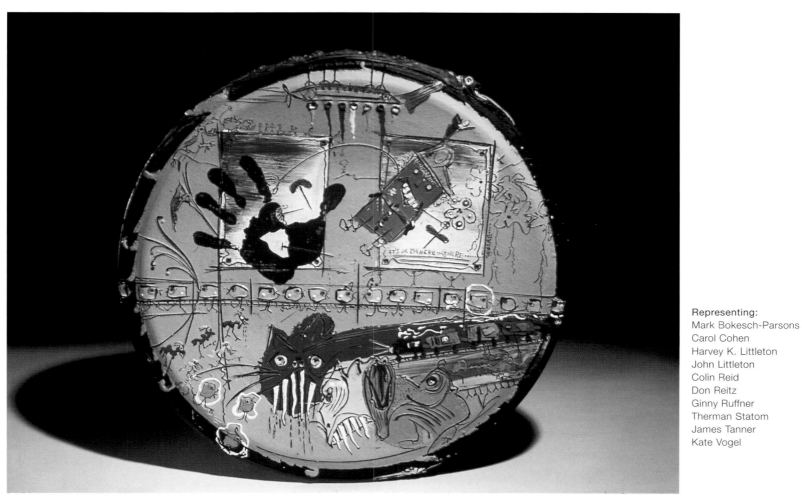

Representing:
Mark Bokesch-Parsons
Carol Cohen
Harvey K. Littleton
John Littleton
Colin Reid
Don Reitz
Ginny Ruffner
Therman Statom
James Tanner
Kate Vogel

Don Reitz, I am Less and Less Embarrassed About More and More, *1984*
wood-fired ceramic, 19.5 x 19.5 x 2.25

Linda Behar, **Fountain** - Priego de Cordoba, Spain, *2004*
cotton embroidery, 4.5 x 6 x 1

Mobilia Gallery

Decorative arts of the 20th and 21st century featuring studio jewelry, textiles, studio furniture and ceramics
Staff: Libby Cooper; JoAnne Cooper; Susan Cooper; Dwaine Best

358 Huron Avenue
Cambridge, MA 02138
voice 617.876.2109
fax 617.876.2110
mobiliaart@aol.com
mobilia-gallery.com

Klaus Bürgel, **Untitled** *brooch, 2004*
hand-fabricated 18k gold, 3.5 x 2 x .5
photo: Galen Palmer

Representing:

Renie Breskin Adams	Donna Marder
Jeanette Ahlgren	Tomomi Maruyama
Linda Behar	Elizabeth McDevitt
Hanne Behrens	John McQueen
Harriete Estel Berman	Kazuko Mitsushima
Flora Book	Joan Parcher
Michael Boyd	Karen Paust
Kathleen Browne	Sarah Perkins
Klaus Bürgel	Gugger Petter
Kathy Buszkiewicz	Giovanna Quadri
Kevin Coates	Robin Quigley
Jim Cole	Anette Rack
Jack Da Silva	Wendy Ramshaw,
Marilyn Da Silva	OBE RDI
Jack Earl	Kim Rawdin
Sandra Enterline	Suzan Rezac
Dorothy Feibleman	Caroline Rügge
Arline Fisch	Marjorie Schick
Gerda Flöckinger, CBE	Joyce Scott
Nora Fok	Richard Shaw
David Freda	Christina Smith
Emi Fujita	Carol Stein
Lydia Gerbig-Fast	Rachelle Thiewes
Nick Hollibaugh	Anna Torma
Mary Lee Hu	Jennifer Trask
Rosita Johanson	Graziano Visintin
Robin J. Kraft	Alexandra Watkins
Okinari Kurokawa	Mizuko Yamada
Birgit Laken	

Leon Bronstein, **We Waste No Time At All,** *2002*
limited edition bronze, 48 x 35 x 61

Modus

Contemporary painting, bronze and glass sculpture with modern enthusiasm
Staff: Karl Yeya, owner; Gabriel Eid; Richard El Mir; Mana Asselli

23 Place des Vosges
Paris 75003
France
voice 33.1.4278.1010
fax 33.1.4278.1400
modus@galerie-modus.com
galerie-modus.com

Representing:
Françoise Abraham
Giampaolo Amoruso
Dominique Dardek
Vincent Magni
Alain Salomon
Jean Pierre Umbdenstock

Loni Kreuder, **Le Pardon***, 2000*
limited edition bronze, 48 x 35 x 61

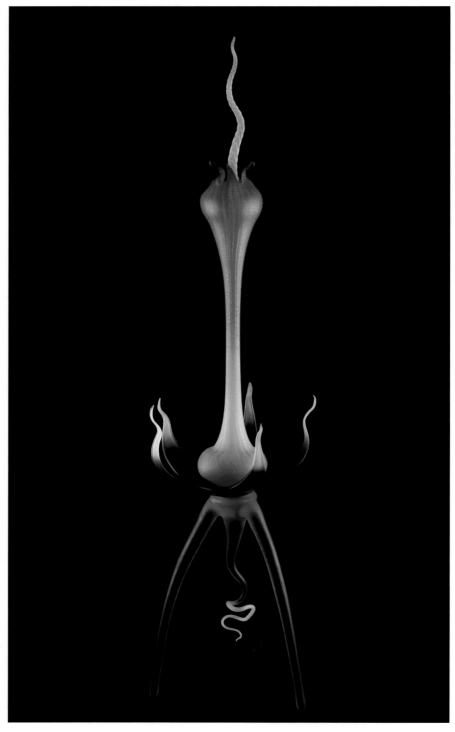

Robert Mickelsen, **Astral Bloom Organism,** *2004*
glass; lampworked, sculpted, sandblasted and oil painted, 36 x 12 x 12
photo: Dan Abbott

Mostly Glass Gallery

Unique art, technically challenging and aesthetically appealing
Staff: Sami Harawi and Charles Reinhardt, owners

3 East Palisade Avenue
Englewood, NJ 07631
voice 201.816.1222
fax 201.816.9582
info@mostlyglass.com
mostlyglass.com

Representing:
Vittorio Costantini
Antonio Dei Rossi
Mario Dei Rossi
Miriam Di Fiore
Iwao Matsushima
Hermann Mejer
Robert Mickelsen
Norberto Moretti
Alison Ruzsa

Alison Ruzsa, I beg your pardon; I never promised you a rose garden, *2004*
alternating layers of glass and painting, 5 x 5.5 x 5.7
photo: Steve Burrell

Alan Peascod, **Dream of Flight II,** *2004*
porcelain, 18h
photo: A. Peascod

Narek Galleries

Leading contemporary Australian artists working in ceramics, wood, glass, textiles and metal
Staff: Karen O'Clery, director

Old Tanja Church
1140 Bermagui Road
Tanja, NSW 2550
Australia
voice 61.2.6494.0112
fax 61.2.6494.0112
info@narekgalleries.com
narekgalleries.com

Representing:
Matthew Harding
Robert Howard
Alan Peascod

Matthew Harding, **Fireseed***, 2003*
New South Wales rosewood, 10 x 16 x 35.5
photo: Big Island Graphics

Bruce A. Niemi, **Celebration,** *2004*
stainless steel, 76 x 40 x 18

226

Niemi Sculpture Gallery & Garden

Contemporary sculpture by more than 30 national artists
Staff: Bruce Niemi, owner; Susan Niemi, director

13300 116th Street
Kenosha, WI 53142
voice 262.857.3456
fax 262.857.4567
gallery@bruceniemi.com
bruceniemi.com

Representing:
Theodore Gall
Bruce A. Niemi
Fritz Olsen

Theodore T. Gall, **Urchin Head,** *2004*
cast bronze, acid patina, 13 x 6 x 6
photo: Wayne Smith

Roseline Delisle, **Triptyque 2.90**, *1990*
porcelain, 10.5 x 5.25

Option Art

Excellence in Canadian contemporary wood, ceramics, jewelry and mixed media sculpture
Staff: Barbara Silverberg, director; Dale Barrett, assistant

4216 de Maisonneuve Blvd. West
Suite 302
Montreal, Quebec H3Z 1K4
Canada
voice 514.932.3987
fax 514.932.6182
info@option-art.ca
option-art.ca

Representing:
Sophie DeFrancesca
Roseline Delisle
Léopold L. Foulem
Janis Kerman
Richard Milette
Gilbert Poissant
David Samplonius
Colin Schleeh
Alex Yeung
Cybèle Young

*Janis Kerman, **Pendant**, 2004*
oxidized sterling silver, 18 and 22k bead, laboradorite and Montana sapphires

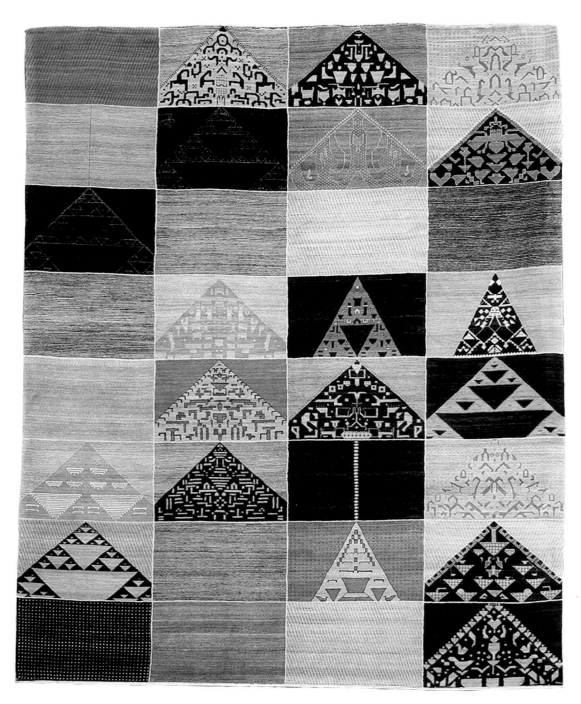

Bahram Shabahang, **Pyramid,** *2004*
wool, 99 x 124

Orley & Shabahang

Artistic antique and contemporary Persian carpets
Staff: Geoffrey A. Orley; Bahram Shabahang; Zsolt Enzsol

223 East Silver Spring Drive
Whitefish Bay, WI 53217
voice 414.332.2486
fax 414.332.9121
percarpets@aol.com

240 South Country Road
Palm Beach, FL 33480
voice 561.655.3371
fax 561.655.0037
shabahangorley@adelphia.net

341 Wing Lake Road
Bloomfield Hills, MI 48301
voice 586.996.5800
fax 248.524.2909
geoffreyorley@aol.com
shabahangcarpets.com

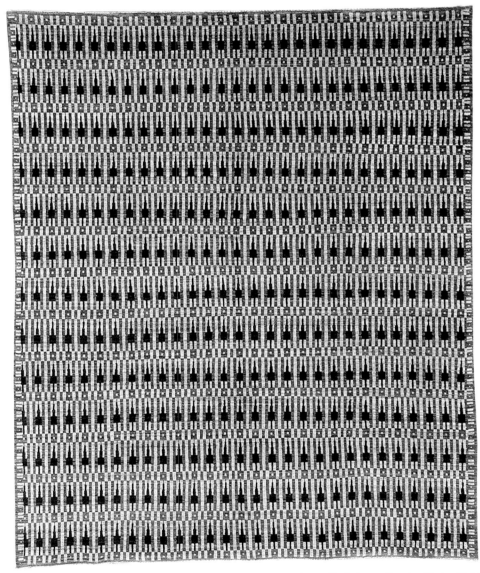

Representing:
Bahram Shabahang

Bahram Shabahang, **Empire State,** *2004*
wool, 100 x 117

231

John McQueen, **Shirt Tales,** *2004*
willow, waxed string, painted wood, 58 x 54 x 16

Perimeter Gallery, Inc.

Contemporary painting, sculpture, works on paper and master crafts
Staff: Frank Paluch, director; Scott Ashley, assistant director; Arielle Sandler, registrar

210 West Superior Street
Chicago, IL 60610
voice 312.266.9473
fax 312.266.7984
perimeterchicago@
 perimetergallery.com
perimetergallery.com

Beverly Mayeri, **Family Support**, *2004*
clay, acrylics, 18 x 8 x 12

Representing:
Lia Cook
Jack Earl
Edward Eberle
Bean Finneran
Kiyomi Iwata
Dona Look
Karen Thuesen
 Massaro
Beverly Mayeri
John McQueen
Jeffrey Mongrain
Toshiko Takaezu
Xavier Toubes

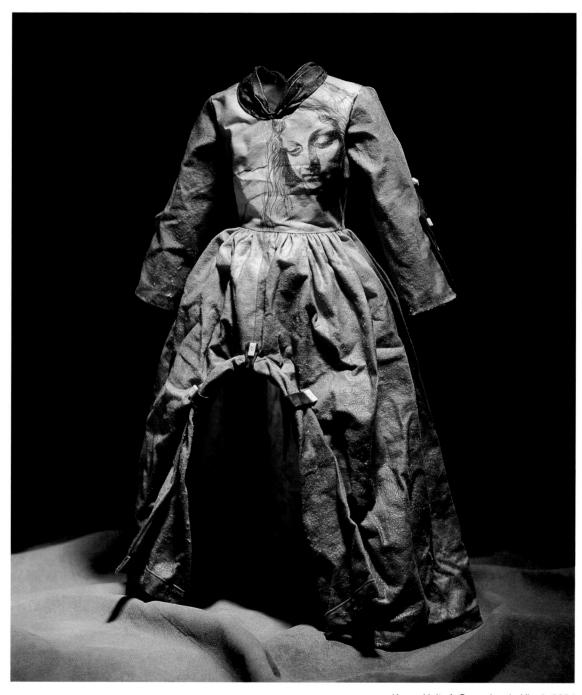

Karen Halt, **A Gown by da Vinci,** *2004*
cotton dipped in beeswax, 21 x 14 x 14
photo: Gary Henderson

Portals Ltd

Two and three-dimensional works in various mediums by contemporary artists
Staff: William and Nancy McIlvaine, owners; Claudia Kleiner, manager; Maria Antonieta Oquendo, gallery assistant

742 North Wells Street
Chicago, IL 60610
voice 312.642.1066
fax 312.642.2991
artisnow@aol.com
portalsgallery.com

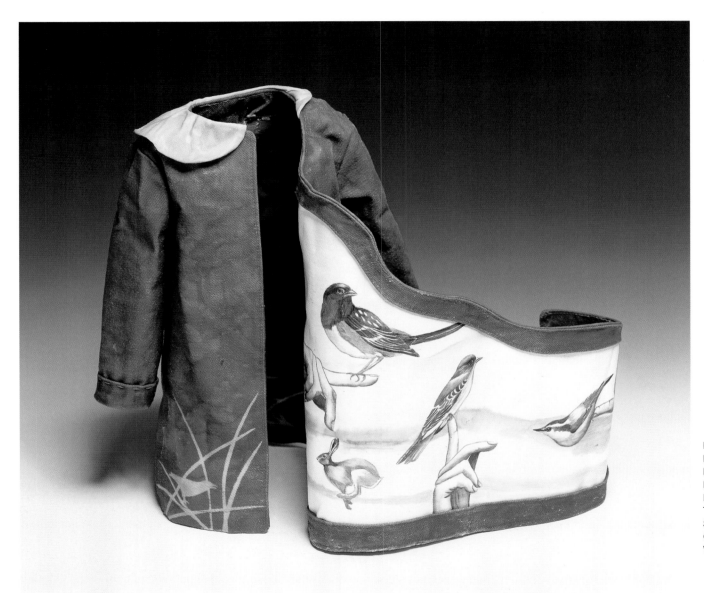

Representing:
Paul Critchley
Karen Halt
Luis Montoya
Leslie Ortiz
Toni Putnam
Sydia Reyes
Constance Roberts
Wendy Ellis Smith

Karen Halt, **The Coat from Albrecht's Camp,** *2004*
hand painted cotton dipped in beeswax and resin, 14 x 16 x 9
photo: Gary Henderson

235

Marvin Lipofsky, **Series Crystalex, Hantich,** *1982-99, Novy Bor, Czechoslavakia*
mold blown glass, cut and acid polished, 11 x 14.5 x 14.5
photo: M. Lee Fatherree

R. Duane Reed Gallery

Contemporary painting, sculpture, ceramics, glass and fiber by internationally recognized artists
Staff: R. Duane Reed; John Elder; Kate Anderson; Merrill Strauss; Glenn Scrivner

529 West 20th Street
New York, NY 10011
voice 212.462.2600
fax 212.462.2510

7513 Forsyth Boulevard
St. Louis, MO 63105
voice 314.862.2333
fax 314.862.8557
reedart@primary.net
rduanereedgallery.com

Representing:
Rudy Autio
Cassandria Blackmore
Christina Bothwell
Jeanne Brennan
Laura Donefer
Mary Giles
Dorothy Hafner
Sabrina Knowles
Marvin Lipofsky
Mari Mezaros
Danny Perkins
Jenny Pohlman
Lindsay Rais
Ross Richmond
Richard Royal
Dalit Tayar
Michal Zehavi

Rudy Autio, **Benedictine***, 2001*
woodfired ceramic, 37 x 31 x 20

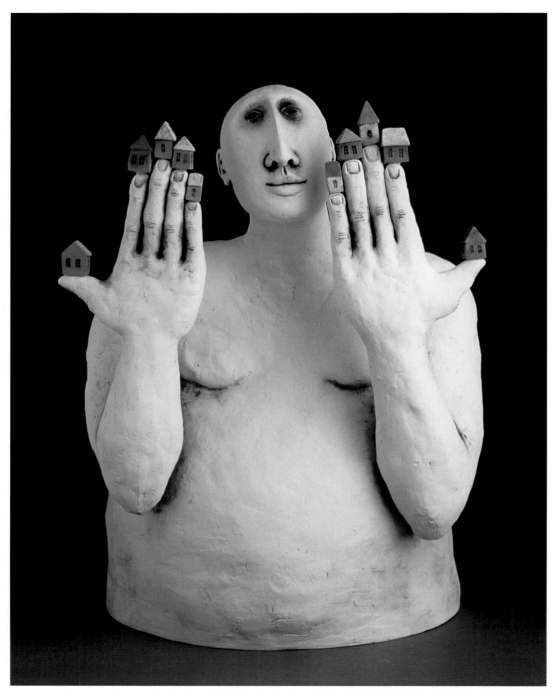

Amanda Shelsher, **A Sense of Place,** *2004*
hand-built stone earthenware, slips, stains, glaze, oxides, 15 x 14 x 8
photo: Bill Shaylor

Raglan Gallery

Contemporary Australian glass, ceramics, sculpture, painting, and Aboriginal art
Staff: Jan Karras, director; Maria Arena

5-7 Raglan Street, Manly
Sydney, NSW 2095
Australia
voice 61.2.9977.0906
fax 61.2.9977.0906
jankarras@hotmail.com
raglangallery.com.au

Representing:
Sandra Black
Pippin Drysdale
Victor Greenaway
Warren Langley
Angela Mellor
Sallie Portnoy
Amanda Shelsher
Mark Thiele
Robert Wynne

Mark Thiele, **Shield***, 2004*
glass, overlaid colors, sandblasted design, acid finish, 24 x 7 x 2
photo: Tom Roschi

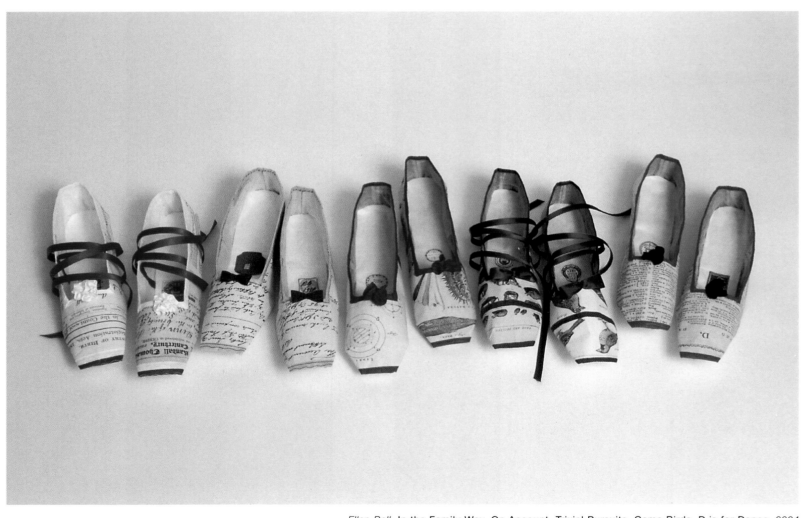

Ellen Bell, **In the Family Way, On Account, Trivial Pursuits, Game Birds, D is for Dance***, 2004*
mixed media, 14 x 10 x 3 each

Rebecca Hossack Gallery

Contemporary Western through to Aboriginal and world art
Staff: Rebecca Hossack, director; Maria Morrow, manager; Emma-Claire Bussell

35 Windmill Street
London W1T 2JS
England
voice 44.20.7436.4899
fax 44.20.7323.3182
rebecca@r-h-g.co.uk
r-h-g.co.uk

Representing:
Ellen Bell
Lucy Casson
Peter Clark
Karen Nicol
Pippa Small
Charles Wells

Peter Clark, **Pug,** *2004*
mixed media, 31.5 x 21.5

Karen Nicol, **Black Tar** *necklace, 2004*
garden twine, chiffon, Jet beads

Pippa Smalls, **Necklace,** *2003*
shell, silk cord

Katherine M. Zadeh, **Bubble Earrings,** *2004*
18k yellow gold, diamonds
photo: James Imbrogno

Sabbia

Elegant and imaginative jewelry; a blend of modern designs with classic motifs
Staff: Deborah Friedmann; Tina Vasiliauskaite

455 Grand Bay Drive
Key Biscayne, FL 33149
voice 305.365.4570
fax 305.365.4572
sabbiafinejewelry@hotmail.com
sabbiafinejewelry.com

Representing:
Ara
Lina Fanourakis
Yossi Harari
Alex Sepkus
Katherine M. Zadeh

Alex Sepkus, **Little Windows** *ring, 2003*
18k gold, diamonds, sapphires
photo: James Imbrogno

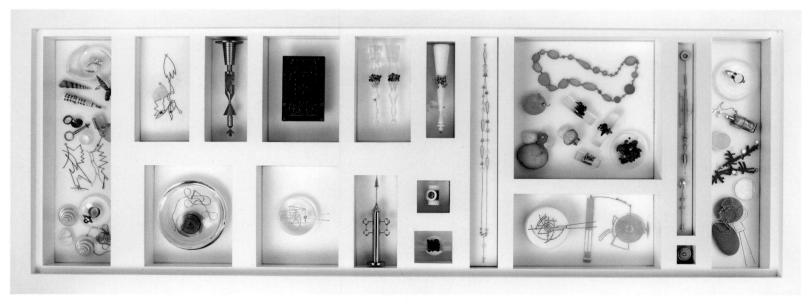

Wendy Ramshaw, OBE RDI, **Prospero's Table**, *2004*
mixed media, 65 x 24.5
photo: Hungry Tiger

The Scottish Gallery

Modern British ceramics, glass and international studio jewelry
Staff: Amanda Game, director; Christina Jansen; Andrew Doherty

16 Dundas Street
Edinburgh EH3 6HZ
Scotland
voice 44.131.558.1200
fax 44.131.558.3900
mail@scottish-gallery.co.uk
scottish-gallery.co.uk

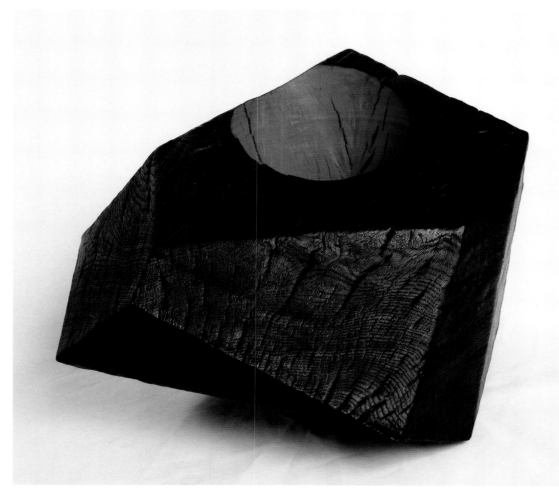

Representing:
Sara Brennan
Linda Green
Jacqueline Mina
Jim Partridge
Frances Priest
Wendy Ramshaw, OBE RDI
Sarah-Jane Selwood
David Watkins

Jim Partridge, **Vessel with Red Interior,** *2003*
oak, 14.5 x 12
photo: Jim Partridge

Sara Brennan, **Black Sand Bands II**
wool, silk, linen tapestry, 17 x 24

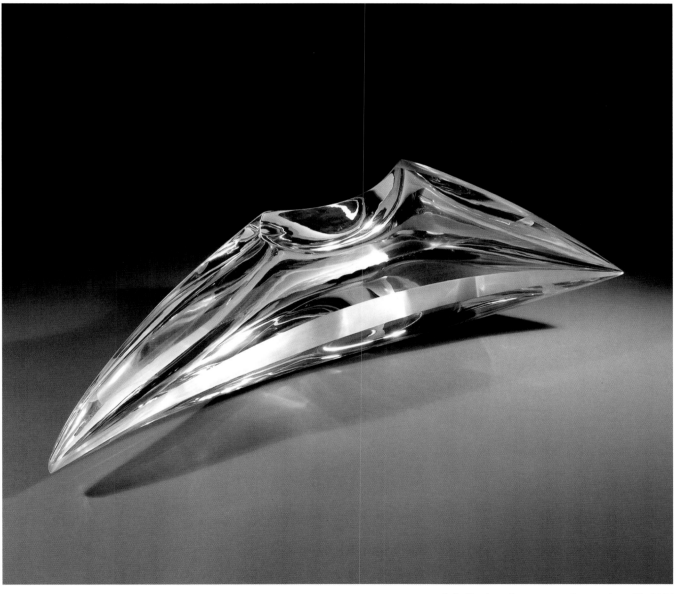

Sally Fawkes, **Anonymous Connections III,** *2004*
cast, mirrored glass

Jun Kaneko, **Untitled,** *2003*
ceramic, 44 x 36 x 30
photo: Dirk Bakker

250

Sherry Leedy Contemporary Art

Ceramic sculpture, glass, painting, photography, mixed media
Staff: Sherry Leedy, director; Jennifer Bowerman, assistant director; Shellie Bender, gallery assistant

2004 Baltimore Avenue
Kansas City, MO 64108
voice 816.221.2626
fax 816.221.8689
sherryleedy@sherryleedy.com
sherryleedy.com

Representing:
John Balistreri
Richard Chung
Yoshiro Ikeda
Jun Kaneko
Judy Onofrio
Doug Owen
Bobby Silverman
Charles Timm-Ballard

Charles Timm-Ballard, **Softening***, 2004*
ceramic, 23 x 22 x 3

Karen Shapiro, Philadelphia Cream Cheese, *2004*
raku fired ceramic, 13 x 10 x 4
photo: Bill Apton

Snyderman-Works Galleries

Finest in contemporary fiber, ceramics, jewelry, metal, wood, studio furniture, glass, painting and sculpture
Staff: Ruth and Rick Snyderman, owners; Bruce Hoffman, director;
Jen McCartney and Frances Hopson, assistant directors; Lynn Schuberth, associate

303 Cherry Street
Philadelphia, PA 19106
voice 215.238.9576
fax 215.238.9351
bruce@snyderman-works.com
snyderman-works.com

Representing:

Wesley Anderegg	Michael James
Kate Anderson	Kay Khan
Adrian Arleo	Stacey Krantz
Karin Birch	Ed Bing Lee
Kate Blacklock	Ke-Sook Lee
Yvonne Pacanovsky	Ayesha Mayadas
Bobrowicz	Milissa Montini
Ruth Borgenicht	Marilyn Pappas
Dorothy Caldwell	Liz Quackenbush
Barbara Cohen	Cynthia Schira
Mardi Jo Cohen	Warren Seelig
Joyce Crain	Karen Shapiro
Nancy Crow	Barbara Lee Smith
Lisa Cylinder	Deborah Speck
Scott Cylinder	Stabley
Marcia Docter	Missy Stevens
Emily DuBois	Anna Torma
John Ford	Pamina Traylor
David Forlano	Carmen Valdes
Karen Gilbert	Deborah Warner
Chris Gustin	Kathy Wegman
Pat Hickman	Tom Wegman
Judith Hoyt	Dave Williamson
Kiyoko Ibe	Roberta Williamson
Ritzi Jacobi	Yoko Yagi
Ferne Jacobs	Noriko Yamaguchi
Judith James	Soonran Youn

Kate Anderson, **Warhol-Haring Teapot/Mickey Mouse,** *2004*
knotted waxed linen, stainless steel, 8.75 x 10.25 x 2
photo: Tony Deck

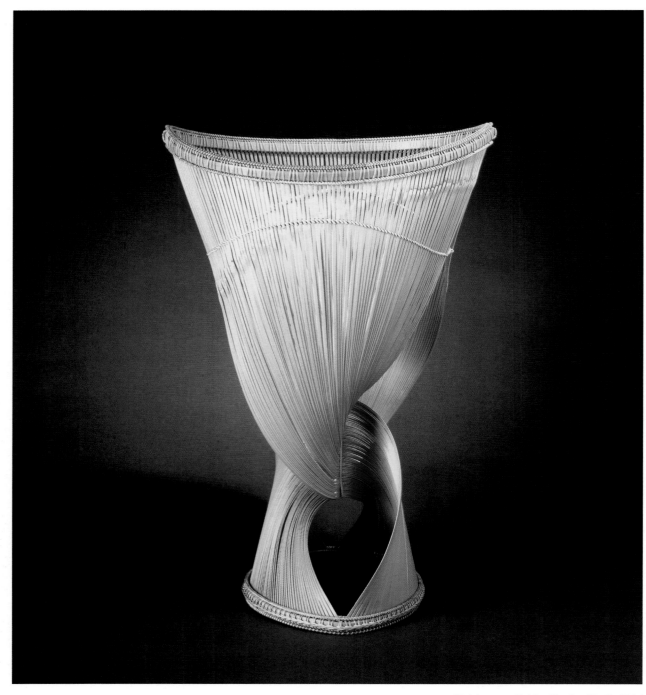

Hatakeyama Seido, **Blazing Up II,** *2004*
bamboo, 17.5 x 11.5 x 8
photo: Carolyn Wright

Tai Gallery/Textile Arts

Japanese bamboo arts and museum quality textiles from Africa, India, Indonesia, and Japan
Staff: Robert T. Coffland; Mary Hunt Kahlenberg

616 1/2 Canyon Road
Santa Fe, NM 87501
voice 505.983.9780
fax 505.989.7770
gallery@textilearts.com
textilearts.com

Representing:
Abe Motoshi
Fujinuma Noboru
Hatakeyama Seido
Honda Syoryu
Honma Hideaki
Katsushiro Soho
Kawano Shoko
Kawashima Shigeo
Monden Yuichi
Morigami Jin
Nagakura Kenichi
Sugita Jozan
Tanaka Kyokusho
Torii Ippo
Yamaguchi Ryuun

Shono Tokuzo, **Large Flower,** *2003*
bamboo, 7.5 x 22.5d
photo: Carolyn Wright

Rebecca Medel, **Orion Reconfigured**, *2004*
indigo dyed and knotted linen over fiber optic thread, 26 x 21 x 2.5
photo: Ken Yanoviak

Thirteen Moons Gallery

Inventive artists who push the boundaries of materials and techniques, fusing art and craft
Staff: Jane Sauer and Janiece Jonsin, co-directors; Jennifer Rohrig, sales; Nancy Hewitt, sales

652 Canyon Road
Santa Fe, NM 87501
voice 505.995.8513
fax 505.995.8507
jjonsin@thirteenmoonsgallery.com
thirteenmoonsgallery.com

Representing:
Adela Akers
Polly Barton
James Bassler
Susan Beiner
Karen Benjamin
Charissa Brock
Carol Eckert
Marko Fields
John Garrett
Jan Hopkins
James Koehler
Rebecca Medel
Jon Eric Riis
Porntip Sangvanich

Jon Eric Riis, **Senses,** *2004*
freshwater pearls, silk, 29 x 66
photo: Bart's Art Photography

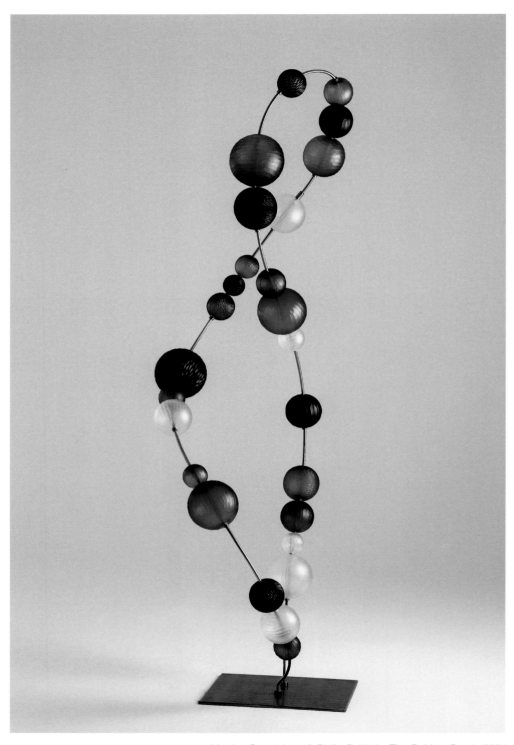

Monica Guggisberg & Philip Baldwin, **The Rubber Band,** *2004*
blown glass, metal, 86 x 28 x 24
photo: Christoph Lehmann

Thomas R. Riley Galleries

Timeless forms backed by education, service and integrity
Staff: Tom Riley; Cindy Riley; Cheri Discenzo

2026 Murray Hill Road
Cleveland, OH 44106
voice 216.421.1445
fax 216.421.1435

642 North High Street
Columbus, OH 43215
voice 614.228.6554
fax 614.228.6550
tom@rileygalleries.com
rileygalleries.com

Representing:
Shelley Muzylowski Allen
Philip Baldwin
David Bennett
Drew Bennett
Don Charles
Deanna Clayton
Keith Clayton
Donald Derry
Matt Eskuche
Kyohei Fujita
Monica Guggisberg
Mark Harris
Steve Jensen
Hitoshi Kakizaki
Nancy Klimley
Lucy Lyon
Mark Matthews
Duncan McClellan
Sharon Meyer
William Morris
Ralph Mossman
Nick Mount
Marc Petrovic
Seth Randal
Mel Rea
David Reekie
Joseph Rossano
Kari Russell-Pool
Stephanie Trenchard
Delross Webber
Karen Willenbrink
John Woodward

John Woodward, **Water Slide,** *2002*
painted ceramic, 29 x 18 x 16

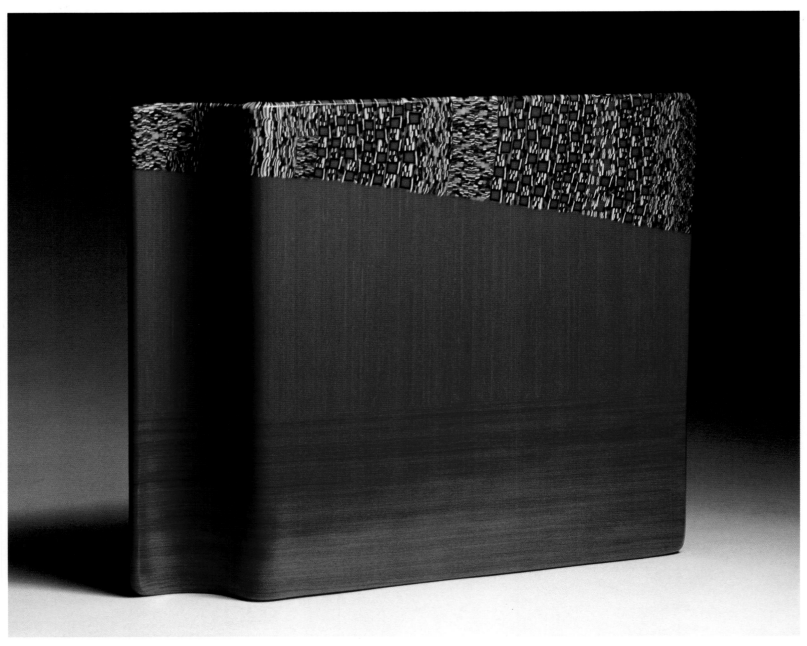

Erica Rosenfeld, LA, CA, 1985
fused glass, 20 x 30 x 16

UrbanGlass

An international center for new art made from glass
Staff: Dawn Bennett, executive director; Leanne Ng, development officer

647 Fulton Street
Brooklyn, NY 11217-1112
voice 718.625.3685
fax 718.625.3889
info@urbanglass.org
urbanglass.org

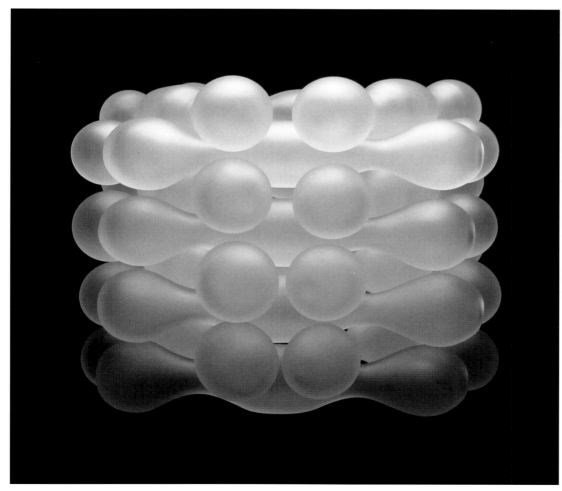

Representing:
William Couig
Laurie Korowitz-Coutu
Robert Panepinto
Erica Rosenfeld
Helene Safire
Noriko Tsuji
Melanie Ungvarsky

William Couig, **Link-On: Hex Miniature,** *2004*
glass, 5 x 5 x 5

Christopher Cantwell, **Hundred Wood Acre,** *2004*
wood inlay on board, 432 x 48

WEISSPOLLACK

Classic contemporary artists working in two- and three-dimensional medium; whose works embody a modernist aesthetic
Staff: Jeffrey Weiss, owner/director; David Pollack, owner/director; Sallie Hackett Brown, manager

2938 Fairfield Avenue
Bridgeport, CT 06605
voice 203.333.7733
fax 203.362.2628
weisspollack@att.net
jeffreyweissgallery.com

Representing:
Leo Amino
Lanette Barber
Christopher Cantwell
Beth Cassidy
Joshua Noah Dopp
Greg Fidler
Carrie Gustafson
Tim Harding
Cliff Lee
Jim Leedy
Hideaki Miyamura
John Urbain

Cliff Lee, **Lotus Vase with a Flower,** *2004*
porcelain, celadon glaze, 15.75 x 7.25

Wounaan People, **Hösig Di Baskets,** *2004*
vegetal fibers, various sizes
photo: Lorran Meares

William Siegal Galleries

Ancient and antique textiles and objects from Pre-Columbian, Aymara, Chinese, Indonesian and African cultures

Staff: Bill Siegal, owner; Norberto Zamudio, director; Laura Gaetjens, assistant

135 West Palace Avenue
Suite 101
Santa Fe, NM 87501
voice 505.820.3300
fax 505.820.7733
williamsiegalgalleries.com

Pre-Inca Culture, **Votive Painted Stones,** *1000 - 4000 AD*
earth pigments on stone, various sizes
photo: Lorran Meares

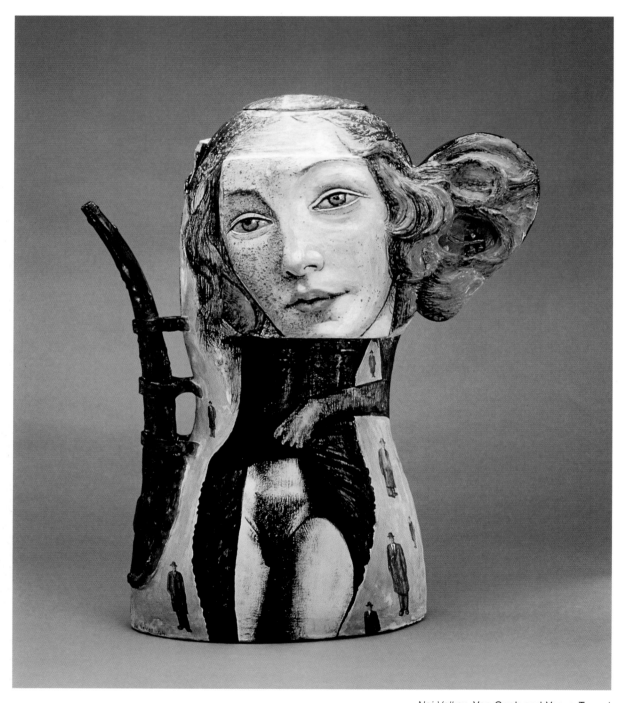

Noi Volkov, Van Gogh and Venus Teapot
ceramic, 18 x 14 x 6

William Zimmer Gallery

Fine and decorative arts
Staff: William and Lynette Zimmer; Jessica Morris; Pamela Wilson; Joan Hayes

10481 Lansing Street
Mendocino, CA 95460
voice 707.937.5121
fax 707.937.2405
wzg@mcn.org
williamzimmergallery.com

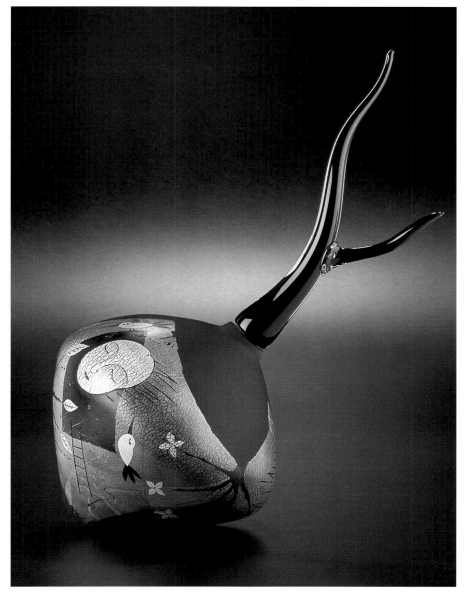

Representing:
Abrasha
Wilhelm Bouchert
Angelika Brennecke
Jeff Brown
R.W. Butts
Graham Carr
Tanija Carr
John Dodd
David Ebner
Peter Hayes
Archie Held
Tai Lake
Sydney Lynch
Guy Michaels
Hiroki Morinoue
Cheryl Rydmark
Jefferson
 Schallenberger
Naoko Takenouchi
Kent Townsend
Noi Volkov

Naoko Takenouchi, **Dream Voyager***, 2004*
glass, silver foil, 17 x 13 x 8

267

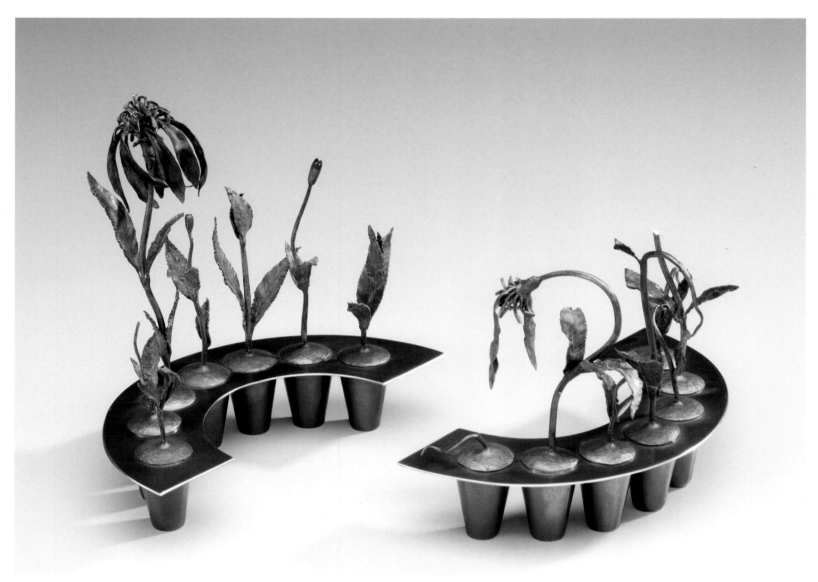

Curtis H. Arima, **Dependency, Day and Night** *pillbox, 2004*
metal, 8.5 x 8.5 x 8.5
photo: R.H. Hensleigh

Yaw Gallery

National and international metalsmiths;
Special focus at SOFA CHICAGO: Pill Box Exhibition
Staff: Nancy L. Yaw, director; Jim Yaw; Edith Robertson

550 North Old Woodward
Birmingham, MI 48009
voice 248.647.5470
fax 248.647.3715
yawgallery@msn.com

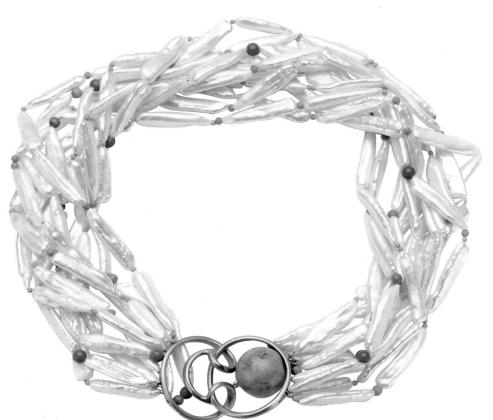

Representing:

Chieko Akagi
Sue Amendolara
Curtis H. Arima
Yvonne Arrit
Amy Bailey
Jennifer D. Banks
Maureen Banner
Michael Banner
Myron Bikakis
Deborah Boskin
Kathleen Bostick
Falk Burger
Harlan Butt
Bridget Catchpole
Christine Clark
Kevin Glen Crane
Jack Da Silva
Marilyn Da Silva
Robert Ebendorf
Susan Ewing
Amy Haskins
Christopher Hentz
Susan Hoge
David Huang
Ion Ionesco
John Iversen
Michael John Jerry
Olle Johanson
Mark Johns

Robin Kraft
Hongsock Lee
Anthony Lent
Deborah Lozier
Thomas Madden
Kelly Malec-Kosak
Mac McCall
Barbara Minor
Paulette Myers
Mary Ann Spavins
 Owen
Miel-Margarita
 Paredes
Sarah Perkins
Edith Robertson
Cornelia Roethel
Claire Sanford
Larry Seiger
Nancy Slagle
Rachelle Thiewes
Pamela Thomford
Linda Threadgill
Julia Turner
Lydia Van Nostrand
Ben Wearley
Susan Elizabeth Wood
Yoshiko Yamamoto
Sayumi Yokoucki

Ion Ionesco, **Straw Pearl Torcade**
jewelry, 16l
photo: R.H. Hensleigh

269

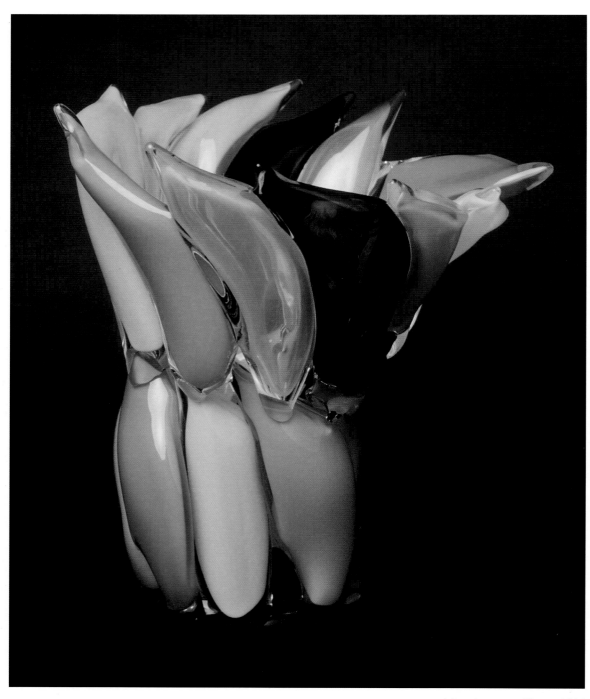

Adam Aaronson, **Flame**, *2004*
blown glass, 13.5 x 10 x 10
photo: Paul Winch-Furness

ZeST Gallery

London's newest destination for contemporary and innovative art glass
Staff: Naomi Hall, gallery manager

Roxby Place
London SW6 1RS
England
voice 44.20.7610.1900
fax 44.20.7610.3355
naomi@zestgallery.com
zestgallery.com

Representing:
Adam Aaronson
Alison Kinnaird, MBE
Barry Martin
Naoko Sato

Naoko Sato, **Transition 52***, 2003*
cast and kiln-formed glass, 12 x 17 x 13
photo: Stephen Brayne

Adam Aaronson, **Waves**, *2003*
blown glass, 6 x 16 x 2.5; 6 x 13 x 2.5
photo: Bernard Dubois

Barry Martin, **Firebird 4-5,** *2004*
glass, bronze, brass, 18 x 14 x 11
photo: Paul Winch-Furness

Res

ources

AMERICAN CRAFT — APRIL/MAY '04

AMERICAN CRAFT — AUG/SEPT 04

the art of craft

AMERICAN CRAFT is published bimonthly by the American Craft Council, the national organization providing leadership in the craft field since 1943. Annual membership in the Council, including a subscription to the magazine, $40, by contacting www.craftcouncil.org or 1-888-313-5527.

AMERICAN

CRAFT

MAR/APR '04

AMERICAN

CRAFT

DEC '03/JAN '04

British Crafts
at SOFA Chicago
5-7 November 2004

www.craftscouncil.org.uk/sofa2004

Awarded for excellence

British Crafts Council
44a Pentonville Road, London N1 9BY, England
T+44 (0)20 7278 7700 F+44 (0)20 7837 6891
busdev@craftscouncil.org.uk
www.craftscouncil.org.uk

SOFA Chicago
5-7 November 2004
Navy Pier
Chicago
www.SOFAEXPO.com

Objects by
1 Robert Marsden
2 Ruth Moillet
3 Julian Stair
4 Shozo Michikawa
5 Daniel Fisher
6 Ellen Bell
7 Walter Keeler
8 Sally Fawkes
9 Barry Martin

1

2

3

1 Barrett Marsden Gallery
17-18 Great Sutton Street, London EC1V 0DN, England
T + 44 (0)20 7336 6396 F +44 (0)20 7336 6391
info@bmgallery.co.uk
www.bmgallery.co.uk

2 Bluecoat Display Centre
Bluecoat Chambers, School Lane, Liverpool L1 3BX, England
T +44 (0)151 709 4014 F +44 (0)151 707 8106
crafts@bluecoatdisplaycentre.com
www.bluecoatdisplaycentre.com

3 British Crafts Council
44a Pentonville Road, London N1 9BY, England
T +44 (0)20 7806 2559 F + 44(0)20 7837 6891
trading@craftscouncil.org.uk
www.craftscouncil.org.uk

4 Galerie Besson
15 Royal Arcade, 28 Old Bond Street, London W1S 4SP, England
T +44 (0)20 7491 1706 F +44 (0)20 7495 3203
enquiries@galeriebesson.co.uk
www.galeriebesson.co.uk

5 Joanna Bird Pottery
19 Grove Park Terrace, London W4 3QE, England
T +44 (0)20 8995 9960 F +44 (0)20 8742 7752
Joanna.bird@ukgateway.net
www.joannabirdpottery.com

6 Rebecca Hossack Gallery
35 Windmill Street, London, W1T 2JS, England
T +44(0)20 7436 4899 F +44(0)20 7323 3182
rebecca@r-h-g.co.uk
www.r-h-g.co.uk

**7 The Gallery,
Ruthin Craft Centre**
Park Road, Ruthin, Denbighshire, LL15 1BB
North Wales
T +44 (0)1824 704774 F +44 (0)1824 702060
thegallery@rccentre.org.uk

8 The Scottish Gallery
16 Dundas Street, Edinburgh EH3 6HZ, Scotland
T +44 (0)131 558 1200 F +44 (0)131 558 3900
mail@scottish-gallery.co.uk
www.scottish-gallery.co.uk

9 Zest Contemporary Glass Gallery
Roxby Place, London SW6 1RS, England
T +44 (0)20 7610 1900 F +44(0)20 7610 3355
naomi@zestgallery.com
www.zestgallery.com

British Crafts Council Charity registration number 280956

7

8

9

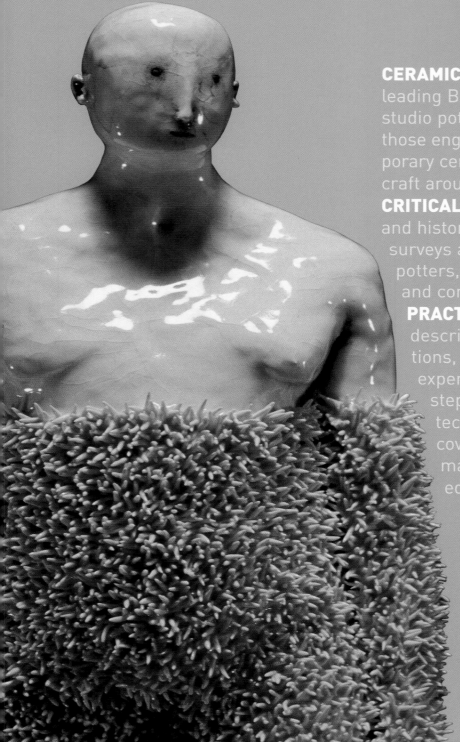

Ceramic Review

THE INTERNATIONAL MAGAZINE OF CERAMIC ART AND CRAFT

CERAMIC REVIEW The leading British magazine of studio pottery, is read by all those engaged with contemporary ceramic art and craft around the world

CRITICAL CR offers current and historical overviews, surveys and reviews from potters, critics, curators and commentators

PRACTICAL Artists describe their inspirations, ambitions and experiences. Step-by-step sequences and technical articles cover methods, materials and equipment

INFORMATIVE Leading figures give insights into the framework of contemporary craft, from directors of national institutions to individual collectors

INCLUSIVE Subscribers play a vital role in CR's debates and surveys through the Letters, Gallery, Reports and Review pages

SOFA SUBSCRIPTIONS
Take out a subscription at SOFA Chicago and receive TWO FREE COPIES
Eight issues for the price of six: $69.
Ceramic Review is a full colour, 76-page bimonthly publication. (Offer applies to subscriptions taken at SOFA CHICAGO 2004, or by faxing our office, quoting 'SOFA', between November 5-7. Fax +44 20 7287 9954)

Clare Curneen – Untitled, H73cm

Technically speaking.

CERAMICS TECHNICAL

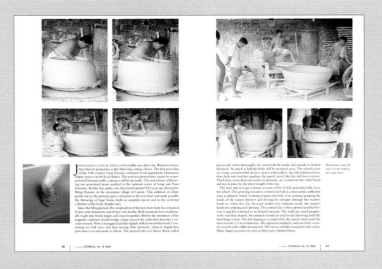

Ceramics TECHNICAL is a biannual magazine devoted to research in the ceramic arts. Articles cover innovative and traditional uses of materials and processes including clay and glazes, kilns and firing, forms, techniques and decorative methods. Photographs, diagrams, glaze receipes, workshops, book reviews and more.

Published May and November.
Cost: $35 (postage included). Credit cards welcome.

Ceramics
MONTHLY

The definitive resource for ceramic arts

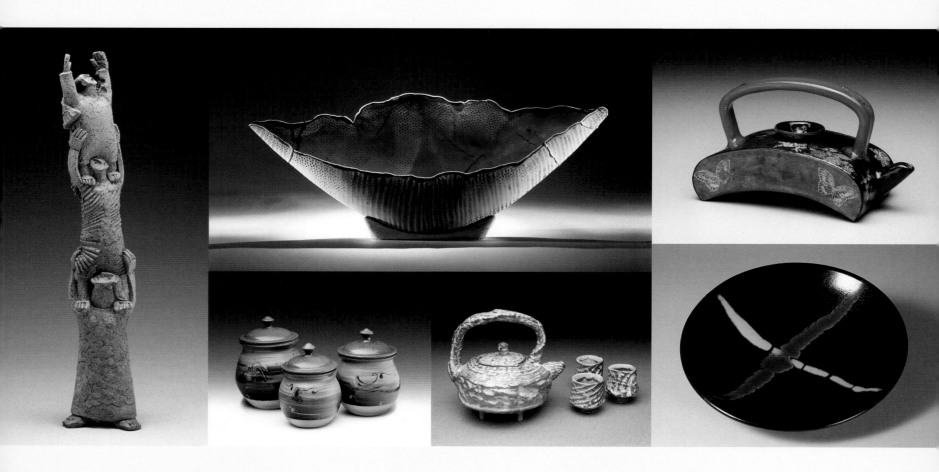

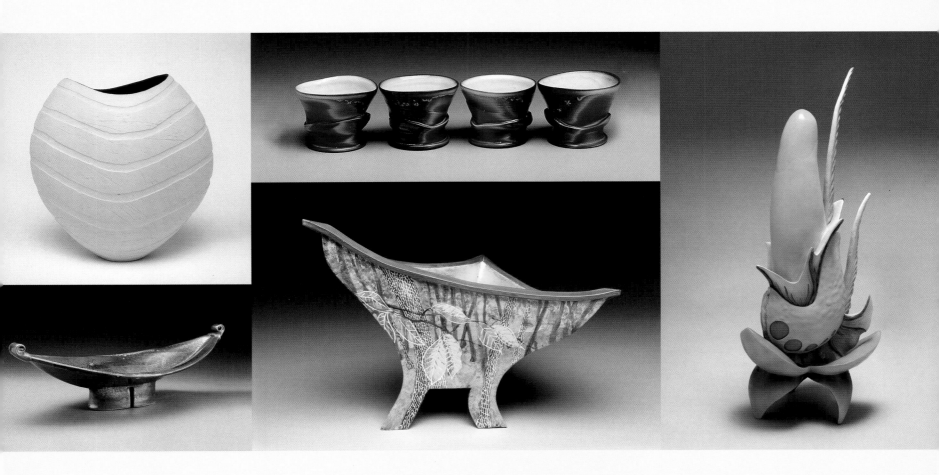

information and inspiration.

Ceramics Monthly, 735 Ceramic Place, Westerville, OH 43081; telephone (614) 794-5890; fax (614) 891-8960; www.ceramicsmonthly.org

Jump Start Your Art Career.

Join The Chicago Artists' Coalition Today.

We've Been Supporting Visual Artists For Nearly 30 Years.

At the Chicago Artists' Coalition (CAC), we're dedicated to creating a positive environment in which artists can live and work. Our primary objectives include providing professional and educational services, as well as advocacy of visual arts issues, for artists and the entire arts community.

CAC publishes the monthly newspaper, *Chicago Artists' News*, which includes features on current events in the regional, national and international art worlds as well as profiles of artists and galleries. The extensive classified section lists exhibition opportunities, jobs, studio space, openings, member announcements and much more, useful to artists all over the country. *Chicago Artists' News* is a great resource for keeping readers in touch with the visual art scene.

Our web site, www.caconline.org, showcases work by member artists, some of which are available for sale. We are also currently expanding the services we offer on the site, so check in periodically to see what's new.

Our annual Chicago Art Open exhibition is the largest survey of Chicago artists under one roof, with over 300 professionals and students. The Art Open runs each October as part of Chicago Artists' Month, sponsored by the Chicago Department of Cultural Affairs. The works of this year's show can be seen on our web site through the end of the year.

CAC provides artists with a number of professional services, including a slide registry; job referral service; access to health insurance; a credit union that provides free checking and low-interest loans; discounts at many leading art supply stores; special programs on professional topics such as taxes, writing grants and marketing your art; monthly artists' salons where artists can network in an informal environment; and more.

For information on how you can become part of this active organization, write, call or print up the membership form from our web site:

Chicago Artists' Coalition
11 E. Hubbard Street, 7th Floor, Chicago, IL 60611
Phone: 312-670-2060 Fax: 312-670-2521
Web: www.caconline.org
E-mail: info@caconline.org

The most comprehensive guide to Chicago's art galleries and services

Chicago Gallery News is an unequalled resource for gallery listings, art-related services, maps, schedules of opening night receptions and city-wide events.

Published three times a year: January, April and September
Subscriptions: $15 per year

chicagogallerynews

730 N. Franklin, Chicago, IL 60610
312.649.0064 phone
312.649.0255 fax
cgnchicago@aol.com email
www.chicagogallerynews.com

www.chicago
gallerynews
.com

chicago**gallery**news

chicagogallerynews

chicagogallerynews

Now Completely Online

rates contemporary Asian art in Chicago

Carrie Secrist Gallery in new West Loop Space

Chicago Gallery News
730 N. Franklin
Chicago, IL 60610
312.649.0064
312.649.0255 fax
info@chicagogallerynews.com

crafts

ART OF IRAQ
The fragile future?

PRODUCTION VALUES
Olivier Geoffroy's
affordable furniture

STRONG STUFF
Deirdre Nelson's
textile art

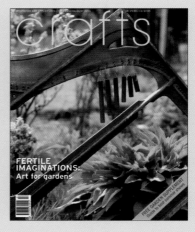

crafts

**FERTILE
IMAGINATIONS:**
Art for gardens

crafts

RICH FITTINGS
Designer works for
Wycombe Square

STAGE STRUCK
The theatrical
ceramics of
Daniel Allen

CORNISH CONNECTIONS
Barbara Hepworth
and the crafts

crafts

SHARP LOOKS
Carl Clerkin and
William Warren –
designs for
the times

CRAFT COUTURE
The fashion for
the hand-made

CHANGING ROOMS?
The future for Red House

crafts

**THE ART OF
COLLECTING**
What contemporary
collectors put
on their shelves

• CHAMPION OF
ARTS MINISTER
Estelle Morris
interviewed

• GOODS REVISITED
Behind the scenes at
Pollock's Toy Museum

crafts

THROUGH THE
Japanese and British
textile artists on tour

Sharon Marston's
sculptural lighting

Marloes ten Bhömer's
shoe designs

crafts

**DEAD
BEAUTIFUL:**
The ceramics of
Bertozzi and Casoni

POLITICS ON
A PLATE:
Stephen Dixon's
new work

SKIN TIGHT:
Leather fashion
by Cordaelia
Craine

crafts

**FORCE OF
NATURE:**
The flowering
of Heather Park

GRAND HOTEL:
Precious McBane's
work for the Zetter

WELL-KEPT SECRET:
Anthony Shaw's
ceramic collection
opens to the public

crafts

VENETIAN VESSELS:
New glass designs
for Salviati

WINNER
TAKES ALL:
The Jerwood
Furniture Prize

PRINTED HISTORY:
The influence of
Phyllis Barron

INSPIRATION

INNOVATION

INFORMATION

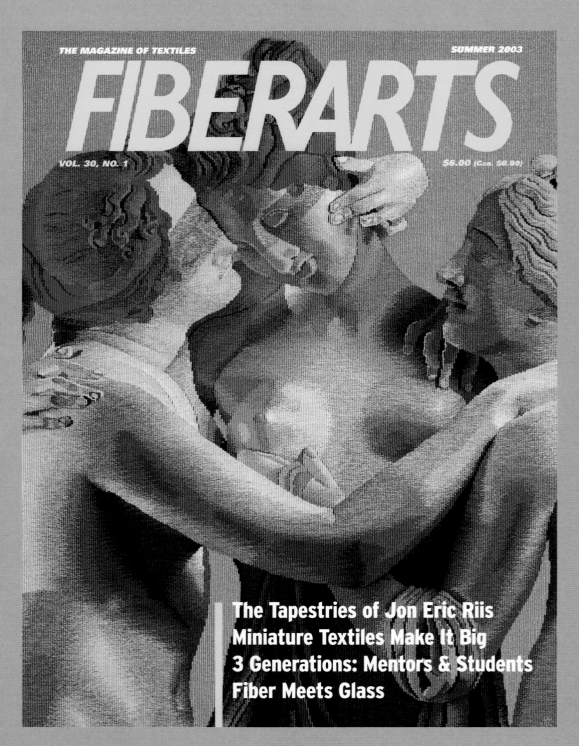

THE MAGAZINE OF TEXTILES

SUMMER 2003

FIBERARTS

VOL. 30, NO. 1

$6.00 (Can. $8.00)

The Tapestries of Jon Eric Riis
Miniature Textiles Make It Big
3 Generations: Mentors & Students
Fiber Meets Glass

URBAN GLASS

UrbanGlass is a not-for-profit international center for the creation and appreciation of new art made from glass. Programs include artist access to furnaces and equipment, classes and workshops, on- and off-site exhibitions, Visiting Artists, GLASS Quarterly, The Bead Project™, UrbanGlass Abroad, The Store at UrbanGlass and The Bead Expo.

647 FULTON STREET
BROOKLYN, NY 11217-1112
TEL: 718.625.3685
FAX: 718.625.3889
EMAIL: INFO@URBANGLASS.ORG
WWW.URBANGLASS.ORG

glass Quarterly brings you the best of the global glass community. Consider us your personal guide to artists, designers, museums, writers, and events that are both continuing traditions and breaking all the rules.

glass Quarterly's stunning four-color photography and award-winning design showcase both well-known artists and debut the newest talent. Leading experts cover important trends in making and collecting art.

glass Quarterly is your invitation to international events, commissions, museum openings, and breaking news from the worlds of art, architecture, and design. Our international correspondents review the latest exhibitions, shows, and books. For nearly 25 years, Glass Quarterly has been the one source for all things glass.

Subscribe Today. 1.800.607.4410

Remarkable Rocks, Kangaroo Island

Bethany Winery, Barossa Valley

Join us in AUSTRALIA in 2005

Membership is open to anyone interested in glass art:

Artists	Galleries	Manufacturers
Educators	Museums	Suppliers
Students	Collectors	Writers

RECEIVE:

GAS NEWS: 6 newsletters each year
Journal documenting the annual conference
Membership and Education Roster
Resource Guide
Link from the GAS web site to member's web site
Newsletter ad discounts
Discount on membership at the Corning Museum of Glass
Access to Member's Only section of GAS web site

TAKE ADVANTAGE OF:

Annual conference, networking opportunities
Database information, mailing lists

GLASS ART

Richard Marquis, 2005 GAS Lifetime Achievement Award winner,
"Monitor," 2004, glass, hot slab construction, 3.5" h x 21" w x 5.25". Photo: R. Marquis

Old Parliament House, Adelaide

Night skyline, Adelaide

35th Annual Conference
GAS@Ausglas: Matters of Substance
Adelaide, Australia May 7-9, 2005

Demonstrations
Lectures
Exhibitions
Technical Display
Panel Discussions
Technical Resource Center
Education Resource Center
Goblet Grab
Auction
Tours
Parties
all in the beautiful location of Australia!

A brochure with conference details
will be mailed in November 2004.

Registration will open December 1, 2004.

S O C I E T Y

Botanic Gardens, Adelaide

Cycling, Botanic Gardens, Adelaide

Diving, North Coast, Kangaroo Island

GLASS ART
SOCIETY

1305 Fourth Avenue, Suite 711
Seattle, Washington 98101 USA

Phone: 206.382.1305
Fax: 206.382.2630
E-mail: info@glassart.org
Web: www.glassart.org

All images of Australia © South Australian Tourism Commission

OVER 3800 MEMBERS
IN 54 COUNTRIES

GENESIS

Gifts and Promised Gifts to the Permanent Collection

Intuit
The Center for Intuitive and Outsider Art

756 N. Milwaukee Avenue
Chicago, IL 60622
312.243.9088
art.org

Featuring works by
William Dawson, David
Philpot, Minnie Evans, Lee
Godie, Howard Finster, Ted
Gordon, Johann Hauser, Dwight
Mackintosh, Justin McCarthy,
Oswald Tschirtner, P.M.
Wentworth, Miles Carpenter,
Willie White, Wesley Willis,
and Joseph Yoakum.

September 10 through December 31, 2004

Gallery hours
Wednesday - Saturday
Noon - 5 pm
Free admission

Eugene Von Bruenchenhein. Untitled painting, signed and dated April 28, 1955. Oil on board. 17.5" x 15"

He moves my hand. Do you think I would ever know how to do a picture like this by myself?

TOOLS OF HER MINISTRY
THE ART OF
SISTER GERTRUDE MORGAN

FEBRUARY 11 - MAY 28, 2005
INTUIT: THE CENTER
FOR INTUITIVE AND OUTSIDER ART

LEAD

HE ART OF SISTER GERTRUDE MORGAN is organized by the American Folk Art Museum, New York. The exhibition has been funded, in part, by grants from N
dation for the Visual Arts, New York State Council on the Arts, The Judith Rothschild Foundation, Robert A. Roth, and Cleo F. Wilson, and the LEF Foundation. T

kerameiki techni

techni

INTERNATIONAL CERAMIC ART REVIEW

Kerameiki Techni

Published in Greece three times a year (April, August, December), in the English language, and is distributed all over the world - subscribers in 85 countries.

Presentations on both worldly acclaimed and lesser known artists
Scoops on up-and-coming new talents
Accounts on international exhibitions, competitions, symposiums and other events
Articles on traditional pottery
Recommendations and reviews on books, videos, catalogues and much more
All accompanied by excellent full colour illustrations

PANORAMA POSTER

Every issue includes an inserted full colour poster (50 x 80 cm), featuring the works of over 70 artists from recent exhibitions held all over the world.

SUBSCRIPTION RATES

INDIVIDUALS:

One year subscription (3 issues)	(Euro) € 39.00 or US $ 45.00 (for USA readers only)
Price per copy (current or back issues)	€ 13.00 or US $ 15.00 (for USA readers only)

Air mail (A' priority) postage included.

INSTITUTIONS:

Universities, Colleges, Schools, Museums, public or private Libraries, Foundations, Art Centers, and other Educational or Cultural Institutions

One year subscription (3 issues)	(Euro) € 60.00 or US $ 69.00 (for USA readers only)
Price per copy (current or back issues)	€ 20.00 or US $ 23.00 (for USA readers only)

WAYS OF PAYMENT

Through our web site www.kerameikitechni.gr (secure site)
Bank check, personal check
Credit Cards: Visa, MasterCard

Kerameiki Techni P.O. Box 76009, Nea Smyrni 17110, Athens - Greece
Tel/fax: ++30 210 932 5551, kerameiki@otenet.gr, www.kerameikitechni.gr

26. Jahrgang · Nr. 1/2004 · Februar/März · € 6,–/sfr 11,– · G 8031 F mit KERAMIKcreativ

KeramikMagazin
CeramicsMagazine

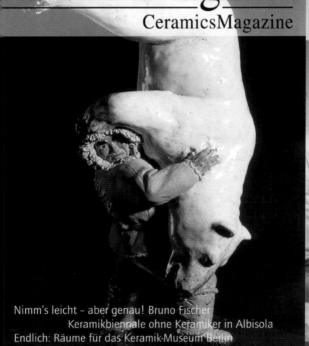

Nimm's leicht – aber genau! Bruno Fischer
Keramikbiennale ohne Keramiker in Albisola
Endlich: Räume für das Keramik-Museum Berlin

26. Jahrgang · Nr. 2/2004 · April/Mai · € 6,–/sfr 11,– · G 8031 F mit KERAMIKcreativ

KeramikMagazin
CeramicsMagazine

Töpferhände: Helga Gambôa. Ein Porträt
Nordische Blüte. Ein Projekt von Nina Maltrud
Interview: Was ist neu in Frankfurt?

26. Jahrgang · Nr. 3/2004 · Juni/Juli · € 6,–/sfr 11,– · G 8031 F mit KERAMIKcreativ

KeramikMagazin
CeramicsMagazine

Nochmal neu! Kannofenbrand in Höhr-Grenzhausen
Immer anders! Im Atelier von Ilse Teipelke
Clay. Eine Ausstellung in der Tate Liverpool

25. Jahrgang · Nr. 4/2003 · August/September · € 6,–/sfr 11,– · G 8031 F mit KERAMIKcreativ

KeramikMagazin
CeramicsMagazine

25. Jahrgang · Nr. 5/2003 · Oktober/November · € 6,–/sfr 11,– · G 8031 F mit KERAMIKcreativ

KeramikMagazin
CeramicsMagazine

25. Jahrgang · Nr. 6/2003 · Dezember/Januar · € 6,–/sfr 11,– · G 8031 F mit KERAMIKcreativ

KeramikMagazin
CeramicsMagazine

KeramikMagazin

CeramicsMagazine

METALSMITH

JEWELRY · DESIGN · METAL ARTS SUMMER 2004

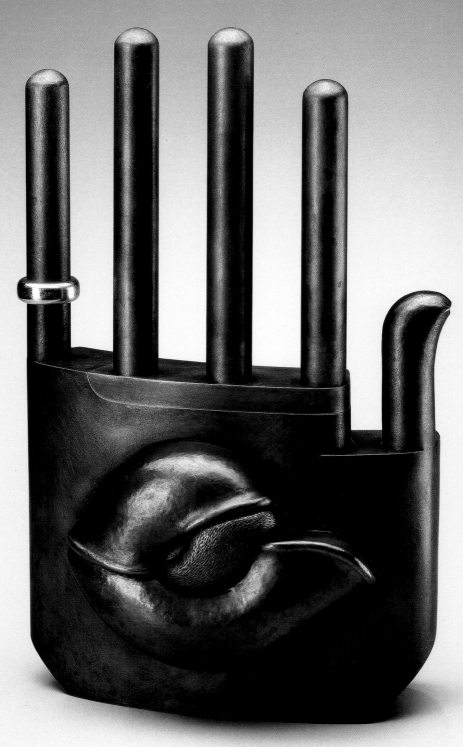

volume 24 number 3
www.snagmetalsmith.org

Taking Hold
The Price of Gold
Forest and the Trees

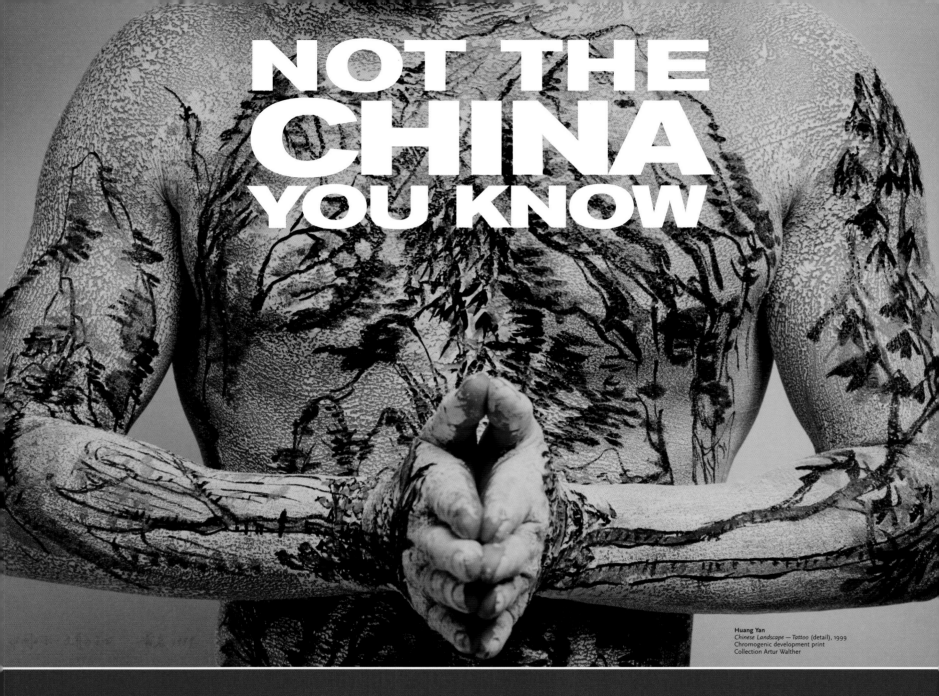

NOT THE CHINA YOU KNOW

Huang Yan
Chinese Landscape — Tattoo (detail), 1999
Chromogenic development print
Collection Artur Walther

NEW PHOTOGRAPHY AND VIDEO FROM CHINA

BETWEEN PAST AND FUTURE ## THROUGH JANUARY 16, 2005

**2 MUSEUMS
1 BIG EXHIBITION**

Smart Museum of Art
University of Chicago
5550 S. Greenwood Ave.
Chicago, IL 60637

Museum of Contemporary Art
220 E. Chicago Ave.
Chicago, IL 60611
www.mcachicago.org

This exhibition is co-organized and circulated by the David and Alfred Smart Museum of Art, University of Chicago, and the International Center of Photography, New York, in collaboration with the Asia Society, New York, and the Museum of Contemporary Art, Chicago.

Between Past and Future: New Photography and Video from China and related programs are generously supported in part by The Smart Family Foundation, National Endowment for the Arts, The Andy Warhol Foundation for the Visual Arts, E. Rhodes and Leona B. Carpenter Foundation, The Henry Luce Foundation, and W.L.S. Spencer Foundation.

Come.
curious.

Just steps from Michigan Avenue and Chicago's historic
Water Tower, the Museum of Contemporary Art presents
today's most innovative and exciting artists.

Ask about • Group rates
• Private tours
• Lunch and catering services
• Versatile special-events spaces

Call 888.MCACHICAGO (622.2442).

M
CA

Museum of
Contemporary
Art

220 E. Chicago Ave.
Chicago, IL 60611
www.mcachicago.org

Photographs by Steve Hall
© Hedrich Blessing

The Best of International Glass Art around the world

NEUES GLAS
NEW GLASS

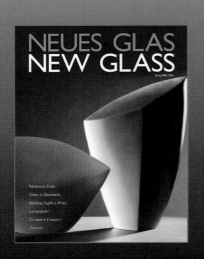

context: An in-depth look at the themes and ideas behind a current exhibition.

collect: The philosophy of collecting, public and private.

ethnic: Ethnographic textiles from across the world.

indulge: Designed to tempt and turn heads, desirable textiles to buy.

destination: Long haul travel, glorious destinations with rich textile traditions.

cohabit: Interiors with stunning textiles captured in beautiful photography.

profile: Artists of international stature and innovative newcomers.

concept: Textiles in contemporary fine art practice.

runway: Critical reporting of fashion trends and current collections.

Definition:

Surface Design encompasses the coloring, patterning, and structuring of fiber and fabric.

This involves the creative exploration of processes such as dyeing, painting, printing, stitching, embellishing, quilting, weaving, knitting, felting, and papermaking.

Mission:

The mission of Surface Design Association is to increase awareness, understanding, and appreciation of textiles in the art and design communities as well as the general public.

We inspire creativity and encourage innovation and further the rich tradition of textile arts through publications, exhibitions, conferences, and educational opportunities.

Member Benefits:

- Four issues of the *Surface Design Journal*
- Four issues of the *SDA Newsletter*
- National and regional conferences
- Networking opportunities
- Inclusion in SDA Slide Library
- SDA Instructors Registry
- Avenues for promotion of your work
- Opportunities for professional development
- Free 30-word non-commercial classified ad in the newsletter
- Exhibition opportunities

Member Services:

- Access to fabric sample library and slide library
- Access to instructor directory
- Resource recommendations

For membership information, visit our web site www.surfacedesign.org

Surface Design Association
PO Box 360
Sebastopol CA 95473
707.829.3110
surfacedesign@mail.com

www.surfacedesign.org

ABBA

SAMET

AIDA

association of israel's decorative arts

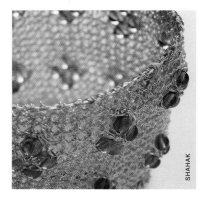

SHAHAK

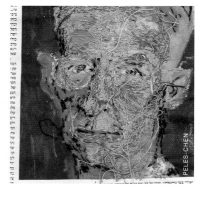

PELES-CHEN

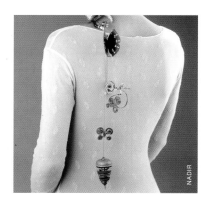

NADIR

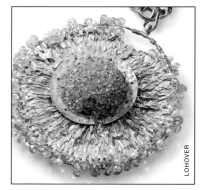

LOHOVER

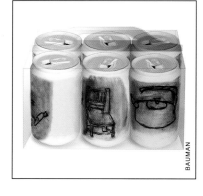

110 East 59ᵀᴴ Street
26ᵀᴴ Floor
New York, New York 10022
212.931.0089 p
info@aidaarts.org
www.aidaarts.org

Contemporary Conceptual Art

AIDA FOUNDERS

Dale and Doug Anderson

Andy and Charles Bronfman

AIDA ADVISORS

Jane Adlin
METROPOLITAN MUSEUM
OF ART

Mark Lyman
SOFA

Anne Meszko
SOFA

Jo Mett
GALLERY CAMINO REAL

Rivka Saker
SOTHEBY'S

Norman Sandler
SANDLER ARCHITECTS

Elisabeth Sandler
SANDLER ARCHITECTS

Aviva Ben Sira
ERETZ ISRAEL MUSEUM

Jeff Solomon
ACBP

Jason Soloway
ACBP

Davira S. Taragin
RACINE ART MUSEUM

PROJECT DIRECTOR

Dara Metz

BAUMAN

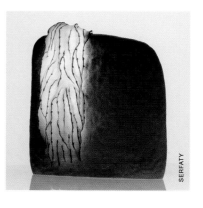

SERFATY

American
Tapestry
Alliance

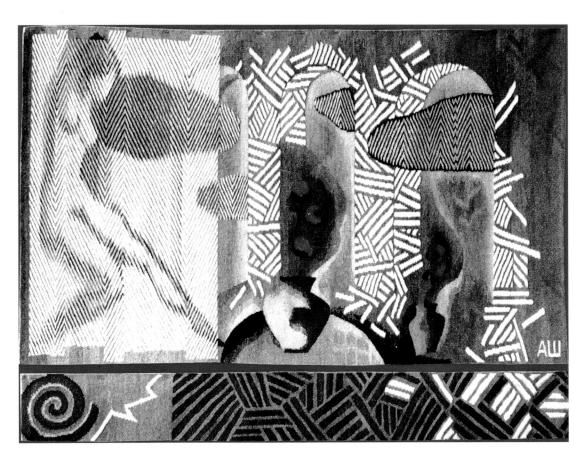

Andrew Schneider, "Interior with Clouds," 48" x 64"

American Tapestry Alliance sponsors the American Tapestry Biennial, an international juried selection of contemporary tapestries. Currently, **American Tapestry Biennial Five** opens September 20th at the Dorr Mill, Guild, NH and runs through January 9, 2005.

A catalog is available. Sponsorship for this exhibition is provided by The National Endowment for the Arts and Friends of Fiber Art International.

For more information on our educational programs see our website.

Visit our website:
www.americantapestryalliance.org

or write: American Tapestry Alliance
PO Box 28600, San Jose, CA 95159-8600

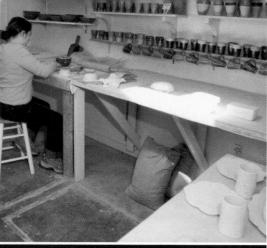

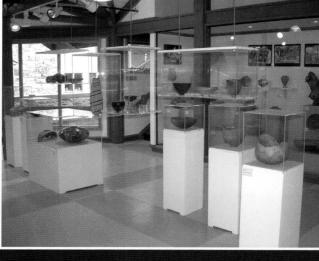

Art Alliance for Contemporary Glass

The Art Alliance for Contemporary Glass
is a not–for–profit organization whose mission is to further the development and appreciation of art made from glass. The Alliance informs collectors, critics and curators by encouraging and supporting museum exhibitions, university glass departments and specialized teaching programs, regional collector groups, visits to private collections, and public seminars.

Support Glass

Membership $65
Your membership entitles you to a subscription to "Glass Focus", the AACG newsletter, and opportunities to attend private events at studios, galleries, collectors homes, Glass Weekend and SOFA. For more information visit our web site at www.ContempGlass.org, email at admin@contempglass.org or call at 847-869-2018.

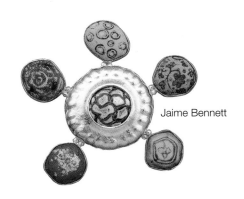
Jaime Bennett

We invite you to join the
ART JEWELRY FORUM and

participate with other collectors who share your enthusiasm for contemporary art jewelry.

OUR MISSION To promote education, appreciation, and support for contemporary art jewelry.

OUR GOALS To sponsor educational programs, panel discussions, and lectures about national and international art jewelry.

To encourage and support exhibitions, publications, and programs which feature art jewelry.

To organize trips with visits to private collections, educational institutions, exhibitions, and artists' studios.

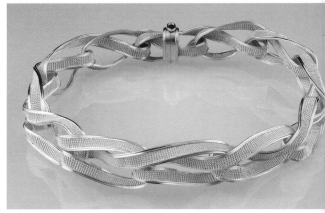
Mary Lee Hu

Join the Art Jewelry Forum today!

E-mail: **info@artjewelryforum.org**

Call: **415.522.2924**

Write us at: Art Jewelry Forum, P.O. Box 590216, San Francisco, CA 94159-0216

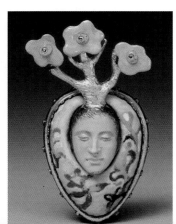
Yeon Mi Kang
AJF's first Emerging Artist Award winner

Chicago Metal Arts Guild (CMAG) offers anyone interested in the metal arts, from students to professionals, the opportunity to become a part of a strong metalsmithing community. This dynamic community enriches the careers of its members, strengthens public perceptions about the field, and advances the place of metal artists in the Chicago art community. It is a forum for sharing business practices and tips, getting artistic feedback from peers, learning new skills in sponsored workshops, gaining exposure to new work and ideas through visiting artists' lectures, providing exhibition opportunities, and promoting our field through educational outreach programs. The Chicago Metal Arts Guild has been recognized as a significant and reliable organization; we've been chosen to host the SNAG (Society of North American Goldsmiths) conference in 2006.

A non-profit organization, we have an eleven member volunteer board of directors. We host our events primarily in the Chicago area, but welcome members from all parts of the Midwest. In our first year we've attracted over one hundred members! Join us in creating a vibrant and active organization that will promote and enhance the Chicago area metals community!

CMAG OFFERS:
- workshops
- lectures
- panel discussions
- quarterly newsletter
- community outreach
- local exhibitions
- membership directory
- website
- studio visits
- social activities

For more information write to:

Chicago Metal Arts Guild
P.O.Box 1382
Oak Park, IL 60304-0382
phone: 708-358-0019

The international art fair for contemporary objects
Presented by the British Crafts Council

12 – 17 JANUARY 2005
At the V&A, London
www.craftscouncil.org.uk/collect

Venue
Temporary Exhibition Galleries
Victoria and Albert Museum,
South Kensington, London, UK

Organizers
British Crafts Council
44a Pentonville Road,
London N1 9BY, UK

For visitor information
+44 (0)20 7806 2512
collect@craftscouncil.org.uk
www.craftscouncil.org.uk/collect

Ceramics by Kate Malone represented
at COLLECT by Clare Beck at Adrian Sassoon, London

Design by Frost Design London

Registered Charity Number 280956

Galleries include:
'Australian Contemporary' by
JamFactory Contemporary Craft,
Adelaide; Bishopsland Educational
Trust, Reading; Blås & Knåda,
Stockholm; Bluecoat Display Centre,
Liverpool; Clare Beck at Adrian
Sassoon, London; Collectief
Amsterdam; Contemporary Ceramics,
London; Contemporary Applied Arts,
London; COSA, London; Crafts Council
Gallery, London; Dovecot Studios,
Edinburgh; Galerie Carla Koch,
Amsterdam; Galerie Im Kelterhaus,
Hochheim Germany; Galerie Louise
Smit, Amsterdam; Galerie Marianne
Heller, Heidelberg; Galerie Ra,
Amsterdam; Galerie

S O, Switzerland; Galerie Tactile,
Geneva; Galerie von Bartha, Basel;
Galleri Nørby, Copenhagen; Gallery
Elmar Weinmayr, Kyoto; Gallery Terra
Keramiek, Delft; Glasgalleriet
Klintegaarden, Arhus; Glass Artists'
Gallery, Sydney; Hannah Peschar
Sculpture Garden, Ockley; Hart
Gallery, London; Katie Jones, London;
Lesley Craze Gallery, London; Galerie
Marzee, Nijmegen The Netherlands;
Plateaux Gallery, London; Puls
Contemporary Ceramics, Brussels;
Raglan Gallery, Sydney; Sarah
Myerscough Fine Art, London; The
Gallery, Ruthin Craft Centre, Wales;
The Scottish Gallery, Edinburgh;
Vessel Gallery, London.

Albert LeCoff, Executive Director, Wood Turning Center, Philiadelphia, PA

Collectors of Wood Art

Salutes Albert LeCoff
2003 Recipient
Lifetime Achievement Award

Collectors of Wood Art, a nonprofit organization, is dedicated to promoting the field of wood art in the areas of turned objects, sculpture, and furniture.

NEXT CWA FORUM
Philadelphia, PA
September 21 - 25, 2005

Find out about CWA — and join! Register at our website: **www.CollectorsOfWoodArt.org**
phone: **888.393.8332**
email: **CWA@NYCAP.RR.COM**
or mail inquiries to: Collectors of Wood Art
P.O. Box 402
Saratoga Springs, NY 12866

Originally a woodworker and wood turner, Albert LeCoff evolved into one of the most active promoters of lathe turned art over the past 25 years. Starting in the 1970s, LeCoff with others organized symposia, exhibitions, and publications that drew wood turners together to learn from each other. He organized the "Gallery of Turned Objects: The First North American Turned Object Show" (1981), one of the first contemporary exhibitions that focused on fine wood turning.

In 1986, he co-founded the Wood Turning Center, an international not-for-profit in Philadelphia, PA. LeCoff created the "Challenge" exhibitions in 1987 to inspire artists to make new innovative work regardless of the market place, and coordinated the "International Lathe Turned Objects (ITOS)" in 1988, which introduced museum audiences to this art form.

Contemporary
Art Workshop

painting

printmaking

photography

drawing

sculpture

installation

gallery

studios

workshop

tours

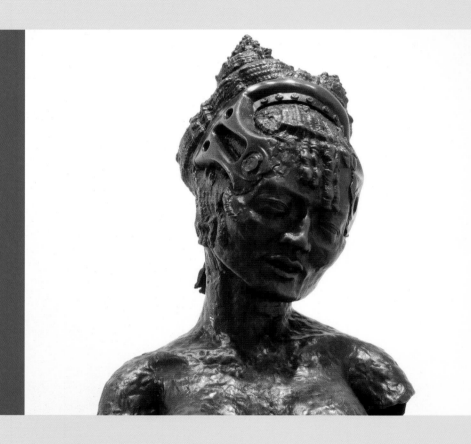

Marshall Svendsen,
Queen (detail), 2003,
bronze, 40" x 16" x 14"

CONTEMPORARY ART WORKSHOP is one of the oldest alternative artists' spaces in the country. Founded in 1949 by a small group of artists including sculptor John Kearney, Leon Golub, and Cosmo Campoli, the workshop has maintained a commitment and dedication to the work of emerging and under-represented artists of Chicago and the Midwest. In addition to monthly gallery exhibitions and open sculpture workshop,

the Contemporary Art Workshop houses John Kearney's studio and over twenty-one active studio spaces.

The current gallery exhibition features paintings by JiYoun Lee and Jonathan Stein, and runs through December 7, 2004.

Contemporary Art Workshop

542 West Grant Place, Chicago, IL 60614

phone: 773.472.4004

email: info@contemporaryartworkshop.org

web: www.contemporaryartworkshop.org

A non-profit, tax exempt corporation dedicated to the arts

Corning Museum of Glass

One Museum Way • Corning, New York 14830 • www.cmog.org

Summer 2005

Design in an Age of Adversity
Czech Glass, 1945-1980

www.furnituresociety.org

Advancing the art of furniture making by inspiring creativity, promoting excellence, and fostering understanding of this art and its place in society.

MEMBERSHIP | EXHIBITIONS | PUBLICATIONS | CONFERENCES

The Furniture Society
111 Grovewood Rd., Asheville, NC 28804

ph: 828 255 1949 | fax: 828 255 1950
mail@furnituresociety.org

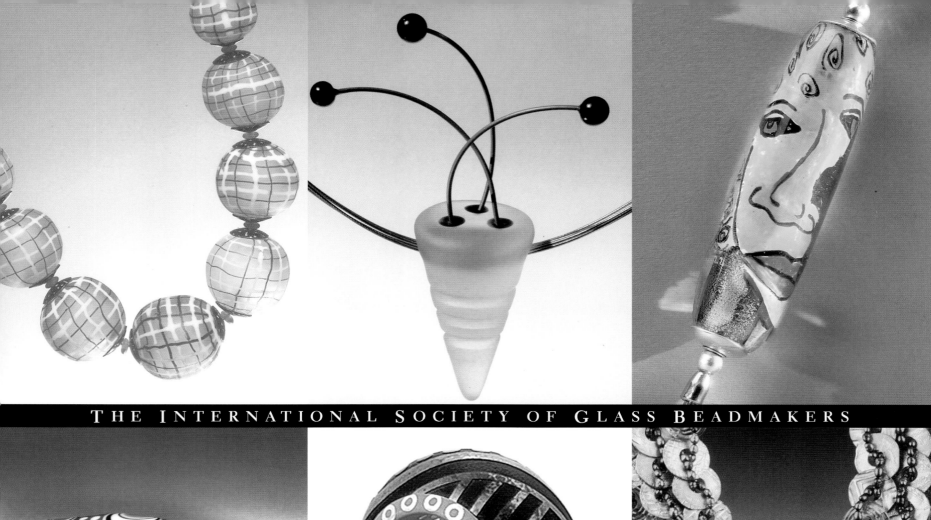

THE INTERNATIONAL SOCIETY OF GLASS BEADMAKERS

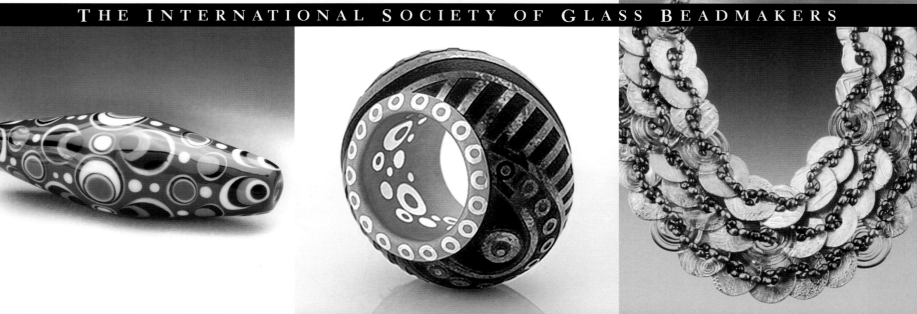

EDUCATING, PROMOTING, AND PRESERVING FOR THE NEXT 4,000 YEARS

For close to 4,000 years, glass beads have been used for adornment, trade, currency, and religious ritual in cultures all over the world. The International Society of Glass Beadmakers provides the resources to fuel the continuing renaissance of glassbeadmaking.

International Society of Glass Beadmakers • 1120 Chester Ave. #470 • Cleveland, OH 44114 USA • 888 742-0242 • www.isgb.org

International
Society of
Glass
Beadmakers

CELEBRATE AMERICAN CRAFT ART AND ARTISTS
JOIN THE JAMES RENWICK ALLIANCE.

LEARN
about contemporary crafts at our seminars,

SHARE
in the creative vision of craft artists at workshops,

REACH OUT
by supporting our programs for school children,

INCREASE
your skills as a connoisseur,

ENJOY
the comaraderie of fellow craft enthusiasts,

PARTICIPATE
in Craft Weekend including symposium and auction, and

TRAVEL
with fellow members on our craft study tours.

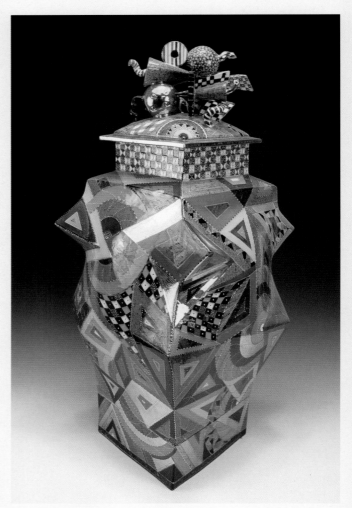

Ralph Bacerra Untitled lidded vessel, 2002 Earthenware

As a member you will help build our nation's premiere collection of contemporary American craft art at the Renwick Gallery.

The James Renwick Alliance, founded in 1982, is the exclusive support group of the Renwick Gallery of the Smithsonian American Art Museum.

For more information: Call 301-907-3888. Or visit our website: www.jra.org

AMY LEMAIRE

MICHAEL WISNER

MICHAEL CORNEY

JOHANNA FISHER

Exhibiting the best in contemporary clay, fiber and metals, since 1975.

October 30-November 25, 2004

Michael Corney and Michael Wisner

Johanna Fisher and Amy Lemaire

Watershed Residents Program

CLASSES ★ GALLERY ★ STUDIOS

PROGRAMS FOR CHILDREN AND ADULTS IN:

Ceramic Arts

Jewelry and Metalsmithing

Fiber Arts

Painting and Drawing

LILLSTREET
ART CENTER

EST. 1975
CHICAGO

Your Art Community.
4401 N. Ravenswood TEL 773 769 4226 www.lillstreet.com

Founders' Circle

The National Support Affiliate for the *Mint Museum of Craft + Design* in Charlotte, North Carolina

TINA RATH
Purple Fox Hanging Wrap Necklace

CHRISTOPHER DRESSER
Tri-legged Sugar Bowl

LINO TAGLIAPIETRA
Coinbra

SAVE THE DATE!
**Mint Condition Gala
Venetian Masquerade**
April 8, 2005

EXHIBITIONS

**The Nature of Craft
and the Penland Experience**
through January 30, 2005

**Speaking Volumes: Vessels from
The Mint Museums Collections**
through April 17, 2005

**Murano: Glass from the Olnick
Spanu Collection**
April 2 through August 21, 2005

ARTS &
SCIENCE
COUNCIL
Advancing Arts, Science & History

M̶I The Mint Museums
Founders' Circle
Mint Museum of Craft + Design

220 N. Tryon Street
Charlotte, NC 28202
704.337.2008

www.**founderscircle**.org

Celebrating Masterworks
in Jewelry, Fiber, Ceramics and Sculpture

Museum of Arts & Design

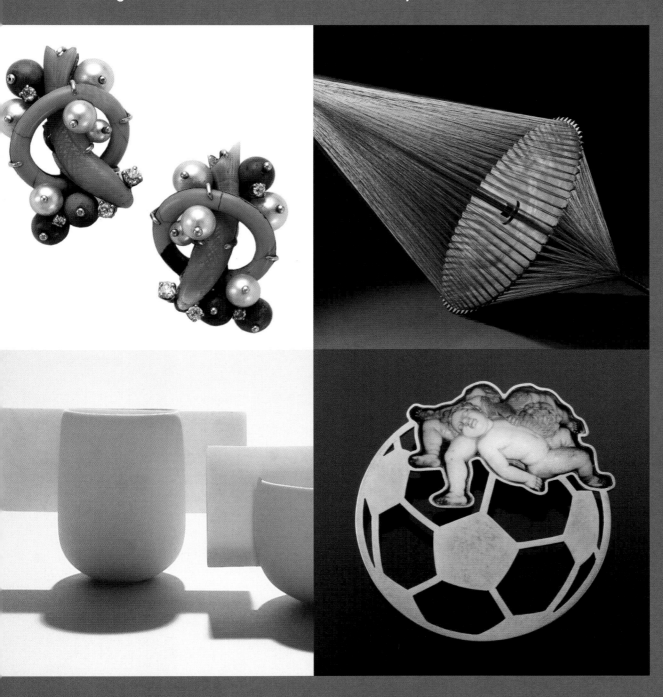

September 8, 2004 – January 2, 2005

Seaman Schepps: A Century of
New York Jewelry Design 1904-2004

FiberArt International 2004
Cutting-edge works by 48 international artists

Treasures from the Vault:
Jewelry from the Permanent Collection

Defining Craft of Our Time

Museum of Arts & Design
40 West 53rd Street
New York, NY 10019
212.956.3535

www.madmuseum.org

January 13 – April 3, 2005

Ruth Duckworth, Modernist Sculptor
First U.S. retrospective of one of world's
most influential living ceramic sculptors

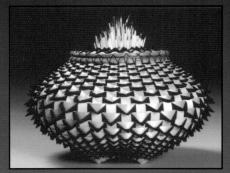
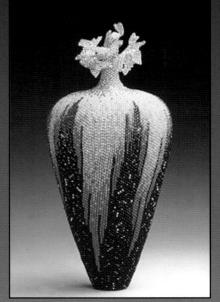
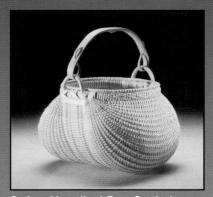
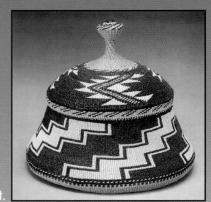

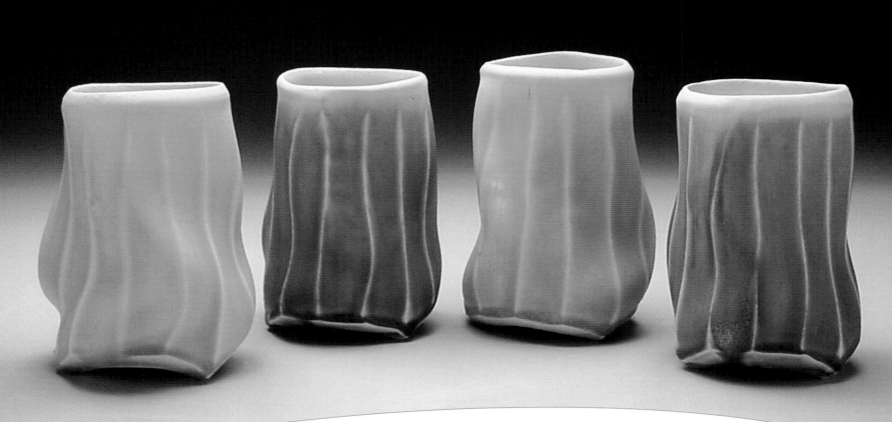

National Council on Education for the Ceramic Arts

Aysha Pelta • Cups, 2003 • Porcelain • Photo: Todd Wahlstrom

Promoting and improving ceramic arts
through education, research and creative practice

▶ **39th Annual Conference**
Centering: Community, Clay and Culture
March 16 – 19, 2005
Baltimore, Maryland

▶ **Benefit Auction**
Fête 05 - Focus on Clay
Saturday, March 19
The Visionary Museum's Whiskey Warehouse

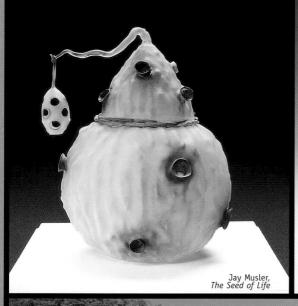

Jay Musler,
The Seed of Life

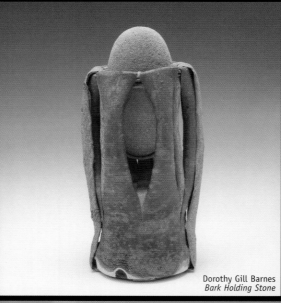

Dorothy Gill Barnes
Bark Holding Stone

Penland
School
of Crafts

A National Center for Craft Education

**Workshops • Gallery
Artist Residencies
Annual Benefit Auction: August 12–13, 2005**

**P.O. Box 37, Penland, NC 28765
828.765.2359
www.penland.org**

Bob Trotman
Big Hedy

Douglas Harling
Golden Peach

Peter Schjeldahl, Juror

NAVY PIER WALK 2004

"Two-Headed Trojan Ducky" Rob Neilson

May 6 – November 8

Navy Pier®
600 East Grand Avenue
Chicago, IL 60611
(312) 595-5019
www.pierwalk.com

Navy Pier Walk 2004 Artists

Actual Size Artworks – Wisconsin
Austin I. Collins – Indiana
Tony Cragg – England
Richard Deacon – England
Ed Francis – Indiana
Erik Geschke – Minnesota
Cristina Iglesias – Spain
Robin Kraft – Indiana
Zoran Mojsilov – Minnesota
Dylan Mortimer – Missouri
Rob Neilson – Wisconsin
Michael O'Brien – Illinois
Andrew Rogers – Australia
Scott Wallace – Minnesota

Transform people, places, and ideas by supporting art education at Pilchuck Glass School

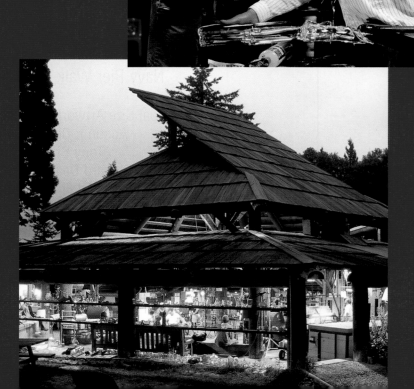

PILCHUCK
G L A S S
S C H O O L

430 Yale Avenue North
Seattle, WA 98109
Phone: 206.621.8422
Fax: 206.621.0713

www.pilchuck.com

R|A|M

A home for Contemporary Crafts on Main Street, USA

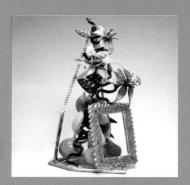

See

The Artist Responds: Albert Paley and Art Nouveau
September 19, 2004 – March 6, 2005
November 6 at 11 am and 2 pm – Meet the Artist

Fashioning Art: Handbags by Judith Leiber
March 29, 2005 – August 14, 2005
Organized by the Corcoran Gallery of Art, Washington, D.C.

Toshiko Takaezu
Coming in Fall 2005

Racine Art Museum
441 Main Street
Racine, Wisconsin
262.638.8300

www.ramart.org

Works in RAM's Collection by

Architects Brininstool+Lynch Ginny Ruffner
Leon Niehues Mark Lindquist
Earl Pardon Jack Earl

Works in wood, fiber, clay, glass, steel, bronze and irony.

SAN FRANCISCO MUSEUM OF CRAFT+DESIGN

550 Sutter Street San Francisco
415.773.0303 www.sfmcd.org

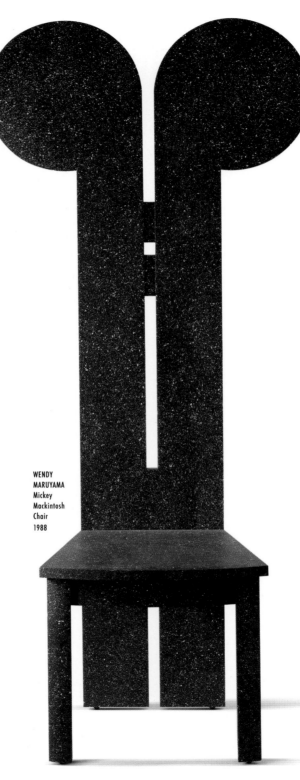

WENDY
MARUYAMA
Mickey
Mackintosh
Chair
1988

Sometimes a chair is just a chair. Sometimes it's a wickedly funny, exquisitely crafted homage to modern design and popular culture. Discover the difference at the new San Francisco Museum of Craft+Design.

The Museum opens October 23. Admission is free.

INAUGURAL
EXHIBITION
DOVETAILING
ART AND LIFE
The Bennett
Collection
Oct. 23 thru
Jan. 31, 2005

www.abatezanetti.it

scuola del vetro abate zanetti

original glass school.

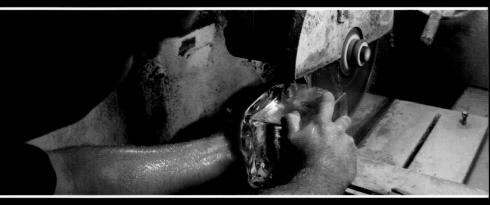

 scuola del vetro abate zanetti murano

Calle Briati 8/b 30141 Murano Venezia Italy tel. +39 0415275757 fax +39 0415274639 www.abatezanetti.it info@abatezanetti.it

THE 3RD WORLD CERAMIC BIENNALE 2005 KOREA

Theme: Ceramics; The Vehicle of Culture

Period: April 23rd ~ June 19th, 2005

Venue: Icheon World Ceramic Center
Gwangju Joseon Royal Kiln Museum
Yeoju World Ceramic Livingware Gallery

PROGRAMS

Main Exhibition	Special Exhibition	Symposium and Workshop	TOYA Education Pavilion
The 3rd Int'l Competition	Ceramics and Architecture	Int'l Ceramic Symposium	
Trans-Ceramic-Art	Landscape and Ceramics	Int'l Symposium on Celadon	
The Color and Shape of Celadon	Ceramics in Nature	Int'l Ceramic Workshop	
Ceramic House II	Roads of Ceramics	Int'l Workshop on Wood-Fired Kilns	
	The Harmony of Hangul and Ceramics		
	World Ceramic Souvenirs		
	Delightful Teapot in Ceramic		

재단법인세계도자기엑스포
WORLD CERAMIC EXPOSITION FOUNDATION

World Ceramic Exposition Foundation l Icheon World Ceramic Center l Gwangju Joseon Royal Kiln Museum l Yeoju World Ceramic Livingware Gallery
Mt. 69-1 Gwango-Dong, Icheon-Si, Gyeonggi-do, Korea 467-020 l Tel: +82-31-631-6509 l Fax: +82-31-631-1614 l **www.wocef.com** l **cebiko@worldceramic.or.kr**

An international residency facility for professional artists working in clay.

WATERSHED
Center for the Ceramic Arts

19 Brick Hill Road
Newcastle, Maine 04553-9716
207.882.6075 phone
207.882.6045 fax

Lynn Thompson, Executive Director
director@watershedceramics.org

www.watershedceramics.org

Wood Turning Center

EDUCATION•PRESERVATION•PROMOTION
Wood And Other Lathe-Turned Material

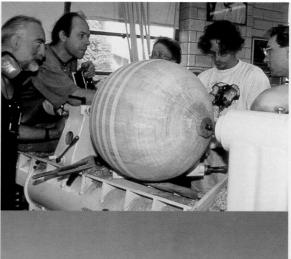

Invites you to become a member

The Wood Turning Center, a Philadelphia-based not-for-profit arts institution, gallery and resource center, is dedicated to the art and craft of lathe-turned objects. Through its programs, the WTC encourages existing and future artists, and cultivates a public appreciation of the field.

Founded in 1986, the Wood Turning Center has become an internationally recognized source of information and assistance to artists, hobbyists, galleries, museums, collectors and educators.

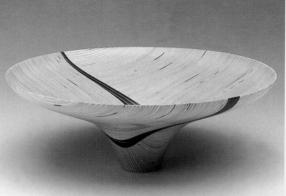

Member Benefits

- A year's subscription to *Turning Points*, our quarterly magazine dedicated to expanding the general understanding and critical analysis of the lathe-turning field.

- 10% discount on purchases of books, slides and videotapes.

- New members also receive a set of 250 decoratively turned Japanese toothpicks.

- Invitations to all exhibition openings.

- Discounted admission to conferences, workshops and symposia.

Members of the Wood Turning Center play a vital role by helping to fulfill its mission of education, preservation and promotion. Because you may share an interest in lathe turning or related arts, we invite you to support WTC with your membership.

As a member, you will deepen both your knowledge and appreciation of the art of lathe-turning and gain insight into the artists who are expanding the art and craft of wood turning.

Turning Points

Turning Points includes reviews of exhibitions, conferences and symposia; articles on the art of lathe-turning, from authentic historical reproductions to the most avant-garde; conservation, collector and artist issues; and a comprehensive calendar of international events.

Wood Turning Center
501 Vine Street, Philadelphia, PA 19106
tel: 215.923.8000 fax: 215.923.4403
turnon@woodturningcenter.org
www.woodturningcenter.org

Hours: Monday–Friday 10am-5pm
 Saturday 12pm-5pm

sofaexpo.com

SOFA2004

Advertisements

The only question is, where to next? American Airlines, together with American Eagle, serves hundreds of cities throughout the U.S., Canada, Latin America, Europe, the Caribbean and Japan. And only American Airlines has More Room Throughout Coach® on more planes than any other airline,* so you can travel the globe in comfort. For reservations, visit AA.com or call American at 1-800-433-7300 or call your travel agent.

 250 cities. 40 countries. One airline. **American**Airlines®

Chris Nissen, *Chicago Night*, oil on canvas,103 x 65"
Northwestern Memorial Hospital art collection, Galter Pavilion, third floor

Healing Through Art

Northwestern Memorial Hospital is in the building stages for a new women's hospital that will become the premier facility for women's health care in the nation. Art will be an important component in the development of a healing and welcoming environment for the facility. The Arts Program is made possible through the generosity of our friends and supporters. We welcome the opportunity to discuss ways that you can make a difference at the hospital through philanthropy. For more information, contact the Office of the Vice President of Northwestern Memorial Foundation at 312-926-7066.

**Northwestern Memorial
Foundation**

palmbeach³
CONTEMPORARY

palmbeach³
PHOTOGRAPHY

palmbeach³
SOFA

palmbeach³
CONTEMPORARYPHOTOGRAPHYSOFA

January 14-17, 2005
Palm Beach County Convention Center

Ⓟ 561.209.1300 Ⓦ www.palmbeach3.com

Ex

Index of Exhibitors

hibitors

Aaron Faber Gallery
666 Fifth Avenue
New York, NY 10103
212.586.8411
fax 212.582.0205
info@aaronfaber.com
aaronfaber.com

Adamar Fine Arts
177 NE 39th Street
Miami, FL 33137
305.576.1355
fax 305.576.0551
adamargal@aol.com
adamargallery.com

Andrew Bae Gallery
300 West Superior Street
Chicago, IL 60610
312.335.8601
fax 312.335.8602
info@andrewbaegallery.com
andrewbaegallery.com

Ann Nathan Gallery
212 West Superior Street
Chicago, IL 60610
312.664.6622
fax 312.664.9392
nathangall@aol.com
annnathangallery.com

Artempresa
San Jerónimo 448
Córdoba 5000
Argentina
54.351.422.1290
fax 54.351.427.1776
artempresa@arnet.com.ar

Australian Contemporary
19 Morphett Street
Adelaide
South Australia
61.8.8410.0727
fax 61.8.8231.0434
auscontemporary@
 jamfactory.com.au

Barrett Marsden Gallery
17-18 Great Sutton Street
London EC1V 0DN
England
44.20.7336.6396
fax 44.20.7336.6391
info@bmgallery.co.uk
bmgallery.co.uk

Barry Friedman Ltd.
32 East 67th Street
New York, NY 10021
212.794.8950
fax 212.794.8889
contact@barryfriedmanltd.com
barryfriedmanltd.com

Beatrice Wood Studio
8560 Ojai-Santa Paula Road
Ojai, CA 93023
805.646.3381
info@beatricewood.com
beatricewood.com

Postal Address:
PO Box 804
Ojai, CA 93024

Beaver Galleries
81 Denison Street, Deakin
Canberra, ACT 2600
Australia
61.2.6282.5294
fax 61.2.6281.1315
mail@beavergalleries.com.au
beavergalleries.com.au

Bellas Artes/Thea Burger
Bellas Artes
653 Canyon Road
Santa Fe, NM 87501
505.983.2745
fax 505.983.1271
bc@bellasartesgallery.com
bellasartesgallery.com

Thea Burger
39 Fifth Avenue, Suite 3B
New York, NY 10003
802.234.6663
fax 802.234.6903
burgerthea@aol.com

Berengo Fine Arts
Fondamenta Vetrai 109/A
Murano, Venice 30141
Italy
39.041.739453
fax 39.041.527.6588
adberen@berengo.com
berengo.com

Bluecoat Display Centre
Bluecoat Chambers
School Lane
Liverpool L1 3BX
England
44.151.709.4014
fax 44.151.707.8106
crafts@bluecoatdisplaycentre.com
bluecoatdisplaycentre.com

British Crafts Council
44a Pentonville Road
London N1 9BY
England
44.20.7806.2557
fax 44.20.7837.6891
trading@craftscouncil.org.uk
craftscouncil.org.uk

browngrotta arts
Wilton, CT
203.834.0623
fax 203.762.5981
art@browngrotta.com
browngrotta.com

**The Bullseye
Connection Gallery**
300 NW Thirteenth Avenue
Portland, OR 97209
503.227.0222
fax 503.227.0008
gallery@bullseyeglass.com
bullseyeconnectiongallery.com

**Caterina Tognon Arte
Contemporanea**
Via San Tomaso, 72
Bergamo 24121
Italy
39.035.243300
fax 39.035.243300
caterinatognon@tin.it
caterinatognon.com

San Marco 2671
Campo San Maurizio
Venice 30124
Italy
39.041.520.7859
fax 39.041.520.7859

Chappell Gallery
526 West 26th Street, #317
New York, NY 10001
212.414.2673
fax 212.414.2678
amchappell@aol.com
chappellgallery.com

14 Newbury Street
Boston, MA 02116
617.236.2255
fax 617.236.5522

Charon Kransen Arts
By Appointment Only
456 West 25th Street
New York, NY 10001
212.627.5073
fax 212.633.9026
chakran@earthlink.net
charonkransenarts.com

Clay
226 Main Street
Venice, CA 90291
310.399.1416
fax 301.230.9203
info@clayinla.com
clayinla.com

The David Collection
44 Black Spring Road
Pound Ridge, NY 10576
914.764.4674
fax 914.764.4675
jkdavid@optonline.net
thedavidcollection.com

del Mano Gallery
11981 San Vicente Boulevard
Los Angeles, CA 90049
310.476.8508
fax 310.471.0897
gallery@delmano.com
delmano.com

Donna Schneier Fine Arts
By Appointment Only
New York, NY
212.472.9175
fax 212.472.6939
dnnaschneier@mhcable.com

Douglas Dawson
400 North Morgan Street
Chicago, IL 60622
312.226.7975
fax 312.226.7974
info@douglasdawson.com
douglasdawson.com

Dubhe Carreño Gallery
1841 South Halsted Street
Chicago, IL 60608
312.666.3150
fax 312.577.0988
info@dubhecarrenogallery.com
dubhecarrenogallery.com

Ferrin Gallery
69 Church Street
Lenox, MA 01240
413.637.4414
fax 914.271.0047
info@ferringallery.com
ferringallery.com

Finer Things Gallery
1898 Nolensville Road
Nashville, TN 37210
615.244.3003
fax 615.254.1833
kkbrooks@bellsouth.net
finerthingsgallery.com

Franklin Parrasch Gallery
20 West 57th Street
New York, NY 10019
212.246.5360
fax 212.246.5391
info@franklinparrasch.com
franklinparrasch.com

**Function + Art/prism
Contemporary Glass**
1046-48 West Fulton Market
Chicago, IL 60607
312.243.2780
info@functionart.com
functionart.com

**Galerie Ateliers
d'Art de France**
4 Passage Roux
Paris 75017
France
33.1.4401.0830
fax 33.1.4401.0835
galerie@ateliersdart.com
createdinfrance.com

Galerie Besson
15 Royal Arcade
28 Old Bond Street
London W1S 4SP
England
44.20.7491.1706
fax 44.20.7495.3203
enquiries@galeriebesson.co.uk
galeriebesson.co.uk

Galerie Daniel Guidat
142 Rue d'Antibes
Cannes 06400
France
33.4.9394.3333
fax 33.4.9394.3334
gdg@danielguidat.com
danielguidat.com

**Galerie des Métiers
d'Art du Québec**
350 St. Paul East
Montreal, Quebec H2Y 1H2
Canada
514.861.2787, ext. 310
fax 514.861.9191
france.bernard@metiers-
 d-art.qc.ca
galeriedesmetiersdart.com

Galerie Mark Hachem
10 Place des Vosges
Paris 75004
France
33.1.4276.9493
fax 33.1.4276.9466
mark@galerie-markhm.com
galerie-markhm.com

Galerie Metal
Nybrogade 26
Copenhagen K, 1203
Denmark
45.33.145540
fax 45.33.145540
galeriemetal@mail.dk
galeriemetal.dk

Galerie Pokorná
Janský Vršek 15
Prague 1, 11800
Czech Republic
420.222.518635
fax 420.222.518635
office@galeriepokorna.cz
galeriepokorna.cz

Galerie Tactus
12 St. Regnegade
Copenhagen 1110
Denmark
45.33.933105
fax 45.35.431547
tactus@galerietactus.com
galerietactus.com

Galleri Grønlund
Birketoften 16a
Vaerloese 3500
Denmark
45.44.442798
fax 45.44.442798
groenlund@get2net.dk
glassart.dk

Galleri Nørby
Vestergade 8
Copenhagen 1456
Denmark
45.33.151920
fax 45.33.151963
info@galleri-noerby.dk
galleri-noerby.dk

Gallery 500 Consulting
3502 Scotts Lane
Philadelphia, PA 19129
215.849.9116
fax 215.849.9116
gallery500@hotmail.com
gallery500.com

Gallery Biba
1400 Alabama Avenue
West Palm Beach, FL 33401
561.832.3933
fax 561.835.1819
robertstcroix@prodigy.net
gallerybiba.com

Gallery DeCraftig
Søpassagen 14, 3.th.
Copenhagen 2100
Denmark
45.27.123451
grethe.wittrock@post.tele.dk

**The Gallery, Ruthin
Craft Centre**
Park Road
Ruthin, Denbighshire LL15 1BB
Wales, UK
44.1824.704774
fax 44.1824.702060
thegallery@rccentre.org.uk

Gallery Yann
106 East Oak Street
Chicago, IL 60611
312.337.5861
fax 312.337.5895
galleryyann@sbcglobal.net

Glass Artists' Gallery
70 Glebe Point Road, Glebe
Sydney, NSW 2037
Australia
61.2.9552.1552
fax 61.2.9552.1552
mail@glassartistsgallery.com.au
glassartistsgallery.com.au

Habatat Galleries
4400 Fernlee Avenue
Royal Oak, MI 48073
248.554.0590
fax 248.554.0594
info@habatat.com
habatat.com

Hawk Galleries
153 East Main Street
Columbus, OH 43215
614.225.9595
fax 614.225.9550
tom@hawkgalleries.com
hawkgalleries.com

Heller Gallery
420 West 14th Street
New York, NY 10014
212.414.4014
fax 212.414.2636
info@hellergallery.com
hellergallery.com

Hibberd McGrath Gallery
101 North Main Street
PO Box 7638
Breckenridge, CO 80424
970.453.6391
fax 970.453.6391
terry@hibberdmcgrath.com
hibberdmcgrath.com

Holsten Galleries
3 Elm Street
Stockbridge, MA 01262
413.298.3044
fax 413.298.3275
artglass@holstengalleries.com
holstengalleries.com

Jean Albano Gallery
215 West Superior Street
Chicago, IL 60610
312.440.0770
fax 312.440.3103
jeanalbano@aol.com
jeanalbanogallery.com

Jerald Melberg Gallery
625 South Sharon Amity Road
Charlotte, NC 28211
704.365.3000
fax 704.365.3016
gallery@jeraldmelberg.com
jeraldmelberg.com

Joanna Bird Pottery
By Appointment
19 Grove Park Terrace
London, W43QE
England
44.208.995.9960
fax 44.208.742.7752
joanna.bird@ukgateway.net
joannabirdpottery.com

John Natsoulas Gallery
521 First Street
Davis, CA 95616
530.756.3938
fax 530.756.3961
art@natsoulas.com
natsoulas.com

**Kaiser Suidan/Next Step
Studio and Gallery**
By Appointment Only
530 Hilton Road
Ferndale, MI 48220
248.414.7050
fax 248.414.7050
kaisersuidan@nextstep
 studio.com
nextstepstudio.com

Katie Gingrass Gallery
241 North Broadway
Milwaukee, WI 53202
414.289.0855
fax 414.289.9255
katieg@execpc.com
gingrassgallery.com

Kirra Galleries
Shop M11 (mid level)
Southgate Arts & Leisure Precinct
Southbank, Victoria 3006
Australia
61.3.9682.7923
fax 61.3.9547.2277
kirra@kirra.com
kirra.com

Kraft Lieberman Gallery
835 West Washington
Chicago, IL 60607
312.948.0555
fax 312.948.0333
klfinearts@aol.com
klfinearts.com

Leif Holmer Gallery AB
Storgatan 19
Box 20
Nässjö, S-57121
Sweden
46.380.12490
fax 46.380.12494
leif@holmergallery.com
marcus@holmergallery.com
holmergallery.com

Leo Kaplan Modern
41 East 57th Street
7th floor
New York, NY 10022
212.872.1616
fax 212.872.1617
lkm@lkmodern.com

Lost Angel Glass
79 West Market Street
Corning, NY 14830
607.937.3578
fax 607.937.3578
meghan@lostangelglass.com
lostangelglass.com

Marx-Saunders Gallery LTD
230 West Superior Street
Chicago, IL 60610
312.573.1400
fax 312.573.0575
marxsaunders@earthlink.net
marxsaunders.com

Mattson's Fine Art
2579 Cove Circle NE
Atlanta, GA 30319
404.636.0342
fax 404.636.0342
sundew@mindspring.com

Maurine Littleton Gallery
1667 Wisconsin Avenue NW
Washington, DC 20007
202.333.9307
fax 202.342.2004
littletongallery@aol.com

Mobilia Gallery
358 Huron Avenue
Cambridge, MA 02138
617.876.2109
fax 617.876.2110
mobiliaart@aol.com
mobilia-gallery.com

Modus
23 Place des Vosges
Paris 75003
France
33.1.4278.1010
fax 33.1.4278.1400
modus@galerie-modus.com
galerie-modus.com

Mostly Glass Gallery
3 East Palisade Avenue
Englewood, NJ 07631
201.816.1222
fax 201.816.9582
info@mostlyglass.com
mostlyglass.com

Narek Galleries
Old Tanja Church
1140 Bermagui Road
Tanja, NSW 2550
Australia
61.2.6494.0112
fax 61.2.6494.0112
info@narekgalleries.com
narekgalleries.com

**Niemi Sculpture
Gallery & Garden**
13300 116th Street
Kenosha, WI 53142
262.857.3456
fax 262.857.4567
gallery@bruceniemi.com
bruceniemi.com

Option Art
4216 de Maisonneuve Blvd. West
Suite 302
Montreal, Quebec H3Z 1K4
Canada
514.932.3987
fax 514.932.6182
info@option-art.ca
option-art.ca

Orley & Shabahang
341 Wing Lake Road
Bloomfield Hills, MI 48301
586.996.5800
fax 248.524.2909
geoffreyorley@aol.com
shabahangcarpets.com

240 South Country Road
Palm Beach, FL 33480
561.655.3371
fax 561.655.0037
shabahangorley@adelphia.net

223 East Silver Spring Drive
Whitefish Bay, WI 53217
414.332.2486
fax 414.332.9121
percarpets@aol.com

Perimeter Gallery, Inc.
210 West Superior Street
Chicago, IL 60610
312.266.9473
fax 312.266.7984
perimeterchicago@perimeter
 gallery.com
perimetergallery.com

Portals Ltd
742 North Wells Street
Chicago, IL 60610
312.642.1066
fax 312.642.2991
artisnow@aol.com
portalsgallery.com

R

R. Duane Reed Gallery
7513 Forsyth Boulevard
St. Louis, MO 63105
314.862.2333
fax 314.862.8557
reedart@primary.net
rduanereedgallery.com

529 West 20th Street
New York, NY 10011
212.462.2600
fax 212.462.2510

Raglan Gallery
5-7 Raglan Street, Manly
Sydney, NSW 2095
Australia
61.2.9977.0906
fax 61.2.9977.0906
jankarras@hotmail.com
raglangallery.com.au

Rebecca Hossack Gallery
35 Windmill Street
London W1T 2JS
England
44.20.7436.4899
fax 44.20.7323.3182
rebecca@r-h-g.co.uk
r-h-g.co.uk

Sabbia
455 Grand Bay Drive
Key Biscayne, FL 33149
305.365.4570
fax 305.365.4572
sabbiafinejewelry@hotmail.com
sabbiafinejewelry.com

The Scottish Gallery
16 Dundas Street
Edinburgh EH3 6HZ
Scotland
44.131.558.1200
fax 44.131.558.3900
mail@scottish-gallery.co.uk
scottish-gallery.co.uk

Sherry Leedy
Contemporary Art
2004 Baltimore Avenue
Kansas City, MO 64108
816.221.2626
fax 816.221.8689
sherryleedy@sherryleedy.com
sherryleedy.com

Snyderman-Works Galleries
303 Cherry Street
Philadelphia, PA 19106
215.238.9576
fax 215.238.9351
bruce@snyderman-works.com
snyderman-works.com

Tai Gallery/Textile Arts
616 1/2 Canyon Road
Santa Fe, NM 87501
505.983.9780
fax 505.989.7770
gallery@textilearts.com
textilearts.com

Thirteen Moons Gallery
652 Canyon Road
Santa Fe, NM 87501
505.995.8513
fax 505.995.8507
jjonsin@thirteenmoonsgallery.com
thirteenmoonsgallery.com

Thomas R. Riley Galleries
642 North High Street
Columbus, OH 43215
614.228.6554
fax 614.228.6550
tom@rileygalleries.com
rileygalleries.com

2026 Murray Hill Road
Cleveland, OH 44106
216.421.1445
fax 216.421.1435

UrbanGlass
647 Fulton Street
Brooklyn, NY 11217-1112
718.625.3685
fax 718.625.3889
info@urbanglass.org
urbanglass.org

WEISSPOLLACK
2938 Fairfield Avenue
Bridgeport, CT 06605
203.333.7733
fax 203.362.2628
weisspollack@att.net
jeffreyweissgallery.com

William Siegal Galleries
135 West Palace Avenue
Suite 101
Santa Fe, NM 87501
505.820.3300
fax 505.820.7733
williamsiegalgalleries.com

William Zimmer Gallery
10481 Lansing Street
Mendocino, CA 95460
707.937.5121
fax 707.937.2405
wzg@mcn.org
williamzimmergallery.com

Yaw Gallery
550 North Old Woodward
Birmingham, MI 48009
248.647.5470
fax 248.647.3715
yawgallery@msn.com

ZeST Gallery
Roxby Place
London SW6 1RS
England
44.20.7610.1900
fax 44.20.7610.3355
naomi@zestgallery.com
zestgallery.com

SOFA 2004

Artists

A

Aaronson, Adam
ZeST Gallery

Abe, Motoshi
Tai Gallery/Textile Arts

Abraham, Françoise
Modus

Abrams, Jackie
Katie Gingrass Gallery

Abrasha
William Zimmer Gallery

Adams, Luke
Mobilia Gallery

Adams, Renie Breskin
Mobilia Gallery

Adell, Carrie
Aaron Faber Gallery

Adell, Jo
Aaron Faber Gallery

Ahlgren, Jeanette
Mobilia Gallery

Aizkorbe, Faustino
Jerald Melberg Gallery

Akagi, Chieko
Yaw Gallery

Akers, Adela
browngrotta arts
Thirteen Moons Gallery

Aldrete-Morris, Catherine
Bullseye Connection Gallery

Alepedis, Efharis
Charon Kransen Arts

Allen, Daniel
The Gallery, Ruthin
 Craft Centre

Allen, Shelley Muzylowski
Thomas R. Riley Galleries

Amendolara, Sue
Yaw Gallery

Amino, Leo
WEISSPOLLACK

Amoruso, Giampaolo
Modus

Amsel, Galia
Bullseye Connection Gallery

Anderegg, Wesley
Snyderman-Works Galleries

Andersen, Carsten From
Galerie Metal

Anderson, Dona
browngrotta arts

Anderson, Jeanine
browngrotta arts

Anderson, Kate
Snyderman-Works Galleries

Anderson, Nikki
Dubhe Carreño Gallery

Angelino, Gianfranco
del Mano Gallery

Aoki, Mikiko
The David Collection

Appel, Nicolai
Galerie Metal

Ara
Sabbia

Arata, Tomomi
The David Collection
Mobilia Gallery

Arentzen, Glenda
Aaron Faber Gallery

Arima, Curtis H.
Yaw Gallery

Arleo, Adrian
Snyderman-Works Galleries

Arman
Galerie Mark Hachem

Arneson, Robert
Franklin Parrasch Gallery
John Natsoulas Gallery

Arnold, Christian
Kirra Galleries

Arp, Marijke
browngrotta arts

Arrit, Yvonne
Yaw Gallery

Aslanis, George
Kirra Galleries

Autio, Rudy
R. Duane Reed Gallery

Aylief, Felicity
Clay

B

Babcock, Herb
Habatat Galleries

Babula, Maryann
Chappell Gallery

Bach, Carolyn Morris
Gallery 500 Consulting

Bailey, Amy
Yaw Gallery

Bakker, Ralph
Charon Kransen Arts

Baldwin, Gordon
Barrett Marsden Gallery

Baldwin, Philip
Thomas R. Riley Galleries

Balistreri, John
Sherry Leedy Contemporary Art

Balsgaard, Jane
browngrotta arts

Banks, Diane
Mobilia Gallery

Banks, Jennifer D.
Yaw Gallery

Banner, Maureen
Yaw Gallery

Banner, Michael
Yaw Gallery

Barber, Lanette
WEISSPOLLACK

Barker, James
Aaron Faber Gallery

Barker, Jo
browngrotta arts

Barnaby, Margaret
Aaron Faber Gallery

Barnes, Dorothy Gill
browngrotta arts

Bartels, Rike
Charon Kransen Arts

Bartlett, Caroline
browngrotta arts

Barton, Polly
Thirteen Moons Gallery

Basch, Sara
The David Collection

Bassler, James
Thirteen Moons Gallery

Battaile, Bennett
Bullseye Connection Gallery

Batura, Tanya
Dubhe Carreño Gallery

Bauer, Ela
Charon Kransen Arts

Bauermeister, Michael
del Mano Gallery

Bayer, Svend
Joanna Bird Pottery

Beal, Stephen
Katie Gingrass Gallery

Beck, Rick
Marx-Saunders Gallery, LTD.

Bégou, Alain
Galerie Daniel Guidat

Bégou, Francis
Galerie Daniel Guidat

Bégou, Marisa
Galerie Daniel Guidat

Becker, Michael
Charon Kransen Arts

Behar, Linda
Mobilia Gallery

Behennah, Dail
browngrotta arts

Behm, Marlies
Mobilia Gallery

Behrens, Brenda
del Mano Gallery

Behrens, Hanne
Mobilia Gallery

Beiner, Susan
Thirteen Moons Gallery

Bélanger, Sylvie
Galerie des Métiers
d'Art du Québec

Bell, Ellen
Rebecca Hossack Gallery

Bell, Vivienne
Chappell Gallery

Belliard, François
Galerie Ateliers
d'Art de France

Benjamin, Karen
Thirteen Moons Gallery

Bennett, David
Thomas R. Riley Galleries

Bennett, Drew
Thomas R. Riley Galleries

Bennett, Garry Knox
Leo Kaplan Modern

Bennicke, Karen
Galleri Nørby

Benzoni, Luigi
Berengo Fine Arts

Berman, Harriete Estel
Charon Kransen Arts
Mobilia Gallery

Bernardi, Luis
Artempresa

Bernstein, Alex Gabriel
Chappell Gallery

Berrocal
Galerie Mark Hachem

Bess, Nancy Moore
browngrotta arts

Bettison, Giles
Barry Friedman Ltd.
Bullseye Connection Gallery

Bikakis, Myron
Yaw Gallery

Biles, Russell
Ferrin Gallery

Binns, David
The Gallery, Ruthin
Craft Centre

Birch, Karin
Snyderman-Works Galleries

Birkkjaer, Birgit
browngrotta arts

Bishoff, Bonnie
Function + Art/prism
Contemporary Glass

Bjerg, Thea
Gallery DeCraftig

Bjerring, Claus
Galerie Tactus

Bjørn, Gitte
Galerie Metal

Black, Sandra
Raglan Gallery

Blacklock, Kate
Snyderman-Works Galleries

Blackman, Jane
Clay

Blackmore, Cassandria
R. Duane Reed Gallery

Blank, Alexander
The David Collection

Blank, Martin
Habatat Galleries

Blavarp, Liv
Charon Kransen Arts

Bloomfield, Greg
Leo Kaplan Modern

Blyfield, Julie
Charon Kransen Arts

Bobrowicz, Yvonne
Pacanovsky
Snyderman-Works Galleries

Bodker, Lene
Marx-Saunders Gallery, LTD.

Boin, Whitney
Aaron Faber Gallery

Bokesch-Parsons, Mark
Maurine Littleton Gallery

Bondanza, Michael
Aaron Faber Gallery

Book, Flora
Mobilia Gallery

Borgenicht, Ruth
Snyderman-Works Galleries

Borghesi, Marco
Aaron Faber Gallery

Boskin, Deborah
Mobilia Gallery
Yaw Gallery

Bostick, Kathleen
Yaw Gallery

Bothwell, Christina
R. Duane Reed Gallery

Boucard, Yves
Leo Kaplan Modern

Bouchert, Wilhelm
William Zimmer Gallery

Bowden, Jane
Mobilia Gallery

Bowes, George
Mobilia Gallery

Boyadjiev, Latchezar
Habatat Galleries

Boyd, Michael
Mobilia Gallery

Braeuer, Antje
Charon Kransen Arts

Bravura, Dusciana
Berengo Fine Arts

Bredsted, Yvette
Galerie Metal

Brennan, Jeanne
R. Duane Reed Gallery

Brennan, Sara
browngrotta arts
The Scottish Gallery

Brennand-Wood, Michael
Bluecoat Display Centre

Brennecke, Angelika
William Zimmer Gallery

Bridgwater, Margaret
Galerie Metal

Brinkmann, Beate
The David Collection

Britton, Alison
Barrett Marsden Gallery

Broadhead, Caroline
Barrett Marsden Gallery

Brock, Charissa
Thirteen Moons Gallery

Brock, Emily
Habatat Galleries

Brown, Christie
Clay

Brown, Jeff
William Zimmer Gallery

Brown, Sandy
Clay

Browne, Kathleen
Mobilia Gallery

Brychtová, Jaroslava
Barry Friedman Ltd.
Donna Schneier Fine Arts
Galerie Pokorná

Buchert, Wilhelm
Aaron Faber Gallery

Buchert-Buge, Ute
Aaron Faber Gallery

Buck, Kim
Galerie Tactus

Buckman, Jan
browngrotta arts

Budde, Jim
Ferrin Gallery

Burchard, Christian
del Mano Gallery

Burgel, Klaus
Mobilia Gallery

Burger, Falk
Yaw Gallery

Bussières, Maude
Galerie des Métiers
d'Art du Québec

Buszkiewicz, Kathy
Mobilia Gallery

Butler, Simon
Glass Artists' Gallery

Butt, Harlan
Mobilia Gallery
Yaw Gallery

Butts, R.W.
William Zimmer Gallery

Cabral, Leonardo
Artempresa

Cacicedo, Jean
Hibberd McGrath Gallery

Caldwell, Dorothy
Snyderman-Works Galleries

Caleo, Lyndsay
Chappell Gallery

Campbell, Pat
browngrotta arts

Cantin, Annie
Galerie des Métiers
 d'Art du Québec

Cantwell, Christopher
WEISSPOLLACK

Carder, Ken
Marx-Saunders Gallery, LTD.

Cardew, Michael
Joanna Bird Pottery

Carlin, David
del Mano Gallery

Carlson, William
Leo Kaplan Modern
Marx-Saunders Gallery, LTD.

Carr, Graham
William Zimmer Gallery

Carr, Tanija
William Zimmer Gallery

Cassidy, Beth
WEISSPOLLACK

Casson, Lucy
Rebecca Hossack Gallery

Castagna, Pino
Berengo Fine Arts

Castle, Wendell
Donna Schneier Fine Arts

Catchpole, Bridget
Yaw Gallery

Cederquist, John
Franklin Parrasch Gallery

Cepka, Anton
Charon Kransen Arts

Chagué, Thiébaut
Joanna Bird Pottery

Chaij, Jorge
Artempresa

Chamblin, Doug
Finer Things Gallery

Chandler, Gordon
Ann Nathan Gallery

Chardiet, José
Leo Kaplan Modern

Charles, Don
Thomas R. Riley Galleries

Chaseling, Scott
Beaver Galleries
Leo Kaplan Modern

Chatterley, Mark
Gallery 500 Consulting

Chavent, Claude
Aaron Faber Gallery

Chavent, Françoise
Aaron Faber Gallery

Chen, Yu Chun
Charon Kransen Arts

Chesney, Nicole
Bullseye Connection Gallery
Heller Gallery

Cheung, Lin
British Crafts Council

Chihuly, Dale
Donna Schneier Fine Arts
Holsten Galleries

Cho, Namu
Aaron Faber Gallery

Chock, Vicky
John Natsoulas Gallery

Choi, Seung Hye
Mobilia Gallery

Chotard, Cathy
Charon Kransen Arts

Christie, Barbara
The David Collection

Chung, Richard
Sherry Leedy Contemporary Art

Cicansky, Victor
John Natsoulas Gallery

Cigler, Václav
Galerie Pokorná

Ciscato, Carina
British Crafts Council

Clark, Christine
Yaw Gallery

Clark, Peter
Rebecca Hossack Gallery

Class, Petra
Charon Kransen Arts

Clausager, Kirsten
Mobilia Gallery

Clayton, Deanna
Thomas R. Riley Galleries

Clayton, Keith
Thomas R. Riley Galleries

Clegg, Tessa
Barrett Marsden Gallery
Barry Friedman Ltd.

Coates, Kevin
Mobilia Gallery

Cochran, Susan P.
Gallery Biba

Cocks, Deb
Glass Artists' Gallery

Cohen, Barbara
Snyderman-Works Galleries

Cohen, Carol
Maurine Littleton Gallery

Cohen, Mardi Jo
Snyderman-Works Galleries

Cole, Jim
Mobilia Gallery

Coleman, Rod
Glass Artists' Gallery

Colquit, Susan
Katie Gingrass Gallery

Constantine, Greg
Jean Albano Gallery

Conty, Angela
Aaron Faber Gallery

Cook, Lia
Perimeter Gallery, Inc.

Cooke-Brown, Allison
Mobilia Gallery

Cooper, Diane
Jean Albano Gallery

Cooper, Robert
Clay

Coper, Hans
Galerie Besson
Joanna Bird Pottery

Cordova, Cristina
Ann Nathan Gallery

Corregan, Daphné
Galerie Ateliers
 d'Art de France

Corvaja, Giovanni
Charon Kransen Arts

Costantini, Vittorio
Mostly Glass Gallery

Cottrell, Simon
Charon Kransen Arts

Couch, Whitney
Mobilia Gallery

Couig, William
UrbanGlass

Couradin, Jean-Christophe
del Mano Gallery

Crain, Joyce
Snyderman-Works Galleries

Crane, Kevin Glenn
Yaw Gallery

Craste, Laurent
Galerie des Métiers
 d'Art du Québec

Crespin, Patrick
Galerie Ateliers
 d'Art de France

Cribbs, KéKé
Leo Kaplan Modern
Marx-Saunders Gallery LTD

Critchley, Paul
Portals Ltd

Crow, Nancy
Snyderman-Works Galleries

Cruz-Diez
Galerie Mark Hachem

Cucchi, Claudia
Charon Kransen Arts

Curneen, Claire
Clay

Curtis, Matthew
Bullseye Connection Gallery

Cutler, Robert
del Mano Gallery

Cylinder, Lisa
Snyderman-Works Galleries

Cylinder, Scott
Snyderman-Works Galleries

Da Silva, Jack
Mobilia Gallery
Yaw Gallery

Da Silva, Marilyn
Mobilia Gallery
Yaw Gallery

Dailey, Dan
Leo Kaplan Modern

Dam, Steffen
Galleri Grønlund

Danberg, Leah
del Mano Gallery

Dardek, Dominique
Modus

Dawson, Robert
Clay

de Amaral, Olga
Bellas Artes/Thea Burger

De Both, Carol
The David Collection

De Forest, Roy
John Natsoulas Gallery

De Lafontaine, Elyse
Galerie des Métiers
 d'Art du Québec

de Santillana, Laura
Barry Friedman Ltd.

de Waal, Edmund
Joanna Bird Pottery

de Wit, Peter
Charon Kransen Arts

DeAngelis, Laura
Ferrin Gallery

DeFrancesca, Sophie
Option Art

Dei Rossi, Antonio
Mostly Glass Gallery

Dei Rossi, Mario
Mostly Glass Gallery

Delisle, Roseline
Option Art

DeMonte, Claudia
Jean Albano Gallery

Dempf, Martina
The David Collection

Dern, Carl
Mobilia Gallery

Derry, Donald
Thomas R. Riley Galleries

DeStaebler, Stephen
Franklin Parrasch Gallery

DeVore, Richard
Bellas Artes/Thea Burger
Franklin Parrasch Gallery

Dewitt, John
Gallery 500 Consulting

Di Fiore, Miriam
Mostly Glass Gallery

Dillingham, Rick
Donna Schneier Fine Arts

Dillon, Marcus
Kirra Galleries

Dixon, Steve
Clay

Docter, Marcia
Snyderman-Works Galleries

Dodd, John
William Zimmer Gallery

Dolack, Linda
Mobilia Gallery

Dombrowski, Joachim
The David Collection

Donat, Ingrid
Barry Friedman Ltd.

Donefer, Laura
R. Duane Reed Gallery

Dopp, Joshua Noah
WEISSPOLLACK

**dos Santos Castiajo,
Carla Maria**
Mobilia Gallery

Douglas, Mel
Beaver Galleries

Dowling, Gaynor
del Mano Gallery

Drexler, Paul
del Mano Gallery

Drivsholm, Trine
Galleri Grønlund

Druin, Marilyn
Aaron Faber Gallery

Drury, Chris
browngrotta arts

Drysdale, Pippin
Raglan Gallery

DuBois, Emily
Snyderman-Works Galleries

Dubois, Valerie
The David Collection

Dubuc, Roland
Galerie des Métiers
 d'Art du Québec

Duckworth, Ruth
Bellas Artes/Thea Burger
Galerie Besson

Duong, Sam Tho
Charon Kransen Arts

Dupré, Ruth
British Crafts Council

Dvorin, Emily
Mobilia Gallery

Earl, Jack
Mobilia Gallery
Perimeter Gallery, Inc.

Eastman, Ken
Barrett Marsden Gallery

Ebendorf, Robert
Yaw Gallery

Eberle, Edward
Perimeter Gallery, Inc.

Ebner, David
William Zimmer Gallery

Eckert, Carol
Thirteen Moons Gallery

Edgerley, Susan
Galerie des Métiers
 d'Art du Québec

Edols, Benjamin
Marx-Saunders Gallery LTD

Edwards, Tim
Australian Contemporary

Eglin, Philip
Barrett Marsden Gallery

Ehmck, Nina
The David Collection

Eisch, Erwin
Barry Friedman Ltd.

Elliott, Kathy
Marx-Saunders Gallery LTD

Ellison-Dorion, Helen
Mobilia Gallery

Ellsworth, David
del Mano Gallery

Emms, Dawn
British Crafts Council

English, Joseph
Aaron Faber Gallery

Engman, Kjell
Leif Holmer Gallery AB

Enterline, Sandra
Mobilia Gallery

Entner, Barry
Lost Angel Glass

Eskuche, Matt
Thomas R. Riley Galleries

Ewing, Susan
Yaw Gallery

F

Faba
Artempresa

Falkenhagen, Diane
Mobilia Gallery

Falkesgaard, Lina
Galerie Tactus

Fanourakis, Lina
Sabbia

Farey, Lizzie
browngrotta arts

Feibleman, Dorothy
Mobilia Gallery

Fein, Harvey
del Mano Gallery

Feller, Lucy
Katie Gingrass Gallery

Fennell, J. Paul
del Mano Gallery

Ferrari, Gerard
Ann Nathan Gallery

Fidler, Greg
WEISSPOLLACK

Fields, Marko
Thirteen Moons Gallery

Fifield, Linda
Katie Gingrass Gallery

Finlay, Gillian
Mobilia Gallery

Finneran, Bean
Perimeter Gallery, Inc.

Fisch, Arline
Mobilia Gallery

Fischer, Wayne
Galerie Ateliers
 d'Art de France

Fisher, Daniel
Joanna Bird Pottery

Fleming, Ron
del Mano Gallery

Flockinger, CBE, Gerda
Mobilia Gallery

Flynn, Liam
del Mano Gallery

Flynn, Pat
Aaron Faber Gallery

Fogelson, Doug
Kraft Lieberman Gallery

Fok, Nora
British Crafts Council
Mobilia Gallery

Folon
Galerie Mark Hachem

Ford, John
Snyderman-Works Galleries

Forlano, David
Snyderman-Works Galleries

Foster, Clay
del Mano Gallery

Foulem, Léopold L.
Option Art

Frank, Peter
Charon Kransen Arts

Freda, David
Mobilia Gallery

Frève, Carole
Galerie des Métiers
 d'Art du Québec

Frey, Viola
Franklin Parrasch Gallery

Friis, Lisbeth
Gallery DeCraftig

Frith, Donald E.
del Mano Gallery

Fritsch, Elizabeth
Joanna Bird Pottery

Fujinuma, Noboru
Tai Gallery/Textile Arts

Fujita, Emi
Mobilia Gallery

Fujita, Kyohei
Thomas R. Riley Galleries

Fukuchi, Kyoko
The David Collection

Furqueron, Reagan
Mobilia Gallery

G

Galazka, Rafal
Mattson's Fine Art

Gall, Theodore
Niemi Sculpture
 Gallery & Garden

Gallas, Tania
The David Collection

Galloway-Whitehead, Gill
The David Collection

Garrett, Dewey
del Mano Gallery

Garrett, John
Thirteen Moons Gallery

Gartzka, Rob
Mobilia Gallery

Garvin, Elizabeth
Gallery Yann

Gavotti, Elizabeth
Artempresa

Geertsen, Michael
Galleri Nørby

Geldersma, John
Jean Albano Gallery

Gérard, Bruno
Galerie des Métiers
 d'Art du Québec

Gerbig-Fast, Lydia
Mobilia Gallery

Geum, KeySook
Andrew Bae Gallery

Giard, Monique
Galerie des Métiers
 d'Art du Québec

Gilbert, Chantal
Galerie des Métiers
 d'Art du Québec

Gilbert, Karen
Snyderman-Works Galleries

Giles, Mary
browngrotta arts
R. Duane Reed Gallery

Gilhooly, David
John Natsoulas Gallery

Gillespie, Ty
Katie Gingrass Gallery

Glancy, Michael
Barry Friedman Ltd.

Gnaedinger, Ursula
Charon Kransen Arts
The David Collection

Goetschius, Steven
del Mano Gallery

Goldberg, Jenna
Function + Art/prism
 Contemporary Glass

Gong, Nancy
Kraft Lieberman Gallery

Good, Michael
Aaron Faber Gallery
The David Collection

Gordon, Alasdair
Kirra Galleries

Gordon, Rish
Kirra Galleries

Gottlieb, Dale
Gallery 500 Consulting

Goudji
Galerie Daniel Guidat

Graabæk, Helle
Gallery DeCraftig

Grebe, Robin
Heller Gallery

Grebeníčová, Stanislava
Chappell Gallery

Grecco, Krista
Ann Nathan Gallery

Green, Linda
browngrotta arts
The Scottish Gallery

Greenaway, Victor
Raglan Gallery

Gross, Michael
Ann Nathan Gallery

Grossen, Françoise
browngrotta arts

Gryder, Christopher
Gallery 500 Consulting

Guggisberg, Monica
Thomas R. Riley Galleries

Gustafson, Carrie
WEISSPOLLACK

Gustin, Chris
Snyderman-Works Galleries

Hafermalz-Wheeler, Christine
Aaron Faber Gallery

Hafner, Dorothy
R. Duane Reed Gallery

Hajikano, Maki
Chappell Gallery

Halabi, Sol
Artempresa

Hall, Laurie
Hibberd McGrath Gallery

Halt, Karen
Portals Ltd

Hamada, Shoji
Donna Schneier Fine Arts
Joanna Bird Pottery

Hanagarth, Sophie
Charon Kransen Arts

Hanning, Tony
Kirra Galleries

Hansen, Else Nicolai
Galerie Metal

Harari, Yossi
Sabbia

Hardenberg, Torben
Galerie Tactus

Harding, Matthew
Narek Galleries

Harding, Tim
WEISSPOLLACK

Harris, Mark
Thomas R. Riley Galleries

Hart, Margit
Mobilia Gallery

Hart, Noel
Kirra Galleries

Hartvig, Jette
Gallery DeCraftig

Haskins, Amy
Yaw Gallery

Hatakeyama, Seido
Tai Gallery/Textile Arts

Hatekayama, Norie
browngrotta arts

Hay, David
Glass Artists' Gallery

Hayashibe, Masako
The David Collection

Hayes, Peter
William Zimmer Gallery

Hector, Valerie
Charon Kransen Arts

Heffernon, Gerald
John Natsoulas Gallery

Hegelund, Bitten
Gallery DeCraftig

Heilig, Marion
The David Collection

Heindl, Anna
Charon Kransen Arts

Heinrich, Barbara
Aaron Faber Gallery
Gallery Yann

Held, Archie
William Zimmer Gallery

Henricksen, Ane
browngrotta arts

Henriksen, Mette Laier
Galerie Metal

Henton, Maggie
browngrotta arts

Hentz, Christopher
Yaw Gallery

Hermsen, Herman
Charon Kransen Arts

Hernmarck, Helena
browngrotta arts

Hewitt, Mark
Ferrin Gallery

Hibbert, Louise
del Mano Gallery

Hickman, Pat
Snyderman-Works Galleries

Hicks, Sheila
browngrotta arts

Hildebrandt, Marion
browngrotta arts

Hill, Chris
Ann Nathan Gallery

Hill, Thomas
Bluecoat Display Centre

Hilton, Eric
Habatat Galleries

Hiramatsu, Yasuki
Charon Kransen Arts

Hirte, Lydia
The David Collection

Hirv, Piret
Charon Kransen Arts

Hlavicka, Tomas
Habatat Galleries

Hobin, Agneta
browngrotta arts

Hoge, Susan
Yaw Gallery

Hole, Nina
Galleri Nørby

Hollibaugh, Nick
Mobilia Gallery

Holmes, Kathleen
Chappell Gallery

Holzapfel, Michelle
del Mano Gallery

Honda, Syoryu
Tai Gallery/Textile Arts

Honma, Hideaki
Tai Gallery/Textile Arts

Honma, Kazue
browngrotta arts

Hopkins, Jan
Thirteen Moons Gallery

Hora, Petr
Habatat Galleries

Horn, Robyn
del Mano Gallery

Hosking, Marian
Australian Contemporary

Houmann, Charlotte
Gallery DeCraftig

Howard, Rachael
Bluecoat Display Centre

Howard, Robert
Narek Galleries

Howe, Brad
Adamar Fine Arts

Hoyer, Todd
del Mano Gallery

Hoyt, Judith
Snyderman-Works Galleries

Hromek, Peter
del Mano Gallery

Hu, Mary Lee
Mobilia Gallery

Huang, David
Mobilia Gallery
Yaw Gallery

Huchthausen, David
Habatat Galleries
Leo Kaplan Modern

Hughes, Edward
Joanna Bird Pottery

Hunt, Kate
browngrotta arts

Hunter, Marianne
Aaron Faber Gallery

Hunter, William
Barry Friedman Ltd.
del Mano Gallery

Hutter, Sidney
Marx-Saunders Gallery LTD

Huycke, David
Galerie Tactus

Hyman, Sylvia
Finer Things Gallery

Ibe, Kiyoko
Snyderman-Works Galleries

Iezumi, Toshio
Chappell Gallery

Ikeda, Yoshiro
Sherry Leedy Contemporary Art

Illo, Patrik
Galerie Pokorná

Ingraham, Katherine
Mobilia Gallery

Inuzuka, Sadashi
Dubhe Carreño Gallery

Ionesco, Ion
Yaw Gallery

Ipsen, Steen
Galleri Nørby

Isaacs, Ron
Katie Gingrass Gallery

Ishida, Meiri
Charon Kransen Arts

Ishikawa, Mari
The David Collection

Ishiyama, Reiko
Charon Kransen Arts

Isupov, Ilya
Ferrin Gallery

Isupov, Sergei
Ferrin Gallery

Ito, Makoto
Chappell Gallery

Iversen, John
Charon Kransen Arts
Yaw Gallery

Iwata, Hiroki
Charon Kransen Arts

Iwata, Kiyomi
Perimeter Gallery, Inc.

Izawa, Yoko
The David Collection

Jacobi, Ritzi
Snyderman-Works Galleries

Jacobs, Ferne
Snyderman-Works Galleries

James, Judith
Snyderman-Works Galleries

James, Michael
Snyderman-Works Galleries

Janich, Hilde
Charon Kransen Arts

Jauquet, William
Katie Gingrass Gallery

Jay, Alina
Charon Kransen Arts

Jensen, Sidsel Dorph
Galerie Tactus

Jensen, Steve
Thomas R. Riley Galleries

Jerry, Michael John
Yaw Gallery

Johanson, Olle
Yaw Gallery

Johanson, Rosita
Mobilia Gallery

Johansson, Karin
Charon Kransen Arts

Johns, Mark
Yaw Gallery

Johnson, Kathy
Mobilia Gallery

Jolley, Richard
Leo Kaplan Modern

Jones, Christine
The Gallery, Ruthin
 Craft Centre

Jónsdóttír, Kristín
browngrotta arts

Jordan, John
del Mano Gallery

Jørgensen, Torben
Galleri Grønlund

Joy, Christine
browngrotta arts

Juenger, Ike
Charon Kransen Arts

Kakizaki, Hitoshi
Thomas R. Riley Galleries

Kaldahl, Martin Bodilsen
Galleri Nørby

Kallenberger, Kreg
Leo Kaplan Modern

Kaneko, Jun
Bullseye Connection Gallery
Sherry Leedy Contemporary Art

Kang, Yeonmi
Charon Kransen Arts

Kaplan, Donna
del Mano Gallery

Karlsen, Jørgen
Galleri Grønlund

Karlslund, Micha Maria
Galleri Grønlund

Katsushiro, Soho
Tai Gallery/Textile Arts

Kaufman, Glen
browngrotta arts

Kaufmann, Martin
Charon Kransen Arts

Kaufmann, Ruth
browngrotta arts

Kaufmann, Ulla
Charon Kransen Arts
Gallery Yann

Kawano, Shoko
Tai Gallery/Textile Arts

Kawashima, Shigeo
Tai Gallery/Textile Arts

Kawata, Tamiko
browngrotta arts

Kazoun, Marya
Berengo Fine Arts

Keeler, Walter
The Gallery, Ruthin
 Craft Centre

Keenan, Chris
Joanna Bird Pottery

Kegley, Charles
Finer Things Gallery

Kegley, Tami
Finer Things Gallery

Kelsey, Paul
Kirra Galleries

Kelzer, Kimberly
Mobilia Gallery

Kennard, Steven
del Mano Gallery

Kent, Ron
del Mano Gallery

Kerman, Janis
Aaron Faber Gallery
Option Art

Kerseg-Hinson, June
del Mano Gallery

Khan, Kay
Snyderman-Works Galleries

Kim, Kyung Shin
The David Collection

Kimball, Richard
Aaron Faber Gallery

Kimura, Shizuko
British Crafts Council

Kindelmann, Heide
The David Collection

Kinnaird, MBE, Alison
ZeST Gallery

Klancic, Anda
browngrotta arts

Klein, Steve
Bullseye Connection Gallery

Klimley, Nancy
Thomas R. Riley Galleries

Kling, Candace
Mobilia Gallery

Klingebiel, Jutta
Mobilia Gallery

Klumpar, Vladimira
Heller Gallery

Knauss, Lewis
browngrotta arts

Knowles, Sabrina
R. Duane Reed Gallery

Knudsen, Gitte-Annette
Gallery DeCraftig

Kobayashi, Mazakazu
browngrotta arts

Kobayashi, Naomi
browngrotta arts

Koch, Gabriele
Clay

Koehler, James
Thirteen Moons Gallery

Koenigsberg, Nancy
browngrotta arts

Kohyama, Yasuhisa
browngrotta arts

Koie, Ryoji
Galerie Besson

Kolesnikova, Irina
browngrotta arts

Koopman, Rena
Mobilia Gallery

Korowitz-Coutu, Laurie
UrbanGlass

Kosonen, Markku
browngrotta arts

Kovatch, Ron
Dubhe Carreño Gallery

Kraen, Anette
Mobilia Gallery

Kraft, Robin J.
Mobilia Gallery
Yaw Gallery

Krakowski, Yael
Charon Kransen Arts

Krantz, Stacey
Snyderman-Works Galleries

Krìvská, Barbora
Galerie Pokorná

Krogh, Astrid
Gallery DeCraftig

Kronhorst, Tina
Galerie Tactus

Krupenia, Deborah
Charon Kransen Arts

Kuhn, Jon
Marx-Saunders Gallery LTD

Kumai, Kyoko
browngrotta arts

Kuramoto, Yoko
Chappell Gallery

Kurokawa, Okinari
Mobilia Gallery

Lacoursier, Leon
del Mano Gallery

Lake, Pipaluk
Chappell Gallery

Lake, Tai
William Zimmer Gallery

Laken, Birgit
Mobilia Gallery

Laky, Gyöngy
browngrotta arts

Lamar, Stoney
del Mano Gallery

Lamarche, Antoine
Galerie des Métiers
 d'Art du Québec

Langley, Warren
Raglan Gallery

Larochelle, Christine
Galerie des Métiers
 d'Art du Québec

Larsen, Merete
del Mano Gallery

Larssen, Ingrid
The David Collection

Latven, Bud
del Mano Gallery

Layport, Ron
del Mano Gallery

Leach, Bernard
Joanna Bird Pottery

Leach, David
Joanna Bird Pottery

Lechman, Patti
Katie Gingrass Gallery

Lee, Cliff
WEISSPOLLACK

Lee, Dongchun
Charon Kransen Arts

Lee, Ed Bing
Snyderman-Works Galleries

Lee, Hongsock
Mobilia Gallery
Yaw Gallery

Lee, Jennifer
Galerie Besson

Lee, Ke-Sook
Snyderman-Works Galleries

Lee, Michael
del Mano Gallery

Leedy, Jim
WEISSPOLLACK

Lemieux Bérubé, Louise
Galerie des Métiers
 d'Art du Québec

Lent, Anthony
Yaw Gallery

LeQuire, Alan
Finer Things Gallery

Levenson, Silvia
Caterina Tognon Arte
 Contemporanea

Levy, Idith
Artempresa

Lewis, John
Leo Kaplan Modern

Liao, Chun
Barrett Marsden Gallery

Libenský, Stanislav
Barry Friedman Ltd.
Donna Schneier Fine Arts
Galerie Pokorná

Licata, Riccardo
Berengo Fine Arts

Lindenstrauss-Larsen, Ayelet
Mobilia Gallery

Lindhardt, Louise Hee
Galerie Metal

Lindqvist, Inge
browngrotta arts

Lindström, Bengt
Berengo Fine Arts

Linssen, Nel
Charon Kransen Arts

Lintault, M. Joan
del Mano Gallery

Lipman, Beth
Heller Gallery

Lipofsky, Marvin
R. Duane Reed Gallery

Lippmann, Puk
Gallery DeCraftig

Littleton, Harvey K.
Donna Schneier Fine Arts
Maurine Littleton Gallery

Littleton, John
Maurine Littleton Gallery

Ljones, Åse
browngrotta arts

Loeser, Thomas
Leo Kaplan Modern

Lomné, Alicia
Bullseye Connection Gallery

Look, Dona
Perimeter Gallery, Inc.

Lory, David
Katie Gingrass Gallery

Loughlin, Jessica
Bullseye Connection Gallery

Løvaas, Astrid
browngrotta arts

Lozier, Deborah
Yaw Gallery

Lucero, Michael
Donna Schneier Fine Arts

Lundberg, Tom
Hibberd McGrath Gallery

Lykke, Ane
Gallery DeCraftig

Lynch, Sydney
William Zimmer Gallery

Lyon, Lucy
Thomas R. Riley Galleries

Maberley, Simon
Kirra Galleries

Macdonald, Marcia
Hibberd McGrath Gallery

Machata, Peter
Charon Kransen Arts

Macnab, John
del Mano Gallery

MacNeil, Linda
Leo Kaplan Modern

MacNutt, Dawn
browngrotta arts

Madden, Thomas
Yaw Gallery

Magni, Vincent
Modus

Mailland, Alain
del Mano Gallery

Makinson, Kathleen
The Gallery, Ruthin
Craft Centre

Malec-Kosak, Kelly
Yaw Gallery

Malinowski, Ruth
browngrotta arts

Malone, Jim
Galerie Besson

Maloof, Sam
del Mano Gallery

Maltby, John
Joanna Bird Pottery

Manz, Bodil
Galleri Nørby

Marchetti, Stefano
Charon Kransen Arts

Marco del Pont, Celia
Artempresa

Marder, Donna
Mobilia Gallery

Marioni, Dante
Marx-Saunders Gallery LTD

Márquez, Noemí
Dubhe Carreño Gallery

Marquis, Richard
Caterina Tognon Arte
Contemporanea

Marsden, Robert
Barrett Marsden Gallery

Martenon, Thierry
del Mano Gallery

Martin, Barry
ZeST Gallery

Martin, Malcolm
del Mano Gallery

Martini, Giulio
Berengo Fine Arts

Maruyama, Tomomi
Mobilia Gallery

Masafumi, Sekine
Mobilia Gallery

Mason, John
Franklin Parrasch Gallery

Massaro, Karen Thuesen
Perimeter Gallery, Inc.

Matoušková, Anna
Chappell Gallery

Matsushima, Iwao
Mostly Glass Gallery

Mattar, Wilheim Tasso
The David Collection

Matthews, Mark
Thomas R. Riley Galleries

Matthias, Christine
Charon Kransen Arts

Mavrick, Elizabeth
Kirra Galleries

Mayadas, Ayesha
Snyderman-Works Galleries

Mayeri, Beverly
Franklin Parrasch Gallery
Perimeter Gallery, Inc.

Mazzoni, Ana
Artempresa

McBride, Kathryn
Ferrin Gallery

McCall, Mac
Mobilia Gallery
Yaw Gallery

McClellan, Duncan
Thomas R. Riley Galleries

McDevitt, Elizabeth
Charon Kransen Arts
Mobilia Gallery

McNicoll, Carol
British Crafts Council

McQueen, John
Mobilia Gallery
Perimeter Gallery, Inc.

Medel, Rebecca
Thirteen Moons Gallery

Mejer, Hermann
Mostly Glass Gallery

Mellor, Angela
Raglan Gallery

Mercer, Sean
Heller Gallery

Merkel-Hess, Mary
browngrotta arts

Metcalf, Bruce
Charon Kransen Arts

Meyer, Gudrun
Gallery Yann

Meyer, Sharon
Thomas R. Riley Galleries

Mezaros, Mari
R. Duane Reed Gallery

Michaels, Guy
William Zimmer Gallery

Michel, Nancy
Mobilia Gallery

Micheluzzi, Massimo
Barry Friedman Ltd.

Michikawa, Shozo
Galerie Besson

Mickelsen, Robert
Mostly Glass Gallery

Miguel
Charon Kransen Arts

Milette, Richard
Option Art

Mills, Eleri
The Gallery, Ruthin
 Craft Centre

Mina, Jacqueline
The Scottish Gallery

Minden, Cynthia
Gallery 500 Consulting

Minkowitz, Norma
Bellas Artes/Thea Burger

Minnhaar, Gretchen
Adamar Fine Arts

Minor, Barbara
Yaw Gallery

Minton, Kimo
Jerald Melberg Gallery

Mitchell, Craig
Clay

Mitchell, Dennis Lee
Dubhe Carreño Gallery

Mitsushima, Kazuko
Mobilia Gallery

Miyamura, Hideaki
WEISSPOLLACK

Møhl, Tobias
Galleri Grønlund

Moilliet, Ruth
Bluecoat Display Centre

Moje, Klaus
Heller Gallery

Møller, Anne Fabricius
Gallery DeCraftig

Monden, Yuichi
Tai Gallery/Textile Arts

Mondro, Anne
Mobilia Gallery

Mongrain, Jeffrey
Perimeter Gallery, Inc.

Monteagudo, Mariana
Dubhe Carreño Gallery

Montini, Milissa
Snyderman-Works Galleries

Montoya, Luis
Hawk Galleries
Portals Ltd

Moore, Marilyn
del Mano Gallery

Moreno, Temo
John Natsoulas Gallery

Moretti, Norberto
Mostly Glass Gallery

Mori, Junko
Bluecoat Display Centre

Morigami, Jin
Tai Gallery/Textile Arts

Morinoue, Hiroki
William Zimmer Gallery

Morris, William
Donna Schneier Fine Arts
Thomas R. Riley Galleries

Morton, Grainne
The David Collection

Mossman, Ralph
Thomas R. Riley Galleries

Mostyn-Jones, Catrin
Bluecoat Display Centre

Moulthrop, Matt
del Mano Gallery

Moulthrop, Philip
del Mano Gallery

Mount, Nick
Thomas R. Riley Galleries

Muerrle, Norbert
Gallery Yann

Muhlfellner, Martina
The David Collection

Mulford, Judy
browngrotta arts
del Mano Gallery

Müllertz, Malene
Galleri Nørby

Munsteiner, Bernd
Aaron Faber Gallery

Munsteiner, Jutta
Aaron Faber Gallery

Munsteiner, Tom
Aaron Faber Gallery

Murphy, Kathie
The David Collection

Murray, David
Chappell Gallery

Murray, Paula
Galerie des Métiers
 d'Art du Québec

Myers, Joel Philip
Barry Friedman Ltd.
Marx-Saunders Gallery LTD

Myers, Paulette
Yaw Gallery

Myers, Rebecca
Kaiser Suidan/Next Step
 Studio and Gallery

N

Nagakura, Kenichi
Tai Gallery/Textile Arts

Nagle, Ron
Franklin Parrasch Gallery

Nahabetian, Dennis
del Mano Gallery

Nahser, Heidi
Gallery Yann

Nakayama, Aya
Mobilia Gallery

Nakamura, Naoka
Charon Kransen Arts

Nancey, Christophe
Galerie Ateliers
 d'Art de France

Negre, Suzanne Otwell
The David Collection

Newell, Catharine
Bullseye Connection Gallery

Newell, Steven
Barrett Marsden Gallery

Newick, Belinda
Australian Contemporary

Newman, Richard
John Natsoulas Gallery

Nicholson, Laura Foster
Katie Gingrass Gallery

Nickerson, John
Hibberd McGrath Gallery

Nicol, Karen
Rebecca Hossack Gallery

Niehues, Leon
browngrotta arts

Niemi, Bruce A.
Niemi Sculpture
 Gallery & Garden

Niessing
Gallery Yann

Nijland, Evert
Charon Kransen Arts

Nio, Keiji
browngrotta arts

Niso
Adamar Fine Arts

Nissen, Kirsten
Gallery DeCraftig

Nittman, David
del Mano Gallery

Nobles, Beth
Hibberd McGrath Gallery

Noyons, Karina
Galerie Metal

O'Dorisio, Joel
Lost Angel Glass

Ohira, Yoichi
Barry Friedman Ltd.

Olsen, Fritz
Niemi Sculpture
　Gallery & Garden

Onofrio, Judy
Sherry Leedy Contemporary Art

Ortiz, Leslie
Hawk Galleries
Portals Ltd

Ossipov, Nikolai
del Mano Gallery

Ott, Helge
The David Collection

Owen, Doug
Sherry Leedy Contemporary Art

Owen, Mary Ann Spavins
Yaw Gallery

Oyekan, Lawson
Barrett Marsden Gallery

Paap, Kristi
Mobilia Gallery

Paganin, Barbara
Charon Kransen Arts

Pala, Štěpán
Galerie Pokorná

Paley, Albert
Hawk Galleries
Jerald Melberg Gallery

Palová, Zora
Galerie Pokorná

Panepinto, Robert
UrbanGlass

Pantano, Chris
Kirra Galleries

Papesch, Gundula
Charon Kransen Arts

Pappas, Marilyn
Snyderman-Works Galleries

Parcher, Joan
Mobilia Gallery

Pardon, Earl
Aaron Faber Gallery

Pardon, Tod
Aaron Faber Gallery

Paredes, Miel-Margarita
Mobilia Gallery
Yaw Gallery

Parker-Eaton, Sarah
del Mano Gallery

Parmentier, Silvia
Artempresa

Partridge, Jim
The Scottish Gallery

Paust, Karen
Mobilia Gallery

Peascod, Alan
Narek Galleries

Peiser, Mark
Marx-Saunders Gallery, LTD.

Perez, Jesus Curia
Ann Nathan Gallery

Perez-Flores
Galerie Mark Hachem

Perez Guaita, Gabriela
Artempresa

Perkins, Danny
R. Duane Reed Gallery

Perkins, Flo
Hawk Galleries

Perkins, Sarah
Mobilia Gallery
Yaw Gallery

Persson, Stig
Galleri Grønlund

Peterson, Michael
del Mano Gallery

Petrovic, Marc
Ferrin Gallery
Thomas R. Riley Galleries

Petter, Gugger
Mobilia Gallery

Pfaff, Judy
Bellas Artes/Thea Burger

Pheulpin, Simone
browngrotta arts

Phillips, Maria
The David Collection

Philp, Paul
Joanna Bird Pottery

Pho, Binh
del Mano Gallery

Pigott, Gwyn Hanssen
Galerie Besson

Pimental, Alexandra
The David Collection

Pinchuk, Anya
Charon Kransen Arts

Pinchuk, Natalya
Charon Kransen Arts

Pino, Claudio
Galerie des Métiers
　d'Art du Québec

Plante, Amie Louise
Charon Kransen Arts

Planteydt, Annelies
Charon Kransen Arts

Plumptre, William
Joanna Bird Pottery

Podgoretz, Larissa
Aaron Faber Gallery

Pohlman, Jenny
R. Duane Reed Gallery

Poissant, Gilbert
Option Art

Pollack, Junco Sato
Katie Gingrass Gallery

Polles
Galerie Mark Hachem

Popliteo
Portals Ltd

Portaleo, Karen
Ferrin Gallery

Portnoy, Sallie
Raglan Gallery

Powell, Stephen Rolfe
Marx-Saunders Gallery, LTD.

Pragnell, Valerie
browngrotta arts

Prasch, Camilla
Galerie Metal

Preston, Mary
Mobilia Gallery

Price, Ken
Franklin Parrasch Gallery

Priddle, Graeme
del Mano Gallery

Priest, Frances
The Scottish Gallery

Priest, Linda Kindler
Aaron Faber Gallery

Pugh, Michael
Kraft Lieberman Gallery

Putnam, Toni
Portals Ltd

Quackenbush, Liz
Snyderman-Works Galleries

Quadri, Giovanna
Mobilia Gallery

Queoff, Tom
Katie Gingrass Gallery

Quigley, Robin
Mobilia Gallery

R

Rack, Anette
Mobilia Gallery

Radstone, Sara
Barrett Marsden Gallery

Raible, Kent
Aaron Faber Gallery

Rainey, Clifford
Habatat Galleries

Rais, Lindsay
R. Duane Reed Gallery

Ramshaw, OBE RDI, Wendy
Mobilia Gallery
The Scottish Gallery

Randal, Seth
Thomas R. Riley Galleries

Rannik, Kaire
Charon Kransen Arts

Rasmussen, Peder
Galleri Nørby

Ratzer, Tina
Gallery DeCraftig

Rauschke, Tom
Katie Gingrass Gallery

Rawdin, Kim
Mobilia Gallery

Rea, Kirstie
Beaver Galleries

Rea, Mel
Thomas R. Riley Galleries

Reed, Todd
Mobilia Gallery

Reekie, David
Thomas R. Riley Galleries

Reichert, Sabine
The David Collection

Reid, Colin
Maurine Littleton Gallery

Reitz, Don
Maurine Littleton Gallery

Rena, Nicholas
Barrett Marsden Gallery

Reyes, Sydia
Portals Ltd

Rezac, Suzan
Mobilia Gallery

Rezzonico, Irene
Berengo Fine Arts

Rhoads, Kait
Chappell Gallery

Richmond, Ross
R. Duane Reed Gallery

Richmond, Vaughn
del Mano Gallery

Rie, Lucie
Galerie Besson
Joanna Bird Pottery

Rieger, Patricia
Dubhe Carreño Gallery

Ries, Christopher
Hawk Galleries

Rietmeyer, Rene
Adamar Fine Arts

Riis, Jon Eric
Thirteen Moons Gallery

Ripolles, Juan
Berengo Fine Arts

Rippon, Tom
Mobilia Gallery

Ritter, Richard
Marx-Saunders Gallery LTD

Roberson, Sang
Hibberd McGrath Gallery

Roberts, Constance
Portals Ltd

Roberts, David
Clay

Robertson, Donald
Galerie des Métiers
 d'Art du Québec

Robertson, Edith
Yaw Gallery

Robinson, John Paul
Galerie des Métiers
 d'Art du Québec

Rodgers, Emma
Bluecoat Display Centre

Roethel, Cornelia
Gallery Yann
Yaw Gallery

Rose, Jim
Ann Nathan Gallery

Rose, Marlene
Adamar Fine Arts

Rosendahl, Trine Trier
Galerie Metal

Rosenfeld, Erica
UrbanGlass

Rosol, Martin
Function + Art/prism
 Contemporary Glass

Rossano, Joseph
Thomas R. Riley Galleries

Rossbach, Ed
browngrotta arts

Rothstein, Scott
browngrotta arts
Mobilia Gallery

Rousseau-Vermette, Mariette
browngrotta arts

Rowe, Keith
Glass Artists' Gallery

Rowe, Michael
Barrett Marsden Gallery

Royal, Richard
R. Duane Reed Gallery

Ruffner, Ginny
Maurine Littleton Gallery

Rugge, Caroline
Mobilia Gallery

Russell, Brian
Jerald Melberg Gallery

Russell, Eric
Aaron Faber Gallery

Russell-Pool, Kari
Thomas R. Riley Galleries

Russo, Joanne
Katie Gingrass Gallery

Ruzsa, Alison
Mostly Glass Gallery

Ryan, Jackie
Charon Kransen Arts

Rydmark, Cheryl
William Zimmer Gallery

S

Sachs, Debra
browngrotta arts

Safire, Helene
UrbanGlass

Saito, Kayo
The David Collection

Salomon, Alain
Modus

Samplonius, David
Option Art

Sand, Toland
Function + Art/prism
 Contemporary Glass

Sanford, Claire
Mobilia Gallery
Yaw Gallery

Sangvanich, Porntip
Thirteen Moons Gallery

Sano, Takeshi
Chappell Gallery

Sano, Youko
Chappell Gallery

Sarneel, Lucy
Charon Kransen Arts

Sass, Louise
Gallery DeCraftig

Sato, Naoko
ZeST Gallery

Saunders, Gayle
Aaron Faber Gallery

Sautner, Barry
Habatat Galleries

Saylan, Merryll
del Mano Gallery

Scarpino, Betty
del Mano Gallery

Schaefer, Fabrice
Charon Kransen Arts

Schallenberger, Jefferson
William Zimmer Gallery

Scharff, Allan
Galerie Tactus

Schick, Marjorie
Mobilia Gallery

Schira, Cynthia
Snyderman-Works Galleries

Schlatter, Sylvia
Charon Kransen Arts

Schleeh, Colin
Katie Gingrass Gallery
Option Art

Schmid, Renate
Charon Kransen Arts

Schmidt, Jack
Habatat Galleries

Schmitz, Claude
Charon Kransen Arts

Scholz, Ursula
Gallery Yann

Schunke, Michael J.
Kaiser Suidan/Next Step
 Studio and Gallery

Schutz, Biba
Charon Kransen Arts

Schwarz, David
Marx-Saunders Gallery, LTD.

Schwieder, Paul
Hawk Galleries

Scoon, Thomas
Marx-Saunders Gallery, LTD.

Scott, Gale
Chappell Gallery

Scott, Joyce
Mobilia Gallery

Seecharran, Vannetta
Charon Kransen Arts

Seelig, Warren
Snyderman-Works Galleries

Seide, Paul
Leo Kaplan Modern

Seiger, Larry
Yaw Gallery

Sekiji, Toshio
browngrotta arts

Sekijima, Hisako
browngrotta arts

Sekimachi, Kay
browngrotta arts

Sells, Brad
Finer Things Gallery

Selwood, Sarah-Jane
The Scottish Gallery

Semecká, Lada
Chappell Gallery

Sengel, David
del Mano Gallery

Sepkus, Alex
Sabbia

Sewell, Benjamin
Australian Contemporary

Shabahang, Bahram
Orley & Shabahang

Shaffer, Mary
Donna Schneier Fine Arts
Habatat Galleries

Shapiro, Karen
Snyderman-Works Galleries

Shapiro, Mark
Ferrin Gallery

Shaw, Richard
John Natsoulas Gallery
Mobilia Gallery

Shaw, Sandy
Katie Gingrass Gallery

Shaw, Tim
Glass Artists' Gallery

Shaw-Sutton, Carol
browngrotta arts

Shelsher, Amanda
Raglan Gallery

Sherrill, Micah
Ferrin Gallery

Shimaoka, Tatsuzo
Joanna Bird Pottery

Shimazu, Esther
John Natsoulas Gallery

Shimizu, Yoko
Mobilia Gallery

Shindo, Hiroyuki
browngrotta arts

Shinn, Carol
Hibberd McGrath Gallery

Shioya, Naomi
Chappell Gallery

Shirk, Helen
Mobilia Gallery

Shuler, Michael
del Mano Gallery

Sieber Fuchs, Verena
Charon Kransen Arts

Sikora, Linda
Ferrin Gallery

Silverman, Bobby
Sherry Leedy Contemporary Art

Simon, Marjorie
Charon Kransen Arts

Simpson, Tommy
Leo Kaplan Modern

Sinner, Steve
del Mano Gallery

Sisson, Karyl
browngrotta arts

Skau, John
Katie Gingrass Gallery

Skidmore, Brent
Function + Art/prism
 Contemporary Glass

Skjottgaard, Bente
Galleri Nørby

Skuja-Braden, I.M.
John Natsoulas Gallery

Slagle, Nancy
Yaw Gallery

Slee, Richard
Barrett Marsden Gallery

Slentz, Jack
del Mano Gallery

Sloan, Susan Kasson
Aaron Faber Gallery

Small, Pippa
Rebecca Hossack Gallery

Smelvær, Britt
browngrotta arts

Smith, Barbara Lee
Snyderman-Works Galleries

Smith, Christina
Mobilia Gallery

Smith, Frasier
Katie Gingrass Gallery

Smith, Hayley
del Mano Gallery

Smith, Jan
The David Collection

Smith, Martin
Barrett Marsden Gallery

Smith, Wendy Ellis
Portals Ltd

So, Jin-Sook
browngrotta arts
Charon Kransen Arts

Sonobe, Etsuko
Mobilia Gallery

Soosloff, Philip
Kraft Lieberman Gallery

Sørenson, Grethe
browngrotta arts

Spano, Elena
Charon Kransen Arts

Sperkova, Blanka
Mobilia Gallery

Spinski, Victor
John Natsoulas Gallery

Spira, Rupert
Clay

Spreng, Georg
Gallery Yann

St. Croix, Robert
Gallery Biba

St. Michael, Natasha
Galerie des Métiers
 d'Art du Québec

Stabley, Deborah Speck
Snyderman-Works Galleries

Stair, Julian
British Crafts Council

Stanger, Jay
Leo Kaplan Modern

Staniszewski, Grzegorz
Mattson's Fine Art

Stankard, Paul
Marx-Saunders Gallery, LTD.

Stankiewicz, Miroslaw
Mattson's Fine Art

Starr, Ron
Kraft Lieberman Gallery

Statom, Therman
Maurine Littleton Gallery

Stebler, Claudia
Charon Kransen Arts

Stein, Carol
Mobilia Gallery

Stevens, Missy
Hibberd McGrath Gallery
Snyderman-Works Galleries

Stiansen, Kari
browngrotta arts

Stirt, Alan
del Mano Gallery

Stokes, Phillip
Kirra Galleries

Streep, Caroline
Aaron Faber Gallery

Strickstein, Scott
Kaiser Suidan/Next Step
 Studio and Gallery

Striffler, Dorothee
Charon Kransen Arts

Stubbs, Crystal
Kirra Galleries

Stutman, Barbara
Charon Kransen Arts

Sugita, Jozan
Tai Gallery/Textile Arts

Suh, Hye-Young
Charon Kransen Arts

Suidan, Kaiser
Kaiser Suidan/Next Step
 Studio and Gallery

Suntum, Per
Galerie Tactus

Susarte Molina, Salvador
Artempresa

Sutton, Ann
British Crafts Council

Sutton, Polly Adams
Katie Gingrass Gallery

Suzuki, Hiroshi
Galerie Tactus

Svensson, Tore
Charon Kransen Arts

Swirnoff, Sandy
Jean Albano Gallery

Syron, JM
Function + Art/prism
Contemporary Glass

Syvanoja, Janna
Charon Kransen Arts

T

Tagliapietra, Lino
Holsten Galleries

Takaezu, Toshiko
Perimeter Gallery, Inc.

Takamiya, Noriko
browngrotta arts

Takenouchi, Naoko
William Zimmer Gallery

Tanaka, Chiyoko
browngrotta arts

Tanaka, Hideho
browngrotta arts

Tanaka, Kyokusho
Tai Gallery/Textile Arts

Tanigaki, Ema
del Mano Gallery

Tanikawa, Tsuroko
browngrotta arts

Tanner, James
Maurine Littleton Gallery

Tate, Blair
browngrotta arts

Tawney, Lenore
browngrotta arts

Tayar, Dalit
R. Duane Reed Gallery

Taylor, Michael
Leo Kaplan Modern

Tchalenko, Janice
Clay

Thakker, Salima
Charon Kransen Arts

Thiele, Mark
Raglan Gallery

Thiewes, Rachelle
Mobilia Gallery
Yaw Gallery

Thoebald, Curt
del Mano Gallery

Thomford, Pamela
Yaw Gallery

Thompson, Cappy
Leo Kaplan Modern

Threadgill, Linda
Mobilia Gallery
Yaw Gallery

Tiellet, Céline
Galerie Ateliers
 d'Art de France

Tiitsar, Ketli
Charon Kransen Arts

Timm-Ballard, Charles
Sherry Leedy Contemporary Art

Timofeeva, Lolita
Berengo Fine Arts

Tolla
Adamar Fine Arts

Tolosa, Maria Alejandra
Artempresa

Tolvanen, Terhi
Charon Kransen Arts

Tomasi, Henriette
Charon Kransen Arts

Tomasi, Martin
Charon Kransen Arts

Tomita, Jun
browngrotta arts

Toops, Cynthia
Mobilia Gallery

Torii, Ippo
Tai Gallery/Textile Arts

Torma, Anna
Mobilia Gallery
Snyderman-Works Galleries

Torreano, John
Jean Albano Gallery

Toso, Gianni
Leo Kaplan Modern

Toth, Myra
Beatrice Wood Studio

Toubes, Xavier
Perimeter Gallery, Inc.

Townsend, Kent
William Zimmer Gallery

Trask, Jennifer
Mobilia Gallery

Traylor, Pamina
Snyderman-Works Galleries

Trekel, Silke
Charon Kransen Arts

Trenchard, Stephanie
Thomas R. Riley Galleries

Truman, Catherine
Charon Kransen Arts

Tsuji, Noriko
UrbanGlass

Tuccillo, John
Ann Nathan Gallery

Turner, Annie
Galerie Besson

Turner, Julia
Yaw Gallery

Uchida, Toshiki
Mobilia Gallery

Umbdenstock, Jean Pierre
Modus

Ungvarsky, Melanie
UrbanGlass

Urbain, John
WEISSPOLLACK

Urbán, Ramon
Jerald Melberg Gallery

Urbschat, Erik
Charon Kransen Arts

Urino, Kyoko
The David Collection

Urruty, Joël
Finer Things Gallery

Valdes, Carmen
Snyderman-Works Galleries

Vallée, Nad
Galerie Daniel Guidat

Vallien, Bertil
Donna Schneier Fine Arts

Valoma, Deborah
browngrotta arts

Van Cline, Mary
Leo Kaplan Modern

van der Leest, Felieke
Charon Kransen Arts

van Kesteren, Maria
Barrett Marsden Gallery

Van Nostrand, Lydia
Yaw Gallery

VandenBerge, Peter
John Natsoulas Gallery

Vatrin, Gérald
Galerie Ateliers
 d'Art de France

Vaughan, Grant
del Mano Gallery

Vermandere, Peter
Charon Kransen Arts

Vermette, Claude
browngrotta arts

Vesery, Jacques
del Mano Gallery

Vigliaturo, Silvio
Berengo Fine Arts

Vikman, Ulla-Maija
browngrotta arts

Vikova, Jindra
Galerie Pokorná

Virden, Jerilyn
Ann Nathan Gallery

Visintin, Graziano
Mobilia Gallery

Visschers, Robean
Charon Kransen Arts

Vízner, František
Barry Friedman Ltd.
Donna Schneier Fine Arts

Vogel, Kate
Maurine Littleton Gallery

Volkov, Noi
William Zimmer Gallery

Voulkos, Peter
Donna Schneier Fine Arts
Franklin Parrasch Gallery

Wagle, Kristen
browngrotta arts

Wagner, Karin
Charon Kransen Arts

Wahl, Wendy
browngrotta arts

Walentynowicz, Janusz
Marx-Saunders Gallery LTD

Walker, Audrey
The Gallery,
 Ruthin Craft Centre

Walker, Jason
Ferrin Gallery

Walker, Robert
Jean Albano Gallery

Walsh, Michaelene
Dubhe Carreño Gallery

Waltz, Silvia
The David Collection

Wang, Kiwon
Gallery Yann

Warner, Deborah
Snyderman-Works Galleries

Wason, Jason
Joanna Bird Pottery

Watkins, Alexandra
Mobilia Gallery

Watkins, David
The Scottish Gallery

Wearley, Ben
Yaw Gallery

Webb, Scott
Kaiser Suidan/Next Step
 Studio and Gallery

Webber, Delross
Thomas R. Riley Galleries

Wegman, Kathy
Snyderman-Works Galleries

Wegman, Tom
Snyderman-Works Galleries

Weinberg, Steven
Leo Kaplan Modern

Weiss, Beate
The David Collection

Weissflog, Hans
del Mano Gallery

Weldon-Sandlin, Red
Ferrin Gallery

Wells, Charles
Rebecca Hossack Gallery

Westphal, Katherine
browngrotta arts

Whiteley, Richard
Bullseye Connection Gallery

Whyte-Schulze, Elizabeth
Katie Gingrass Gallery
Mobilia Gallery

Wieske, Ellen
Mobilia Gallery

Wiken, Kaaren
Katie Gingrass Gallery

Willenbrink, Karen
Thomas R. Riley Galleries

Williamson, Dave
Snyderman-Works Galleries

Williamson, Roberta
Snyderman-Works Galleries

Wilson, Emily
Jerald Melberg Gallery

Wingfield, Leah
Habatat Galleries

Wise, Jeff
Aaron Faber Gallery

Wise, Susan
Aaron Faber Gallery

Wittrock, Grethe
Gallery DeCraftig

Woffenden, Emma
Barrett Marsden Gallery